SUPIMA

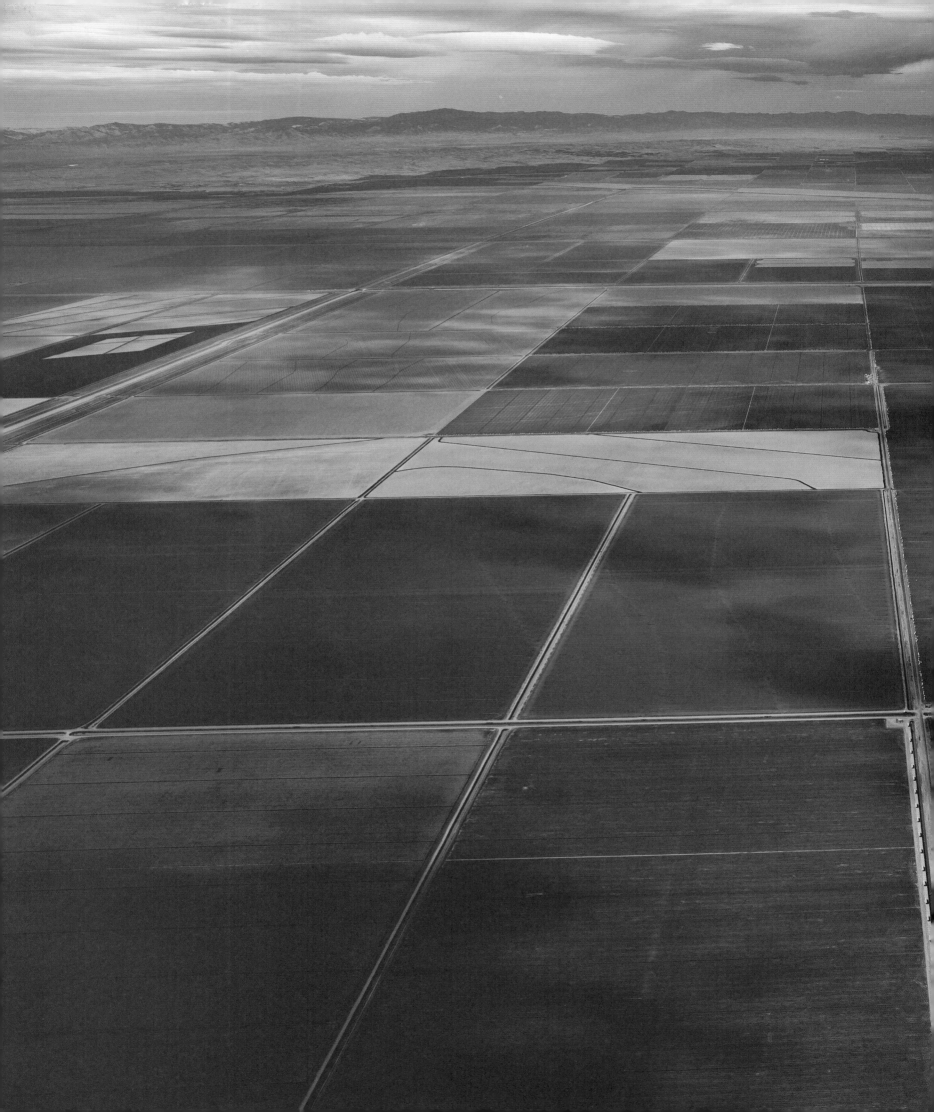

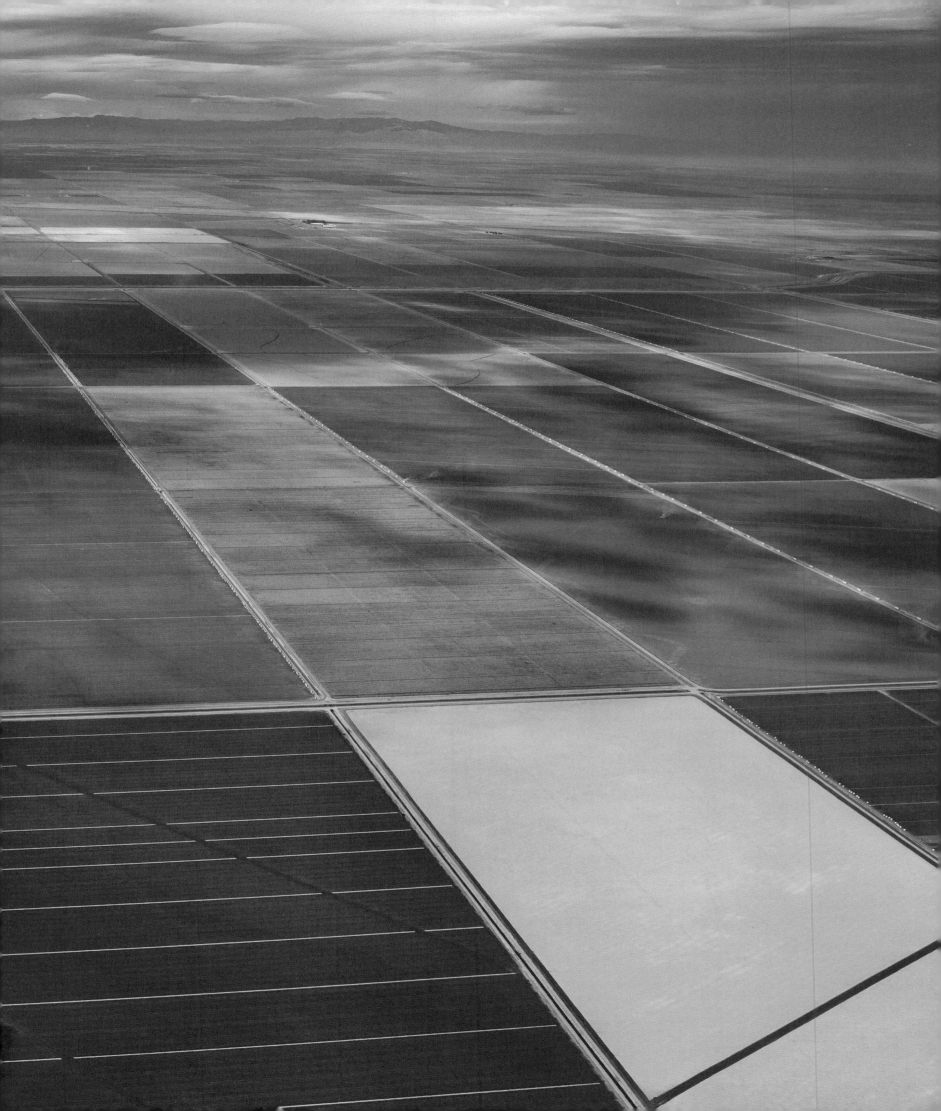

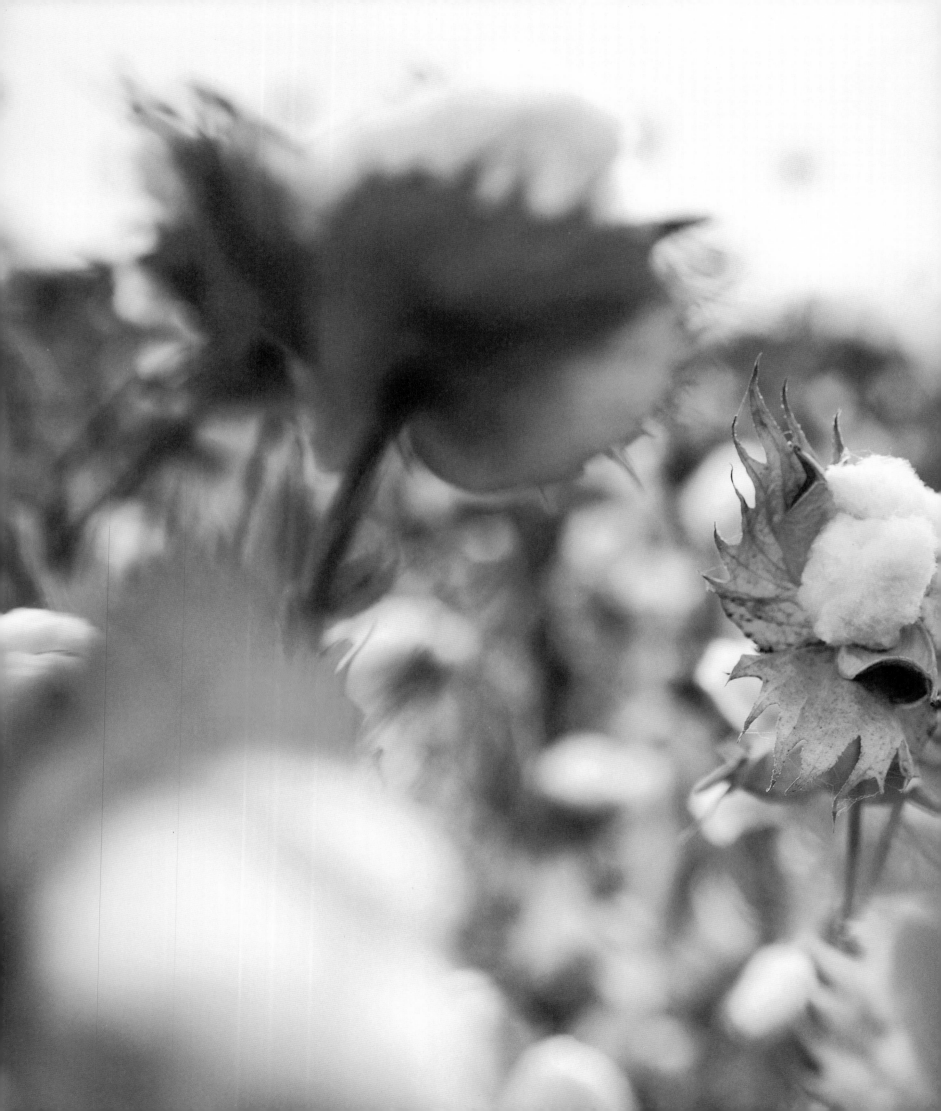

SUPIMA

WORLD'S FINEST COTTONS

RIZZOLI
NEW YORK

New York · Paris · London · Milan

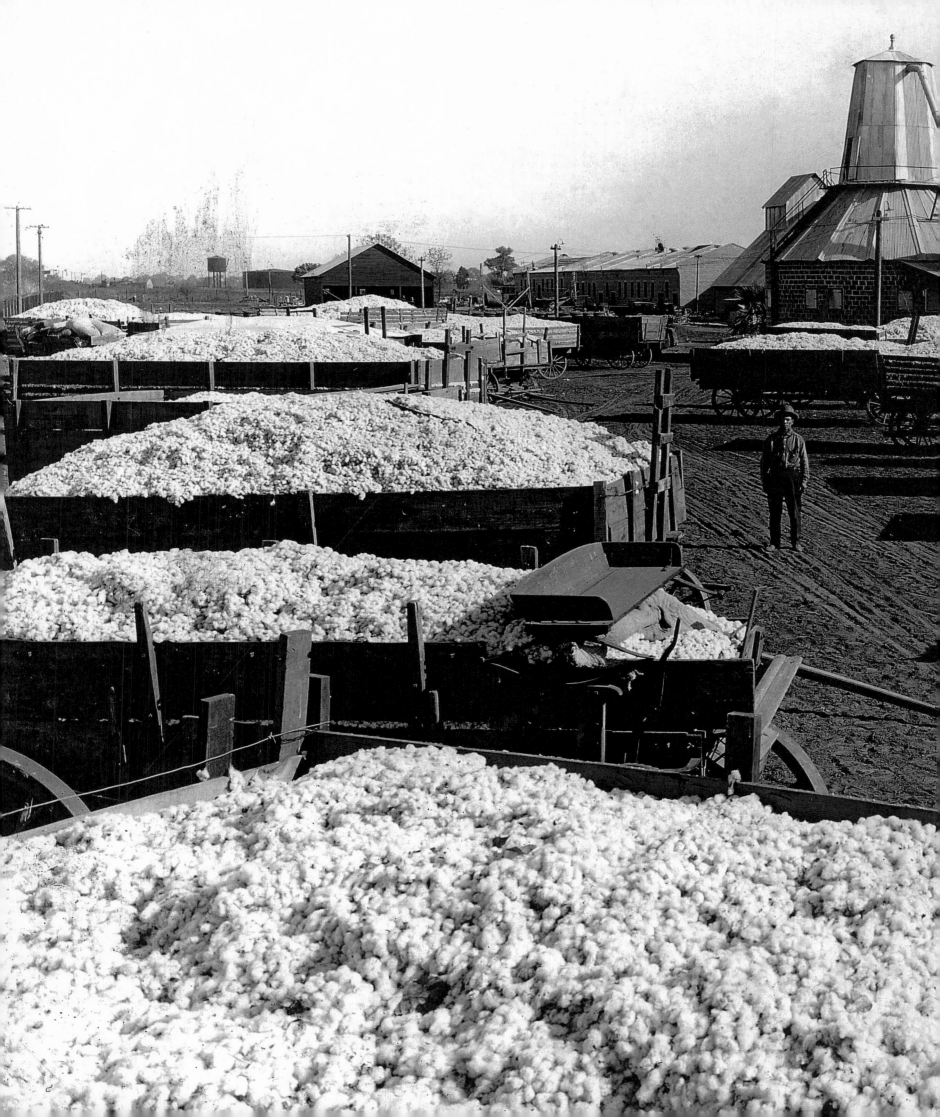

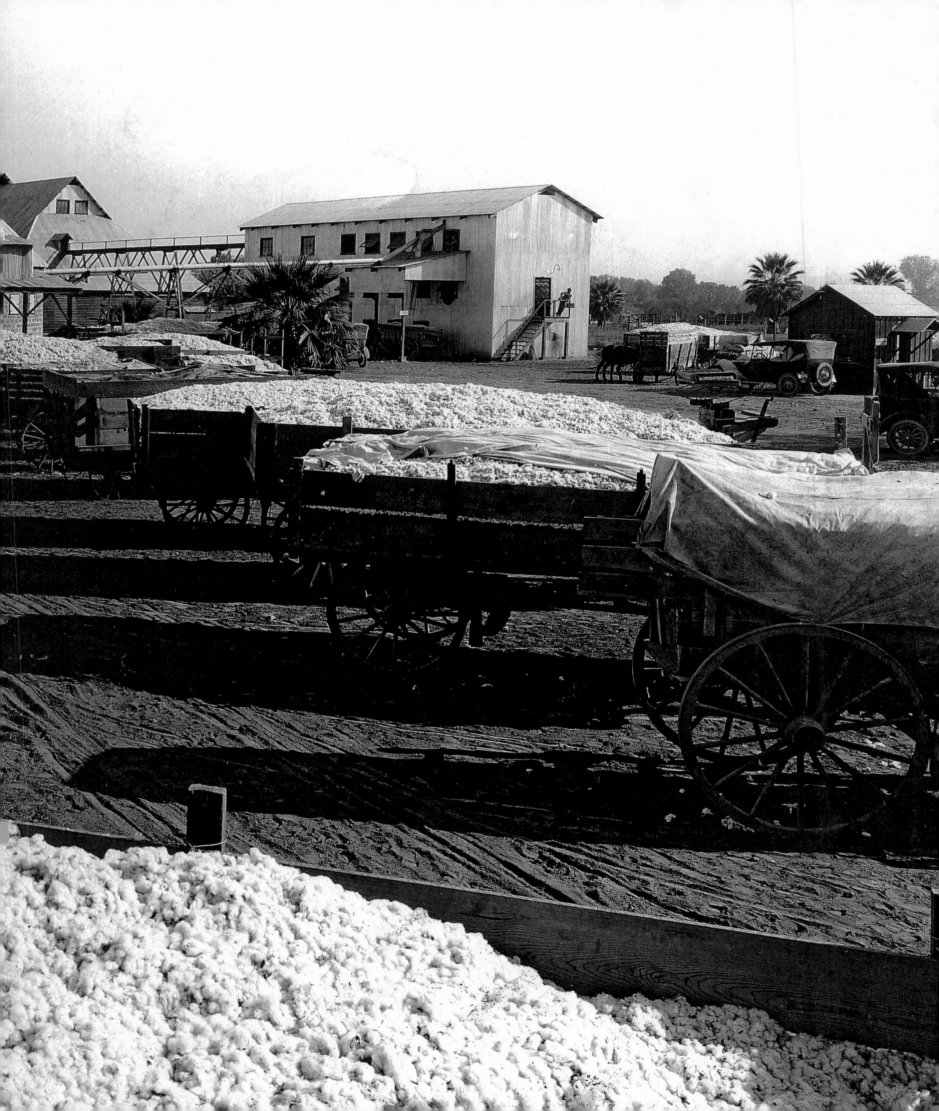

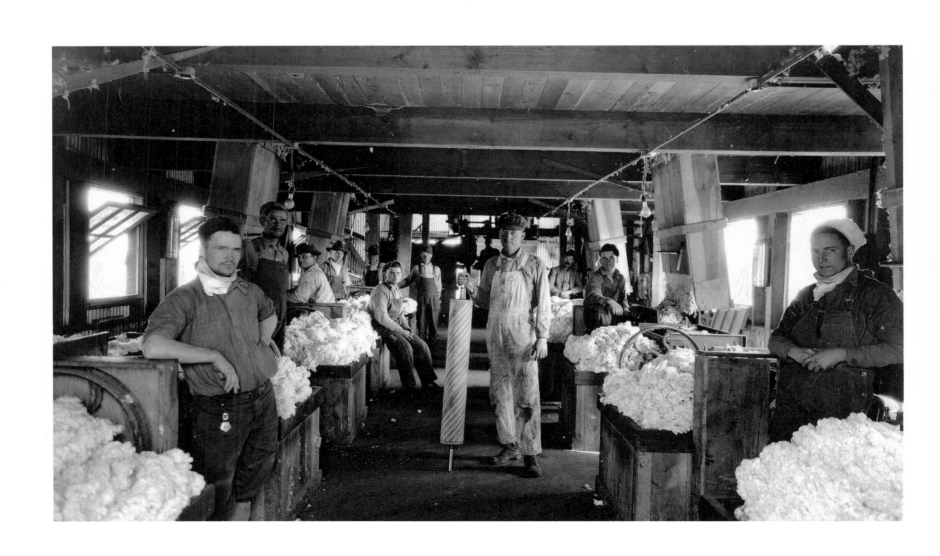

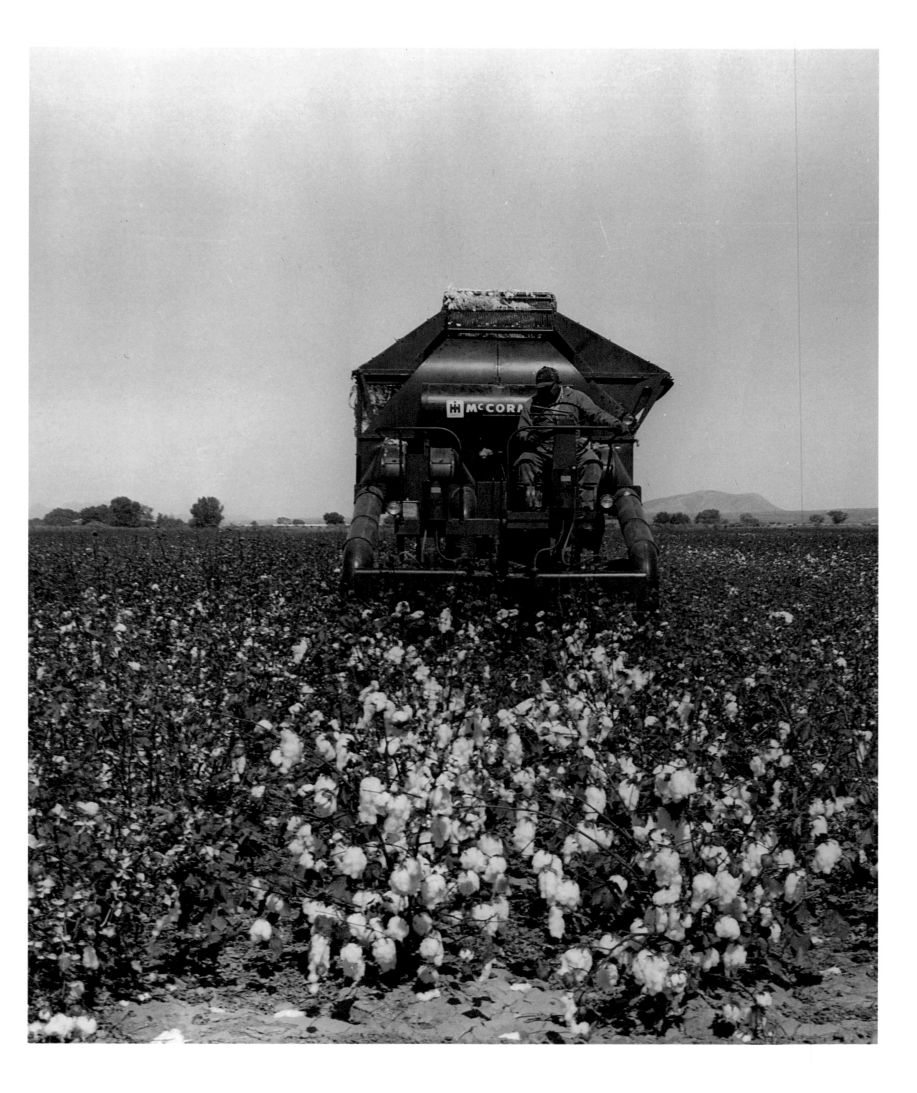

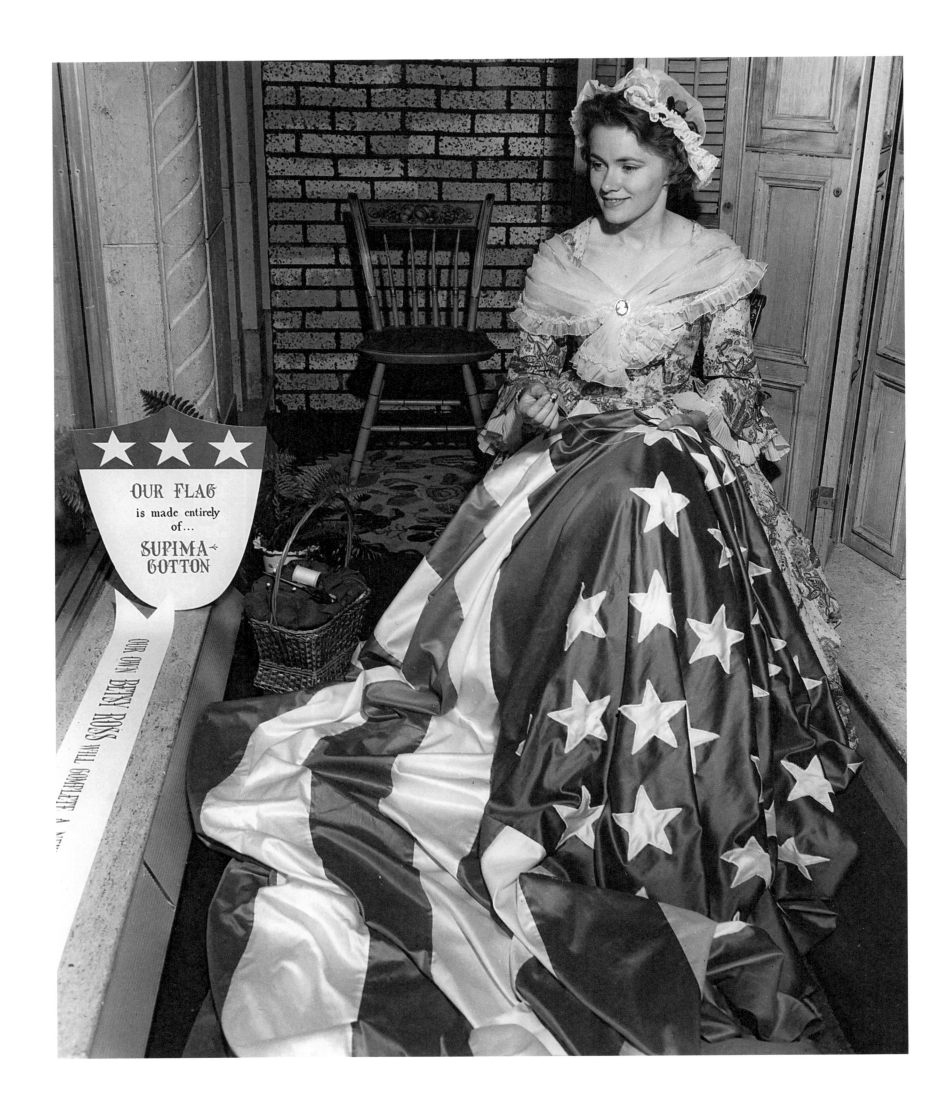

OUR FLAG
is made entirely
of...
SUPIMA
COTTON

OUR OWN BETSY ROSS WILL COMPLETE A NEW

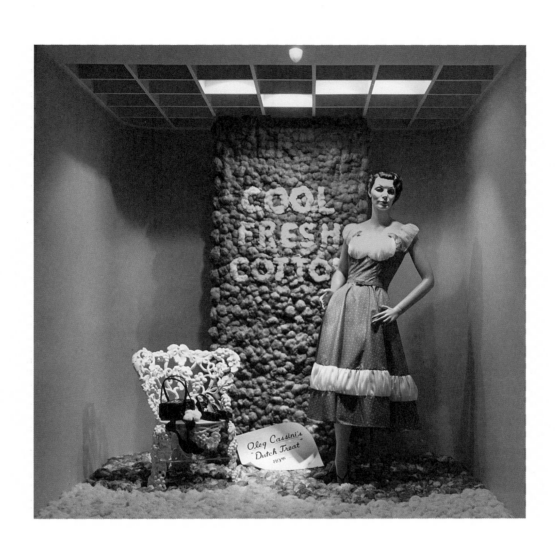

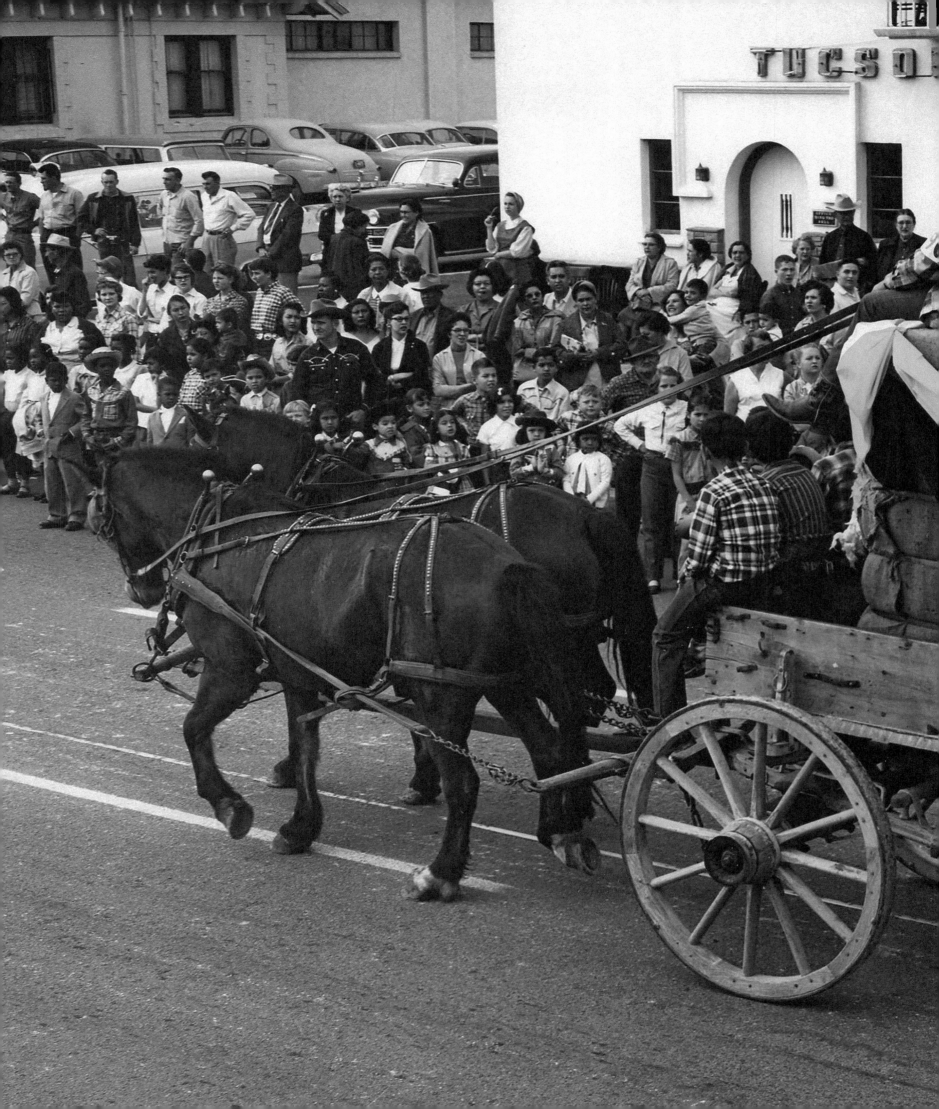

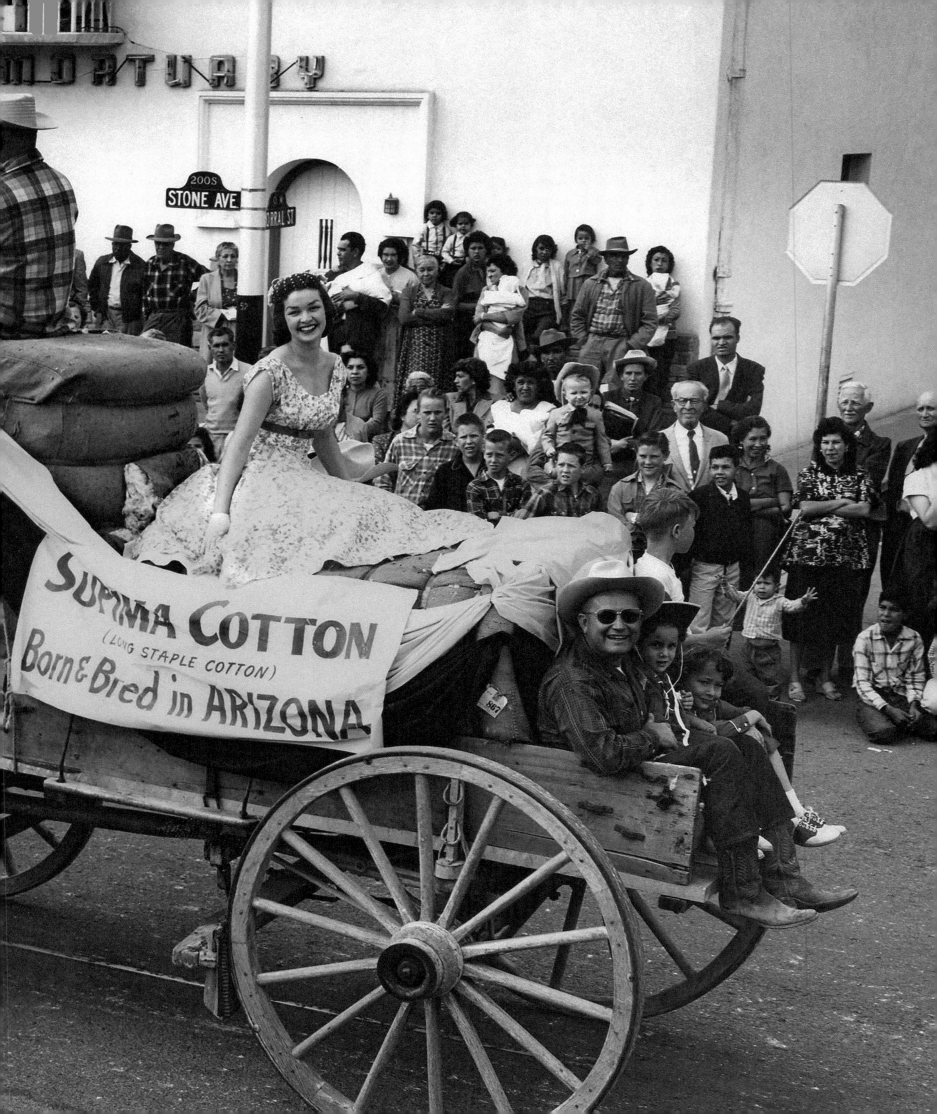

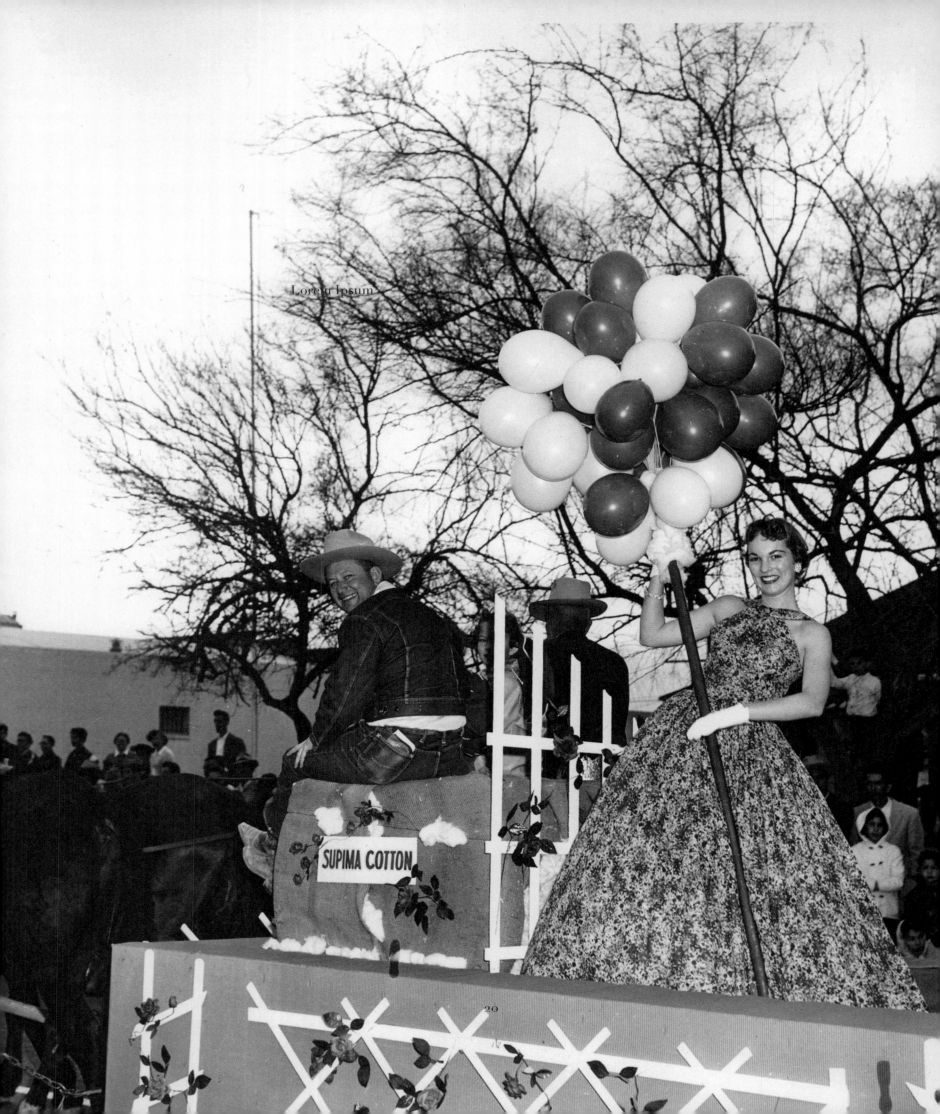

SUPIMA COTTON

BUILDING SUPIMA: AN AMERICAN FIBER

Fern Mallis

What is Supima? Is it a bird? A plane? A superhero? No, it's a super cotton! The name sounds light and lofty, like an exhaled breath or a soft specimen of cloud. Supima is woven into our lives in a myriad of ways, from when we dry off after a shower with the best towels, to when we get dressed for the day, to when we finally hit our fine thread count sheets. We are familiar with its wonderful properties—colorfast, breathable, smooth, and long lasting—yet for ages only industry insiders knew the name of this quintessentially American luxury fiber.

Supima is a rare variety of cotton. More precisely, it is the top one percent of cotton produced in the world, developed over a century of agricultural engineering to have a super long staple—that is, the individual fibers that are twisted together to make the cotton yarns we know and love—and grown right here in the USA. A third stronger than regular cotton, it is also silkier and resistant to pilling. That's where the "superior" part of Supima comes in. The "Pima" end of the portmanteau honors the Pima Indian tribe—Americans in the truest sense—of Arizona, where the extra-long-staple cotton was first developed in 1911. Once recognized, the fiber's qualities were first put to use for industry. In 1916, Goodyear invested in producing the cotton for cording in its automobile, bicycle, and airplane tires. In response to growing demand, a group of American Pima

farmers came together in 1954 to create the Supima Associa-
tion of America. It was then—with typical American gump-
tion—that Supima realized it could do more than transport
you: it could partner with the emerging designers of the day
as the United States evolved into a world-class cultural force.

There is no fashion without fiber. That's where it starts.
One cannot have an intelligent conversation about fashion
without discussing textiles. It is a testament to Supima's
innovation that it remains the United States' premier export
crop for the global fashion industry, maintaining a legacy of
American agriculture, the first lifeblood of our country.
In my four decades in fashion, I have had the privilege of
witnessing great changes, and have been instrumental in many
more. Building the Council of Fashion Designers of America
(CFDA) into a directional body, and creating New York
Fashion Week—which galvanized the American fashion
designers and ultimately made New York a global force in
fashion—gave me the opportunity to reflect on the heritage
of our country's fashion and what makes it distinctive in an
increasingly globalized world. As an American fashion
ambassador traveling internationally, I see a bright future
for successive new generations of talent.

But back to the beginning. In 1956, when Supima first
launched a consumer-facing ad campaign, American fashion
was still very much in the shadow of Europe. A bit more than
a decade after World War II, I remember an America of TV
shows featuring Donna Reed cotton aprons and housedresses.
This picture of the late 1950s and 1960s starred housewives
and homemakers, to whom the glitz of Paris held a far-off
allure. Claire McCardell was a notable exception. One of the
first American designers to work under her own name,
McCardell swore off European influence after 1940 and put
to use sturdy basic fabrics—jersey, calico, and denim—to intro-
duce a distinctly American look, versatile enough to move
from house chores to cocktails. Supima partnered with and
featured McCardell garments in its campaigns until her death,
championing simple, strong looks that matched Supima's own
sense of American identity.

This love of practicality and ease would lead Supima to part-
ner with Anne Klein, the fashion designer credited with the
creation of American sportswear. Klein's line of separates
revolutionized the wardrobe of women entering the work-
force in the late 1960s and early 1970s. These women did
not need Continental silks or taffetas. They needed resil-
ient cotton that worked as hard as they did. Supima nodded

to America's rough and tumble heritage in early Western themed campaigns, setting an elegant Oleg Cassini dress atop a cowboy hat. This image is particularly evocative of Supima's—and American fashion's—complex character.

Between Claire McCardell's and Anne Klein's domestic garments and sportswear, Supima would also partner with eveningwear designers like Oleg Cassini and Bill Blass, who put cotton to more extravagant use. The CFDA, founded in 1962, gave American designers like these a new platform and voice. In the 1960s, Oleg Cassini was dressing the most fashionable of first ladies, Jacqueline Kennedy Onassis. American fashion designers Arnold Scaasi, Geoffrey Beene, and others led the charge toward the formation of American design houses. This new assuredness can be seen in Supima's ads photographed by the legendary William Helburn. Supima depicted American fashion with its own brand of elegance, trading in haute couture stiffness for romance and adventure. The best models of the day—including Coco Chanel muse Suzy Parker—starred in these campaigns.

Yet still in 1973, when Eleanor Lambert (founder of the CFDA) brought five Americans to Paris, it shocked the world that the Yanks would triumph in the battle of Versailles. The legendary

showdown between Yves Saint Laurent, Hubert de Givenchy, Emanuel Ungaro, Pierre Cardin, and Christian Dior against Halston, Oscar de la Renta, Bill Blass, Stephen Burrows, and Anne Klein gave stateside fashion true international prestige. Supima was the cotton of choice for these first names of American design, but would continue to build its base in staples: pajamas and beachwear by brands like Pembroke Squires were perfect for an increasingly mobile and adventurous middle class. Supima celebrated the new American woman in an advertisement featuring a winking model with a suggestive space rocket, ready to take on the world in her Bill Blass.

The 1970s were a tumultuous decade in America and around the world. Clingy polyester shirts and suits danced their way into our lives with John Travolta and *Saturday Night Fever* (1977). Fortunately, in that same year, Diane Keaton in *Annie Hall* ignited a cotton-based American look borrowed liberally from the closets of Ralph Lauren. Designer jeans were introduced by brands like Gloria Vanderbilt and Calvin Klein, paving the way for an American-led global denim takeover. By 1988, domestic demand for Supima cotton was sufficient to start an international export program. Swiss and Italian high-end shirting mills were the first to use the cotton, and Japan soon followed suit.

In the aftermath political upheaval of the 1980s, runaway inflation, and the energy crisis, Americans wanted to pull a blanket over their heads. The phenomenon of "nesting" saw homemakers invest in plush towels and crisp sheeting. Supima entered consumers' hearts and homes in the most luxurious brands of the day: Martex, Wamsutta, and Charisma.

In the 1990s, the dawn of the information age, branding became more complex. Supima launched a licensing program and established a long partnership with American juggernaut Brooks Brothers. The natural materials movement coincided with increased insight into what everyday consumers wore. At the CFDA, where I took the helm in 1991, it became increasingly clear that fashion would become a broad cultural force, as much a part of American life as music or entertainment. In 2001, when New York Fashion Week was sold to IMG, I traveled the world establishing more fashion weeks. Here I saw that New York Fashion Week did more than bring designers together at home; it brought an international design community to New York and spread America's influence in the broader design community. Supima was leading the way, too, weaving its cotton around the world—by 2002, with the designer denim trend in full swing, Japan, Italy, and Turkey all produced premium jeans with Supima cotton.

The influence of American sportswear would not stop at jeans, nor would workwear remain premium separates. Facebook's Mark Zuckerberg forever changed the world from inside a hoodie in 2004, heralding an era of atomized workers and ever more informal office attire. Today, Supima can be found in the basics of UNIQLO, in model-off-duty looks, in the required yoga uniform of America's health boom, and in the luxurious T-shirts of Michael Stars and Majestic Filatures. As brands like Casper and 3x1 seek to revolutionize their industries with transparency, Supima has proved to be a perfect partner. For all the technological innovations in the world, nothing beats the pure quality and breathability of cotton.

Supima brilliantly committed to the future of American fashion in 2008, inviting students from the country's leading design schools to compete with looks crafted from Supima textiles during New York Fashion Week. It has been my honor to judge this contemporary update on an industry tradition. The future of fashion is in the young students of these design schools, and Supima has invested in their journey. So what, in the end, is Supima, the super cotton? It is the hidden ingredient in our lives we didn't know we loved. It is an integral part of American fashion, an exemplar of our country's creativity, quality, ingenuity, and strength.

EARLY DAYS OF SUPIMA

Pages 12–13. Wagons of recently picked Supima cotton destined for use as cord in Goodyear tires, Salt River Valley, AZ.

Page 14. Interior view of an early twentieth-century cotton gin operated by the Goodyear Tire & Rubber Company, Salt River Valley, AZ, 1920.

Page 15. Two-row picker taking up the harvest in Phoenix, AZ.

Page 16. An American flag crafted of Supima cotton to celebrate the Fourth of July.

Page 17. Early promotion in a retail display for a dress designed by Oleg Cassini using Supima fabrics.

Pages 18–19. Supima on parade as Tucson, AZ, celebrates the year's Supima harvest.

Page 20. Supima leads the local parade in Tucson, AZ, the heart of Supima cotton production in the 1960s.

BUILDING SUPIMA: A VISUAL LEGACY

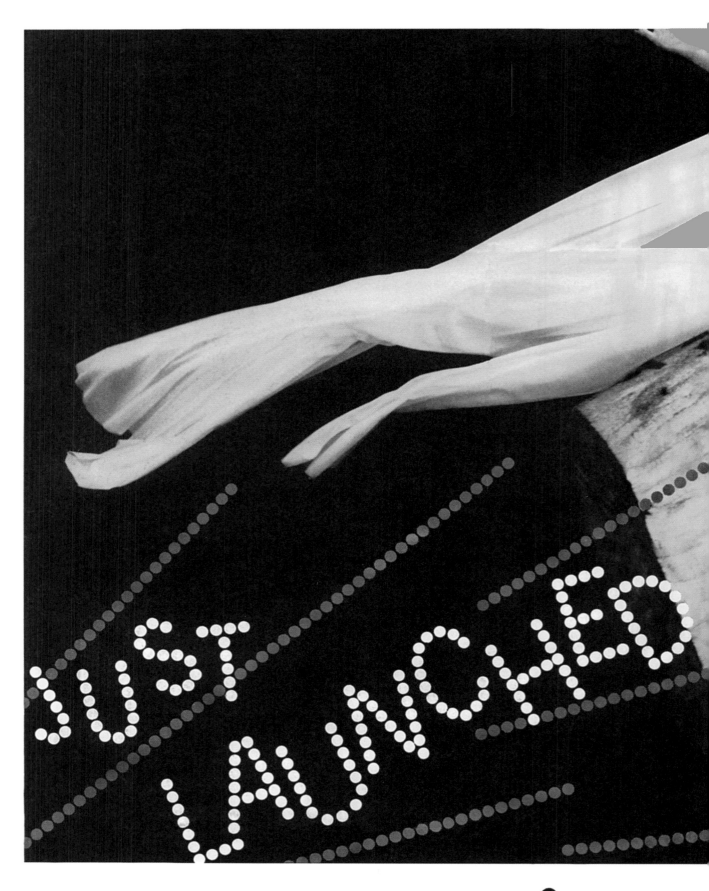

JUST LAUNCHED

SuPima

THE
CHAMPAGNE
OF COTTONS

It's here—now! Supima! A spectacular new cotton
unprecedented lustre, unheard of strength. Every tra
tional virtue that cotton has, Supima has, plus ma
additional virtues that are exclusive. Born and
right here in America—Supima establishes a comple
new world standard all its own. It takes color

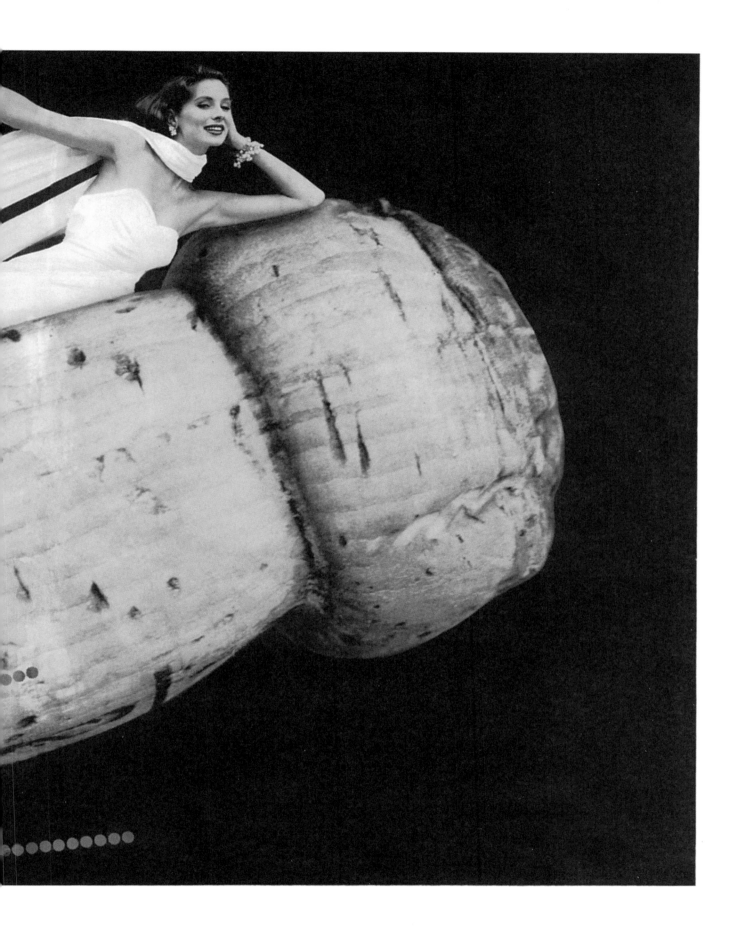

iful bloom. It drapes with the grace of a willow. tinguishes itself equally in virile men's shirtings n the sheerest fabrics you've ever looked through. her cotton fields in the entire world are yielding a with so bright a future. Soon you will recognize auty in the finest men's shirts as well as in the most elegant women's dresses. Ask your converter about Supima now. Or write us direct and we will tell you where and when fabrics woven of Supima yarn will be available. Look for the registered Supima label shown to the right. Supima Association of America, 40 Worth Street, New York 13, N.Y. BEekman 3-5857.

SuPima®
WORLD'S FINEST COTTON

BORN
AND
BRED
IN
AMERICA

Pages 32–33. Supima launched with a splash in 1954 in the pages of major magazines. The vivacious "Just Launched" campaign ran in *Women's Wear Daily* in 1955, celebrating Supima's first anniversary.

Page 34. "Born and Bred in America," from the early 1960s, showcased Supima's uniquely American appeal. The design and message proved enduring enough to run again in 2011.

Opposite. The typography-driven campaigns of the early 1960s captured Supima's bold spirit, earning a coveted AIGA design award in 1964. They included the introduction of "Pedigreed Seed," a concept that set Supima apart and emphasized its homegrown origins, first published in regional editions of *LIFE* magazine.

Pages 38–39. This campaign drew attention to the full-color advertisements that ran in *McCall's, LIFE, Esquire, Vogue, Harper's Bazaar,* and *The New Yorker* throughout the 1960s.

Did you ever wear a shirt grown from pedigreed seed?

If you've ever worn a shirt of a SuPima cotton fabric the answer is yes. How would you know? By the silky feel, the lustrous look, the happy freshness washing after washing. SuPima fabrics never let you down. *Can't* let you down because they are made of extra-long staple cotton scientifically grown in Arizona, Texas and New Mexico from special seed—*pedigreed* seed—developed after years of research by agricultural geneticists. SuPima fabrics are not just cotton. They are superior *pima* cotton—softer, silkier, stronger, more lustrous. Shirts of SuPima fabric look better, *feel* better. The best makers feature them. The best dressed men wear them. Make sure there's a SuPima label in the next shirt *you* buy. SuPima Association of America, Empire State Building, New York.

SUPIMA IS THE REGISTERED CERTIFICATION MARK FOR PRODUCTS MADE OF SOUTHWESTERN EXTRA-LONG STAPLE COTTON.

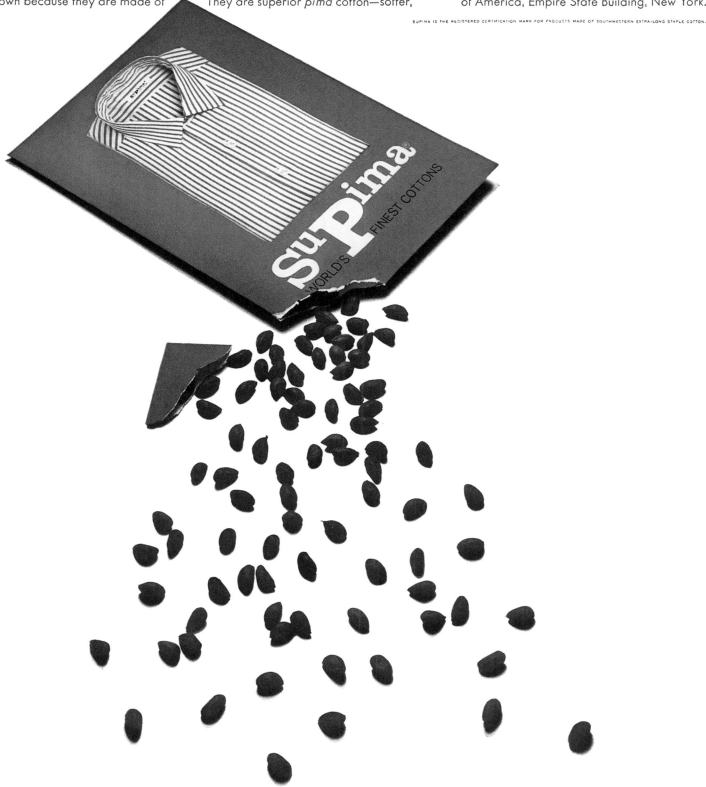

Advertised in LIFE Magazine

su**p**ima
cotton fabrics
are softer,
silkier, stronger,
more lustrous

What started as a whisper

suPima

cotton fabri tton fabri re softer ier, stron re lustrou

has now become a shout!
The whole country will be hearing it
in McCall's, Life, Esquire, Vogue, Harper's Bazaar, The New Yorker

With more and more manufacturers using SuPima fabrics, it's time that more and more people be told of SuPima's superiorities. Through full page, full color advertisements in America's leading magazines the entire nation will soon learn the story of SuPima and the various kinds of apparel in which it is available. Made from extra long staple cotton grown exclusively in Arizona, Texas and New Mexico, SuPima fabrics are now found in such diverse items as men's socks and women's couturier dresses,

men's T-shirts and women's lingerie. Wherever good makers make a point of quality they point proudly to their use of SuPima. Actually, SuPima is its own best advertisement. The second they see it, touch it, both men and women recognize its extra softness, extra silkiness, extra lustre. SuPima is pima at its best. Quality controlled, pedigreed! It's America's luxury cotton fabric developed for the few, but demanded by the multitude. SuPima Association of America, Empire State Building, New York, N.Y.

suPima
WORLD'S FINEST COTTONS

SUPIMA IS THE REGISTERED CERTIFICATION MARK FOR PRODUCTS MADE OF SOUTHWESTERN EXTRA-LONG STAPLE COTTON

MEN'S FASHION CAMPAIGNS

Opposite. Supima appealed to the upscale audience of *The New York Times* in a 1964 ad featuring Diplomat cotton pajamas.

Page 42. Cluett Peabody & Co. manufactured Arrow, a brand that enjoyed great popularity in the early 1900s. By the 1950s, Supima was the cotton of choice for the classic line of shirts and detachable collars.

Page 43. Like much men's advertising of the early 1960s, Supima drew comparisons between sports heroes and the corporate man, whose fitness is highlighted here by his trim Manhattan Shirt Company broadcloth.

Page 44. Julius Withers Monk, a well-heeled impresario of the New York cabaret scene, served as Supima's brand ambassador in campaigns for 1963–65. Here Monk poses on the field with New York City's beloved Mets.

Page 45. Monk opened the Plaza Hotel's nightclub, the Rendezvous Room, the year before the ads featuring him first appeared in *The New Yorker*. The Supima man exuded sophistication, humor, and adventure.

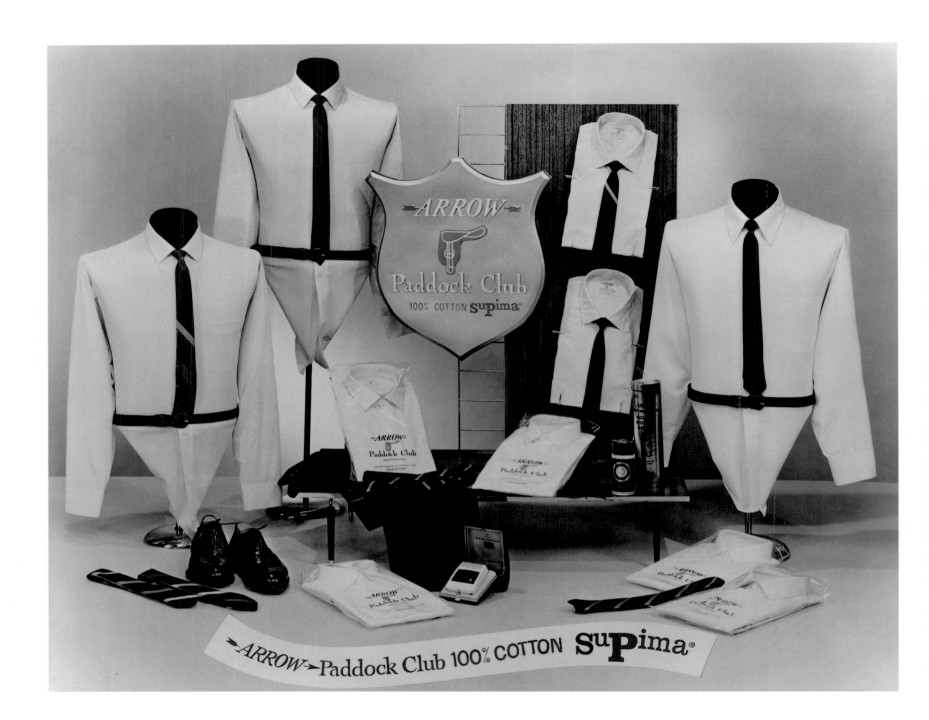

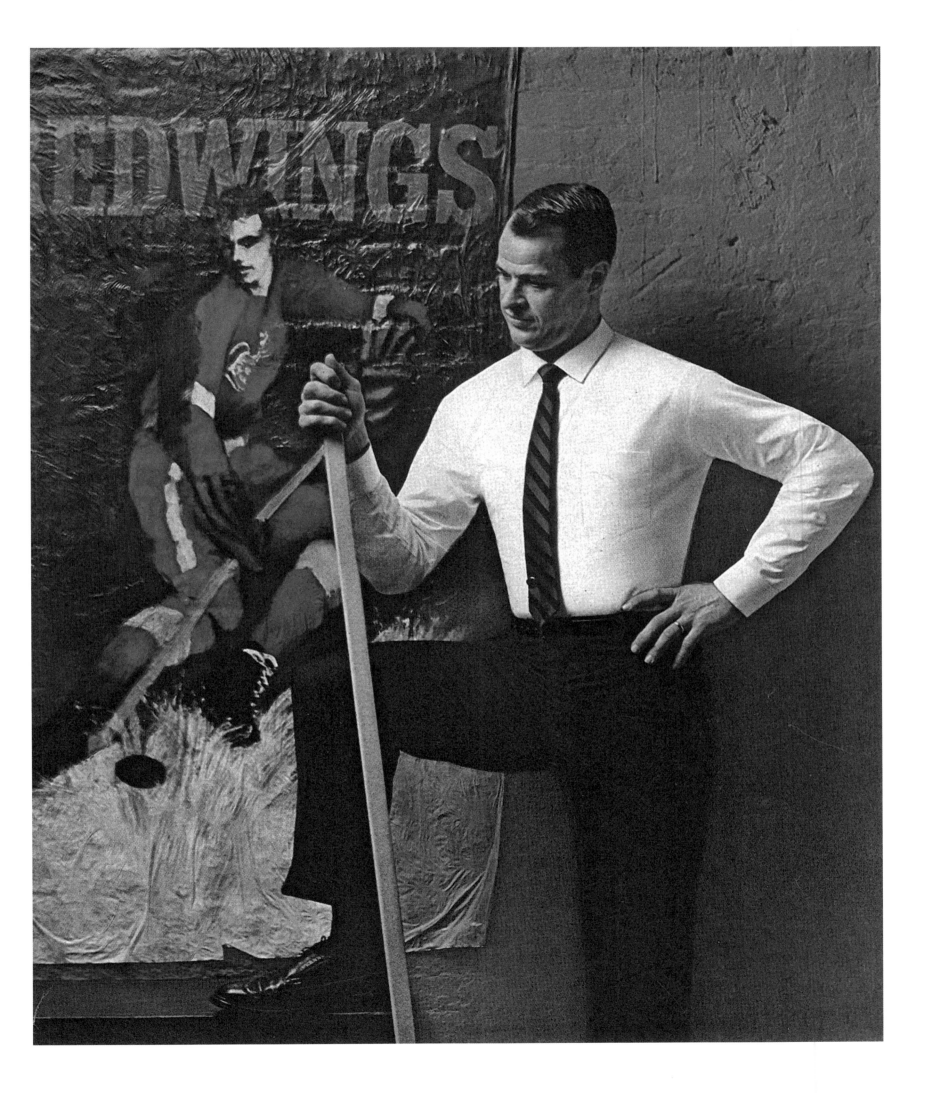

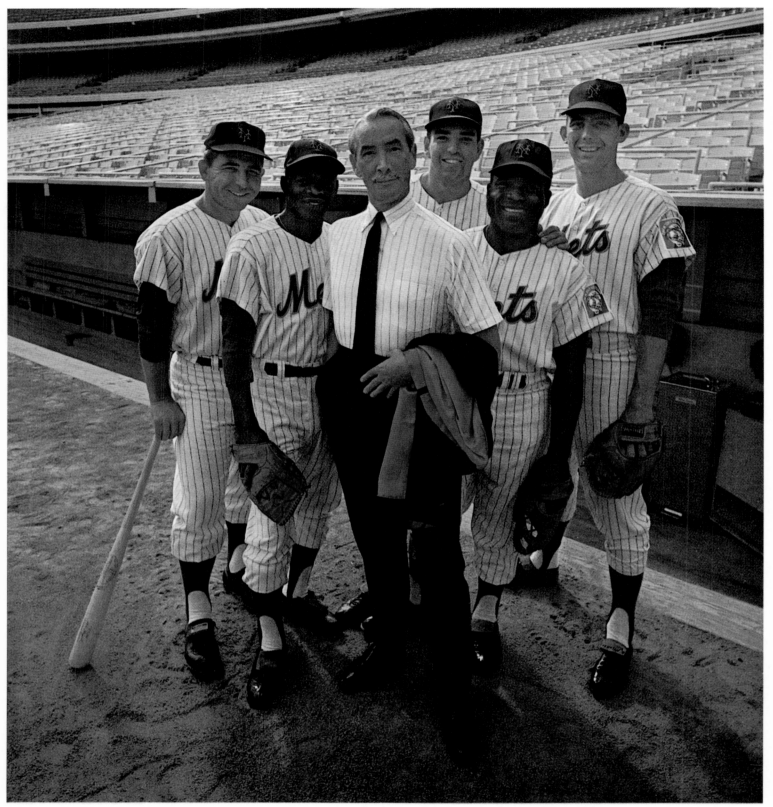

Julius Monk, the Mets and SuPima®

WORLD'S FINEST COTTONS

When short sleeves are the order of the day, Mr. Monk (who spends his days enjoying the Mets and his nights entertaining "Plaza 9—" audiences) still manages to look impeccably attired. In this case he gives all the credit to the **Eagle Shirtmakers**, who with admirable modesty, pass it on to the SuPima cotton broadcloth by Russell Mills, of which his shirt is fashioned. Eagle's spokeswoman, the well known and articulate Miss Afflerbach, spared the time from her endless chores in Quakertown to explain that only SuPima, woven of superior pima, grown exclusively in our own Southwest, is so soft, so lustrous and so silky. Available at most distinguished stores throughout the country. SuPima Association of America, Empire State Building, New York, New York.

MEET THE METS, GREET THE METS AT SHEA STADIUM. SUPIMA IS THE REGISTERED CERTIFICATION MARK FOR PRODUCTS MADE OF SOUTHWESTERN EXTRA-LONG STAPLE COTTON.

As advertised in The New Yorker

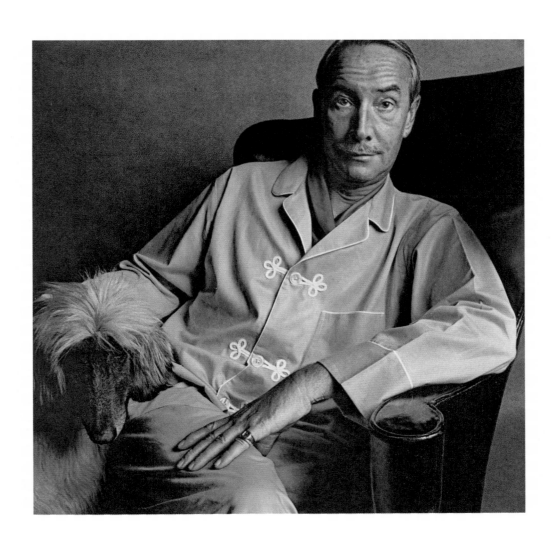

WAY OUT WEST IN THE LAND OF COTTON

Opposite. Supima's ads of the early 1960s underscored the fiber's Southwestern origins via cowboy imagery like cacti and spurs paired with garments by emerging American ready-to-wear designers. Here, a model in an elegant Oleg Cassini creation balances atop a cowboy hat, embodying Supima's uniquely American mix of brawn and sophistication.

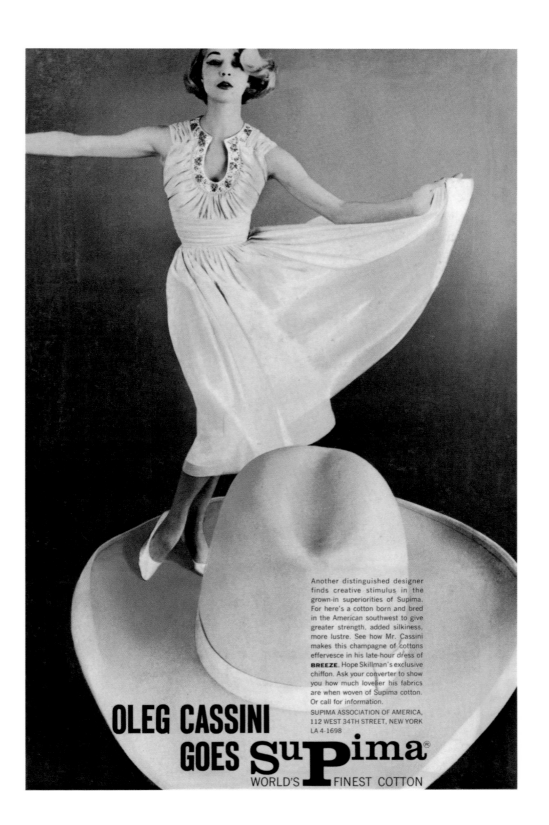

Another distinguished designer finds creative stimulus in the grown-in superiorities of Supima. For here's a cotton born and bred in the American southwest to give greater strength, added silkiness, more lustre. See how Mr. Cassini makes this champagne of cottons effervesce in his late-hour dress of **BREEZE**, Hope Skillman's exclusive chiffon. Ask your converter to show you how much lovelier his fabrics are when woven of Supima cotton. Or call for information. SUPIMA ASSOCIATION OF AMERICA, 112 WEST 34TH STREET, NEW YORK LA 4-1698

OLEG CASSINI GOES SuPima®
WORLD'S FINEST COTTON

SUPIMA CAMPAIGNS REACH NEW HEIGHTS

Opposite. From 1955 to 1960 Supima enjoyed a golden age primarily in creative partnership with the legendary photographer William Helburn. Exotic concepts, refined styling, and the era's top models cemented Supima as a significant player in the burgeoning American fashion scene. The first Helburn ad, featuring legendary model Dovima, ran in *Vogue* and *The New Yorker.*

Page 51. Suzy Parker wears a dress by Claire McCardell in "Americana," a campaign featured in *Vogue*, February 1958.

Page 52. Suzy Parker poses in Harvey Berin, an American designer celebrated for his well-made but accessible day dresses, glamorous enough for first lady Pat Nixon.

Page 54. William Helburn shot Romana Swann on Central Park's Great Lawn for this surreal campaign featuring dresses by American designer Dorothy Cox.

Pages 55, 57. "Worldly Wise," an aspiration of midcentury armchair travelers, described the sophisticated Brigance and Pembroke Squires dresses modeled by Suzy Parker for southeast Asian Supima ads in *Vogue*, late 1960.

Gala
Premiere

Su**P**ima®

WORLD'S **P** FINEST COTTON

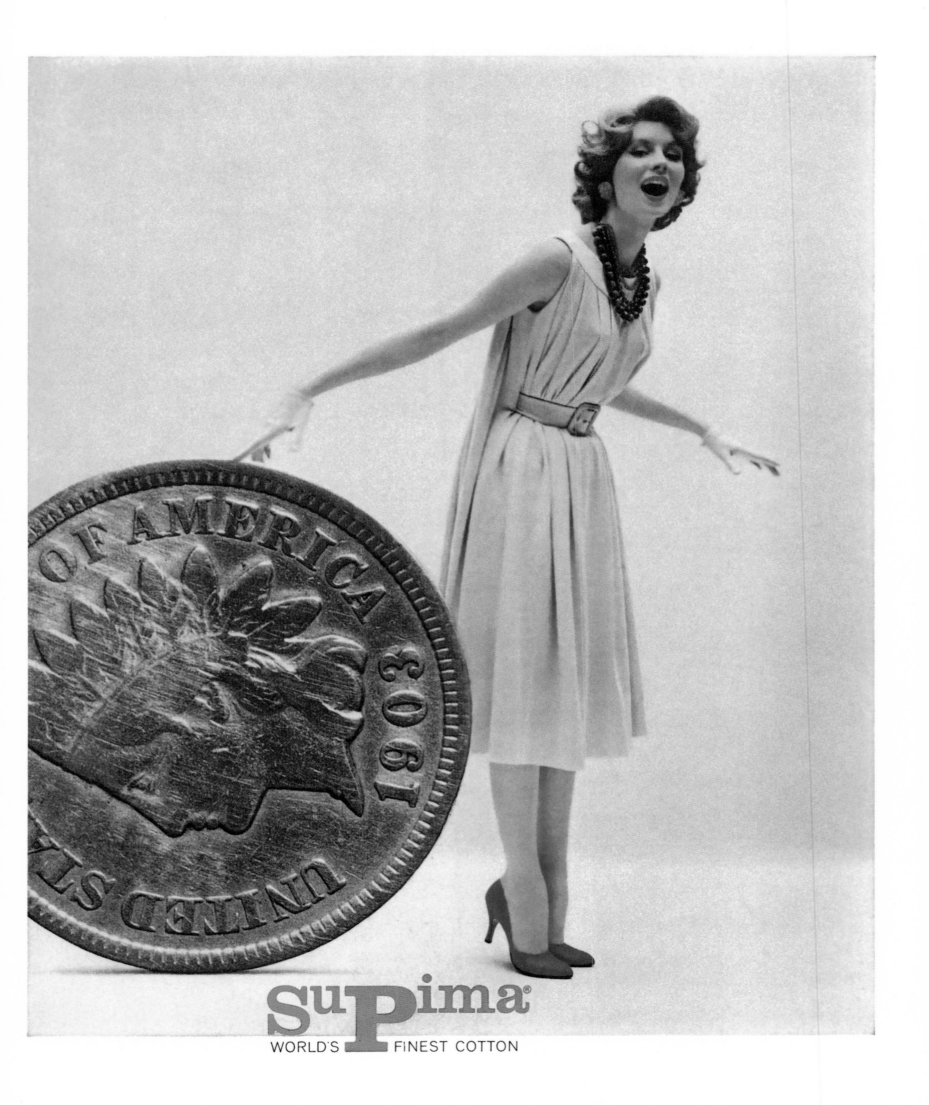

Su**P**ima®

WORLD'S FINEST COTTON

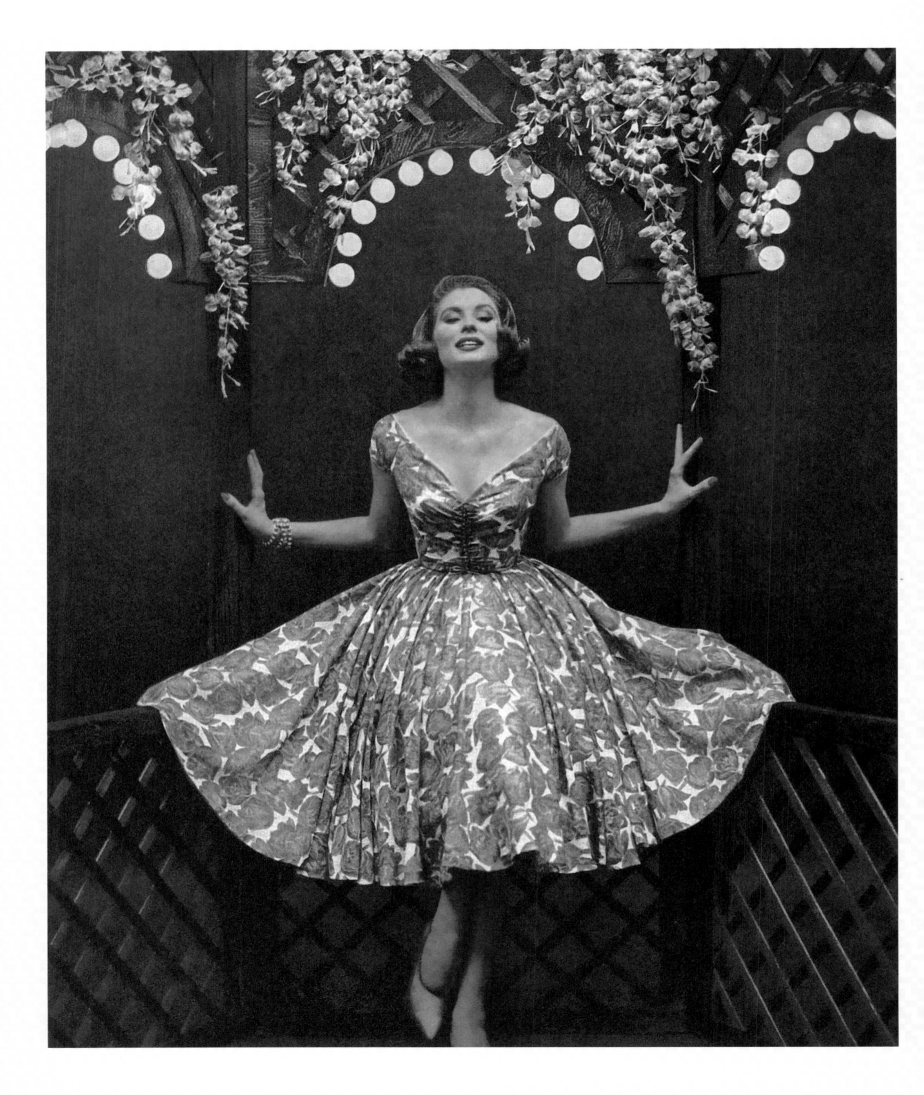

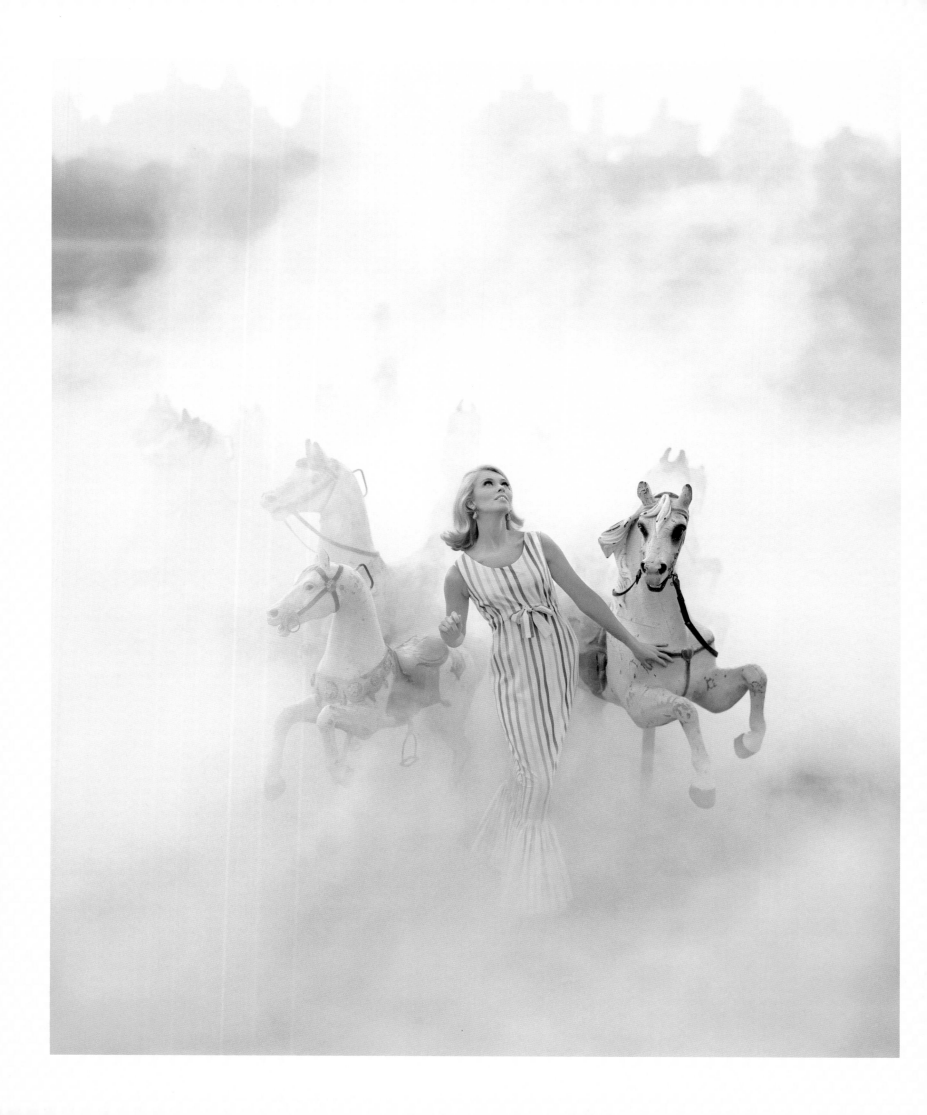

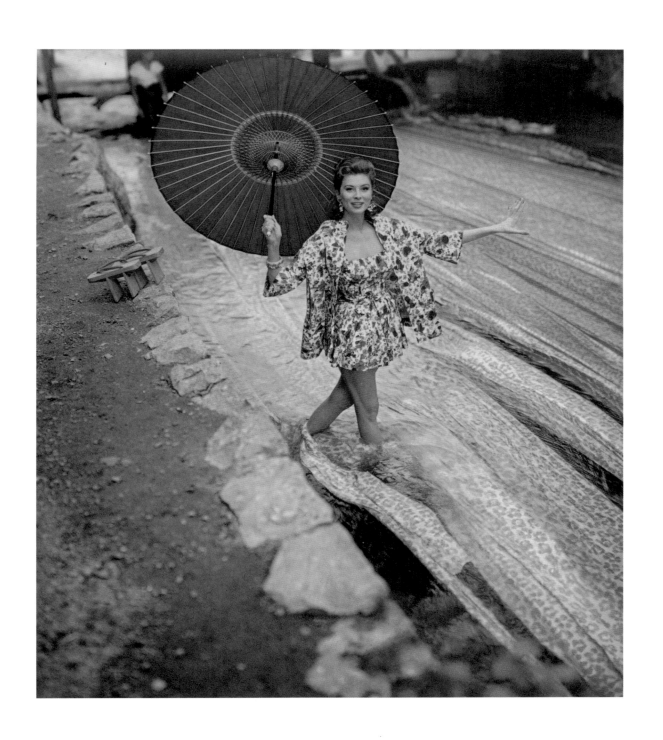

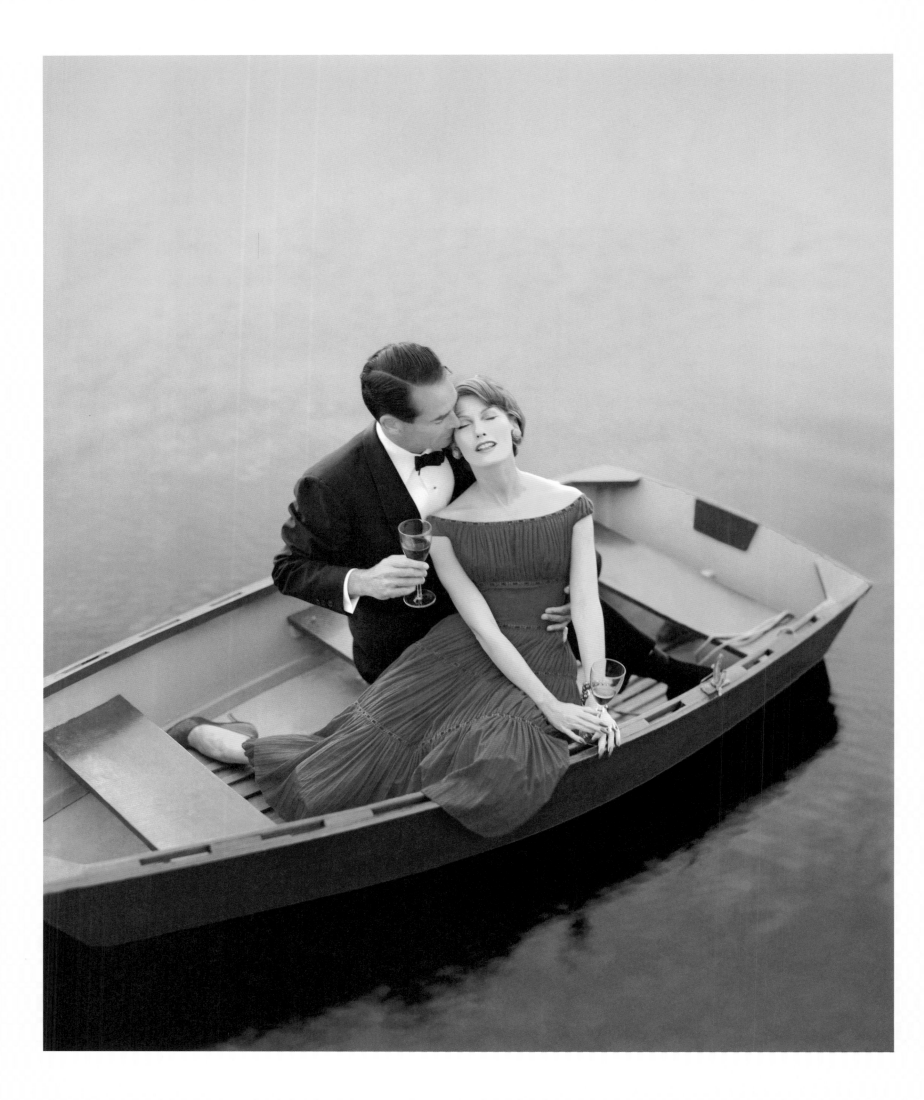

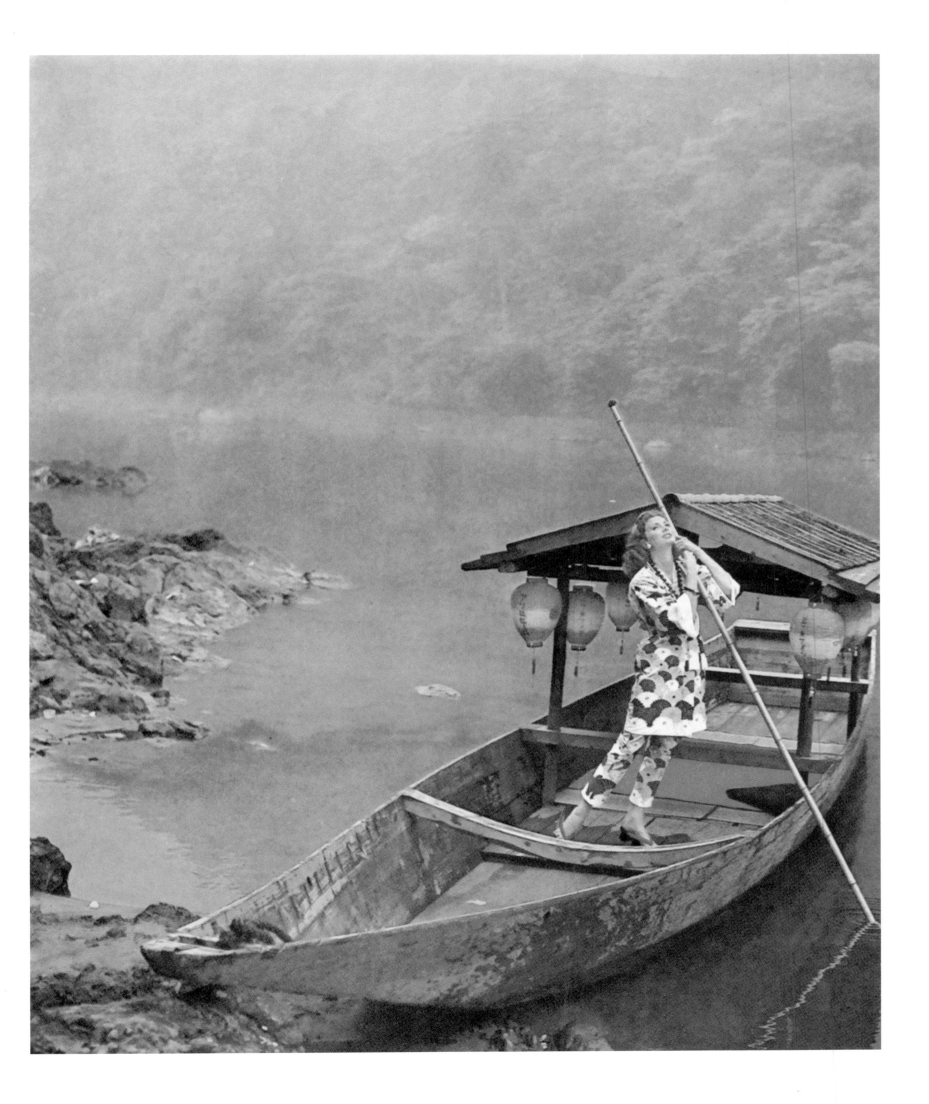

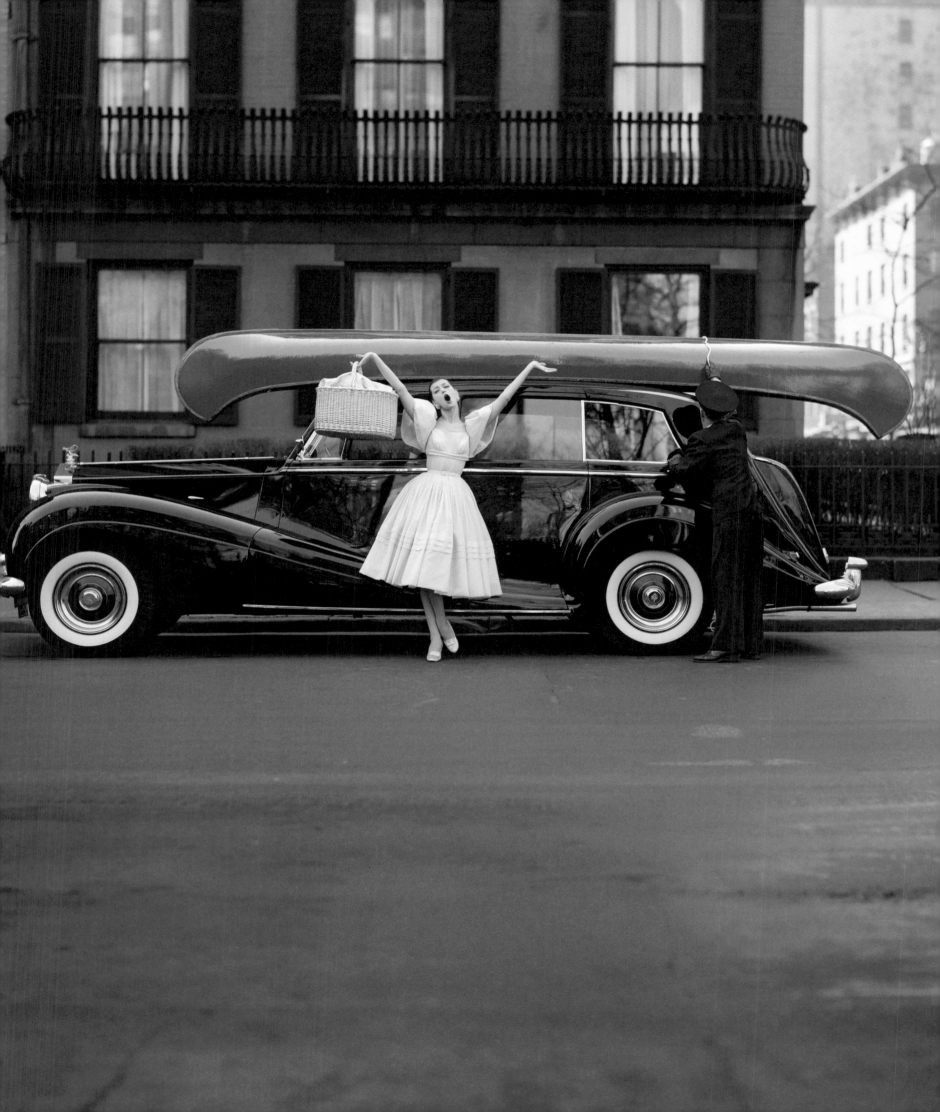

AN AMERICAN ADVENTURE

Pages 56, 58. Barbara Mullen, a legendary model of the 1960s, both on the water and gracing a Supima ad that would become William Helburn's most celebrated image, *The Red Canoe.*

Opposite. William Helburn associated Supima with travel and adventure, as in this 1964 image of Lucinda Hollingsworth, dressed in beach pajamas by Pembroke Squires, aboard a raft.

Page 63. In a bold 1961 *Vogue* campaign, Supima suggestively heralded both the new American woman and American design as exemplified by Bill Blass.

Page 64. Jacques Tiffeau, a French-born proponent of the miniskirt and one of America's first celebrity designers, used Supima to embolden his prints. The swinging "Charlie" ad ran in *The New Yorker*, May 1966.

Page 65. "Kooky Like a Fox," an early 1970s Supima campaign, featured a free-spirited model who would rather roll her own cigarettes and festoon a statue than spend another minute with her date. Showcased were the Californian designer Maggy Reese's flowing creations.

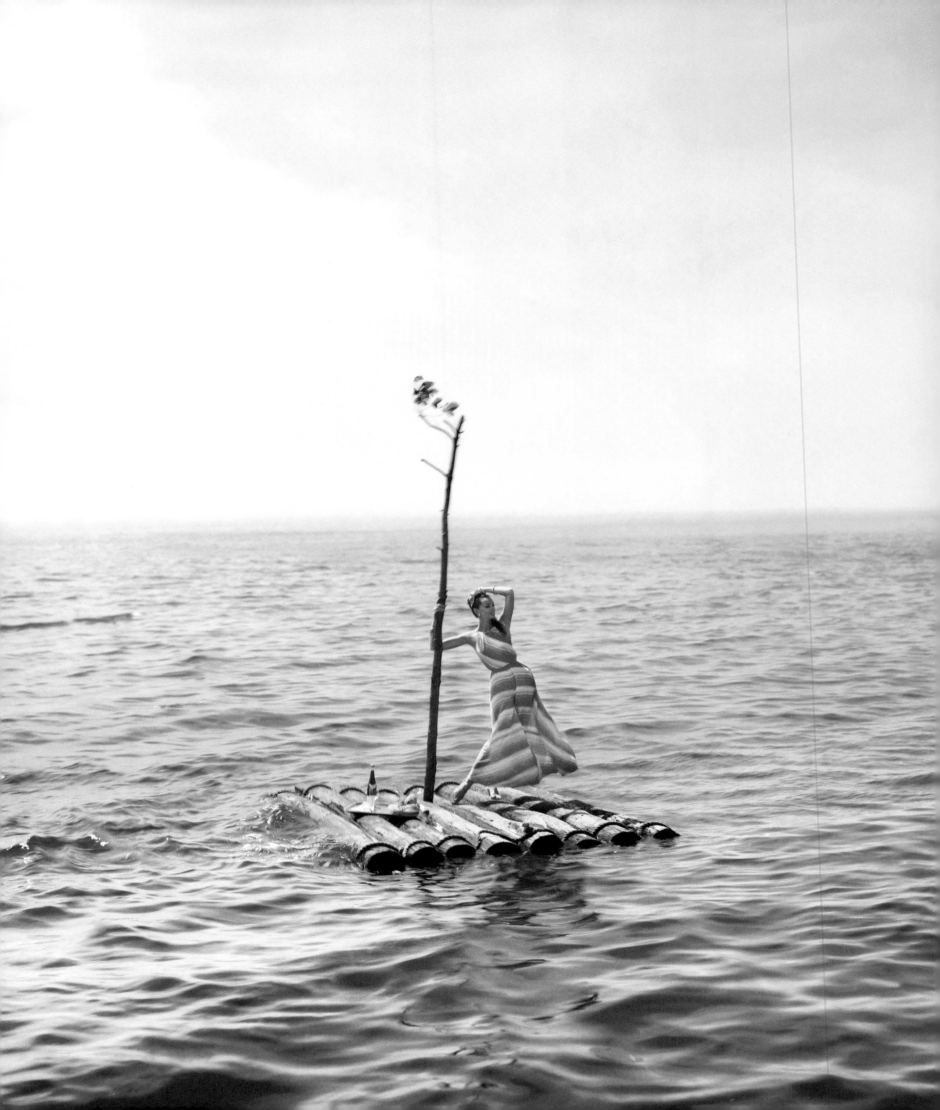

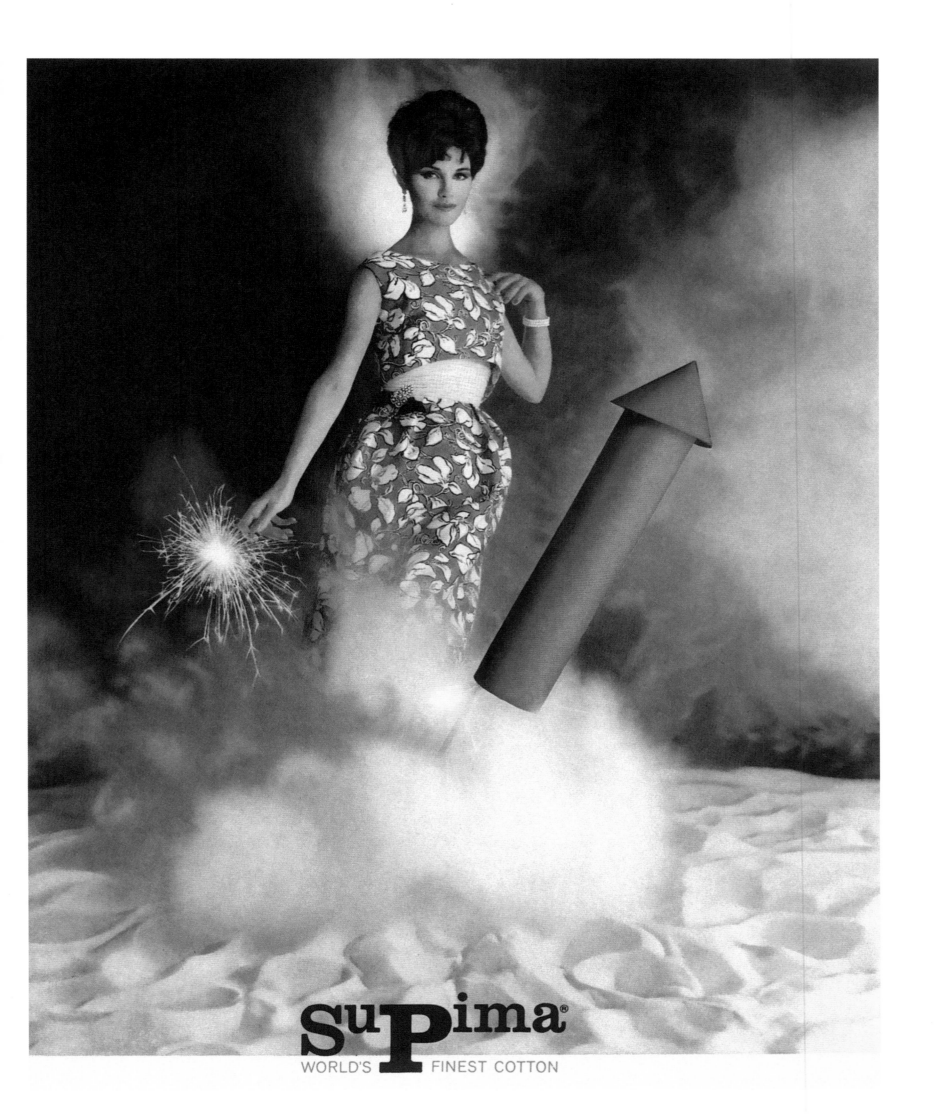

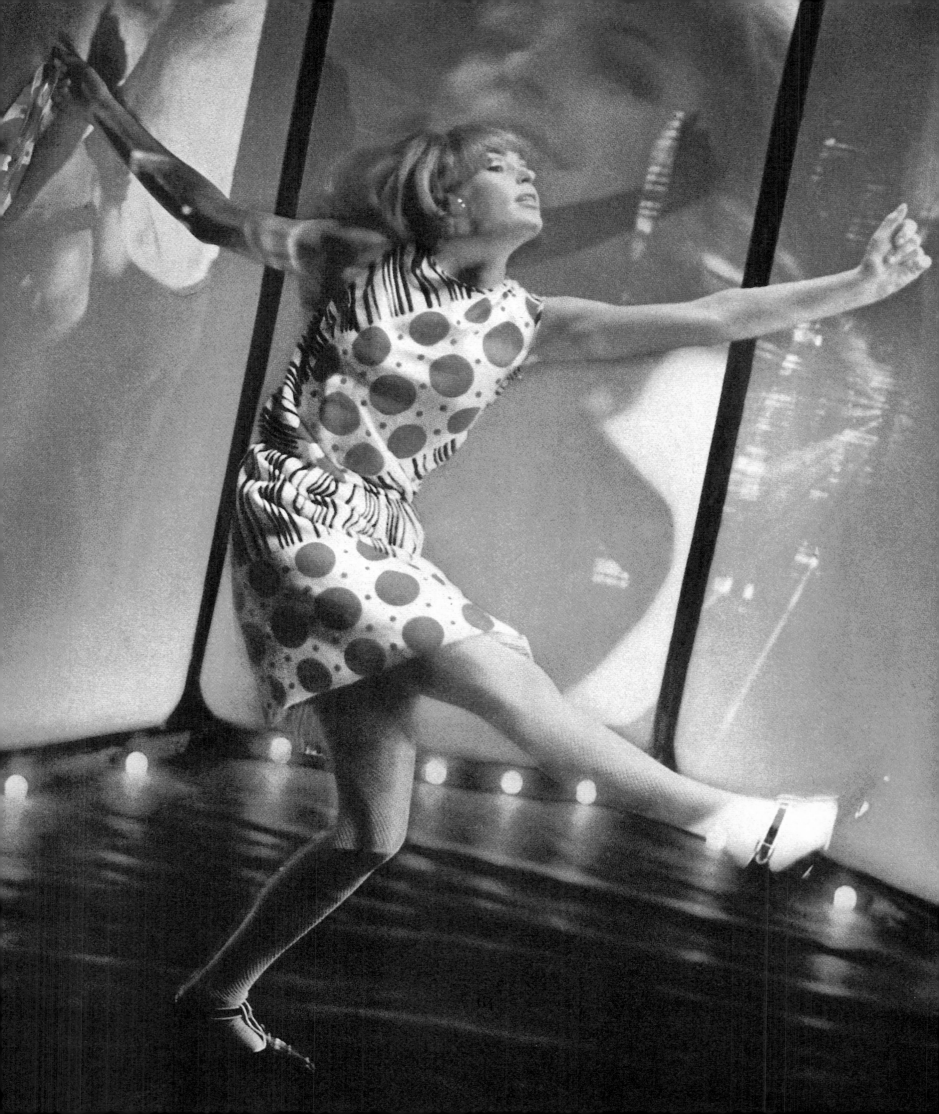

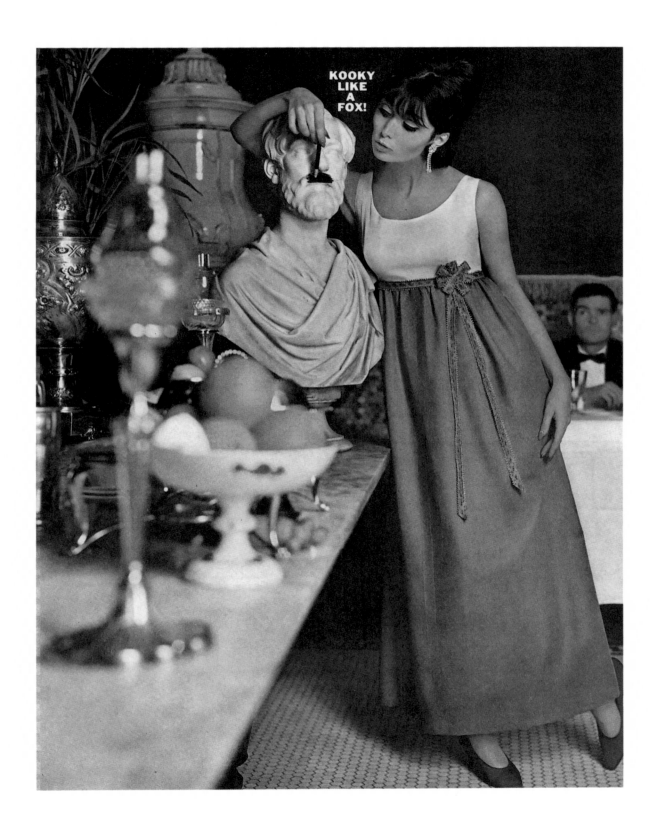

SUPIMA IN THE 1990s AND 2000s

Supima's New York offices closed briefly in the late 1970s, though the growing and seed breeding program continued. One 1980s partner campaign featured the iconic eyepatch-wearing C. F. Hathaway man, a concept developed by Ogilvy & Mather in 1951.

Pages 66–67. Supima's American-grown colorfast fibers were perfect for the earthy casual fashions of the 1990s, even for shoes, as highlighted in this 1992 campaign.

Opposite. Throughout the 1990s, Supima developed a campaign highlighting its "Precious Fibers," which brought quality and value to even the most casual applications.

SINISHA NISEVIC FOR SUPIMA

Pages 70–75. Synthesizing the naturalism of the 1990s with a return to the New York glamour of Supima's 1950s and 1960s campaigns, "Sea of Cotton: Urban Dreams" played out across a surreal downtown landscape. Featured from 2006 to 2009 in *T: The New York Times Style Magazine*, Sinisha Nisevic's imagery brought Supima's dual strengths to contemporary audiences.

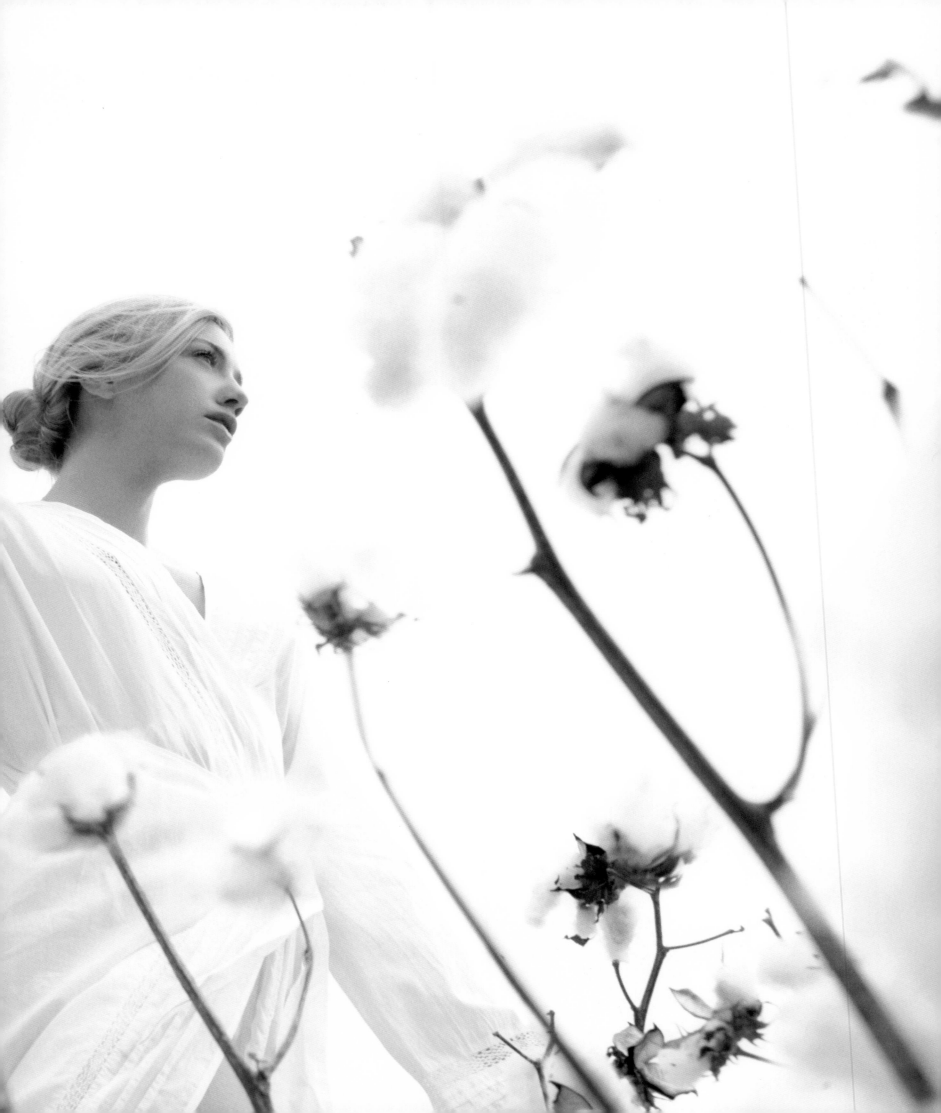

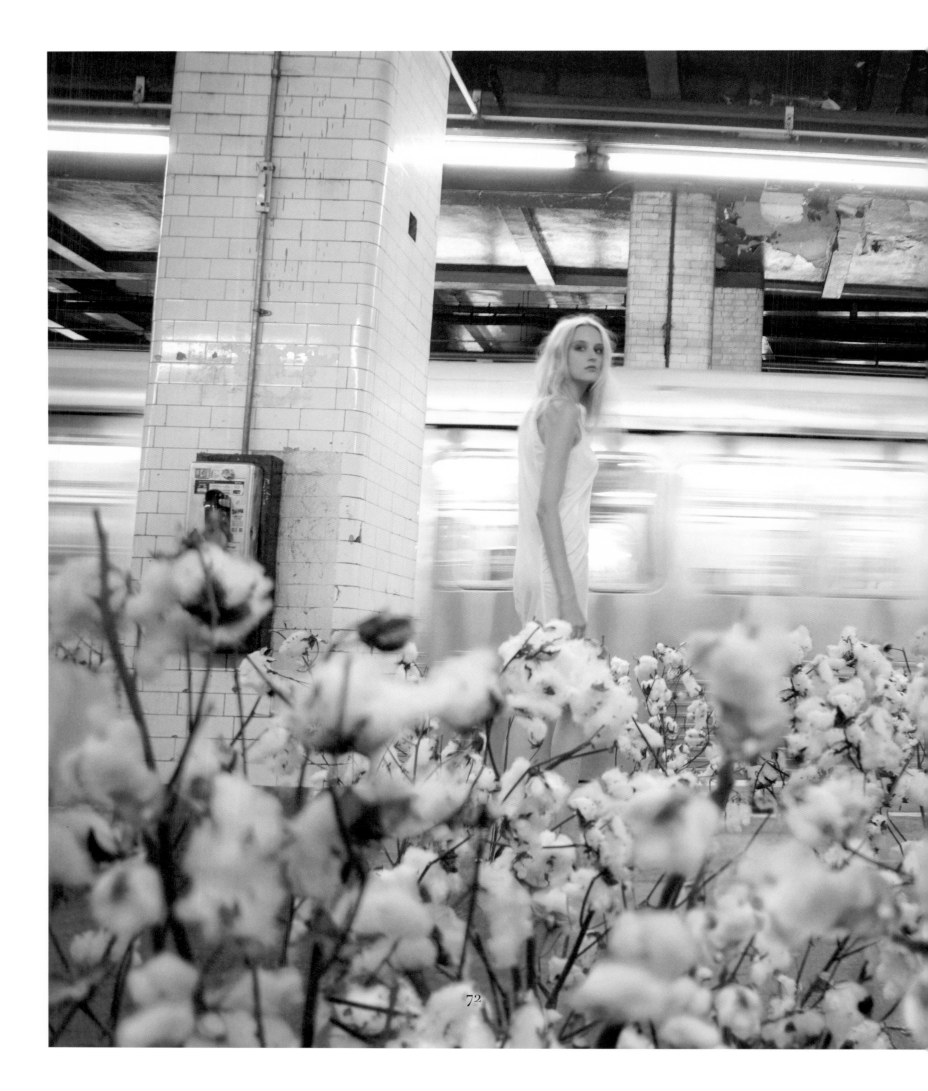

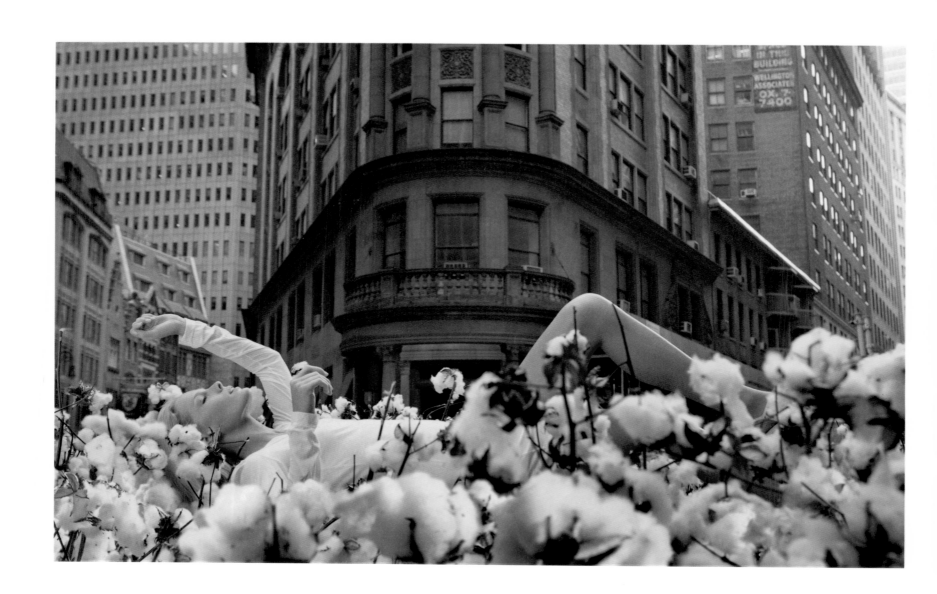

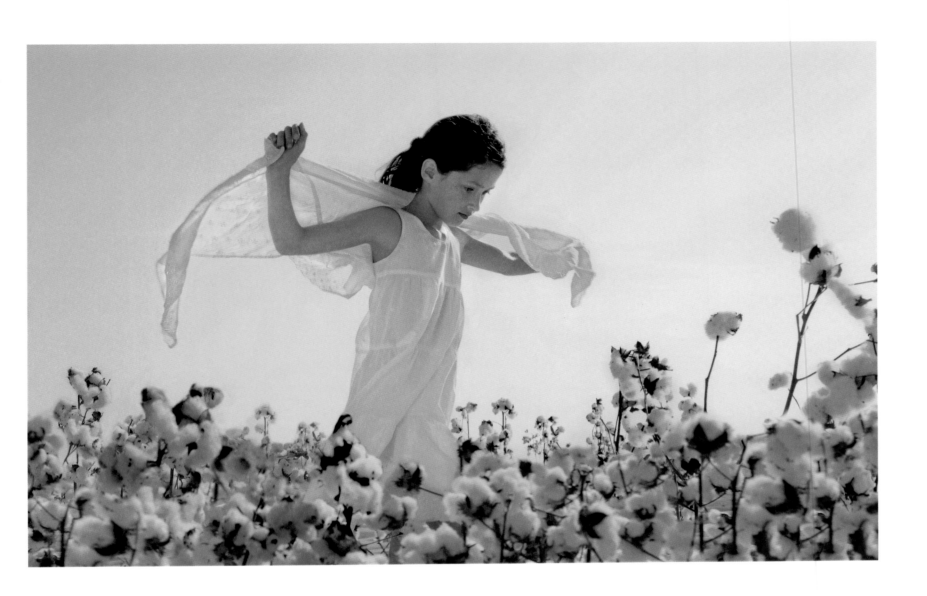

ROE ETHRIDGE FOR SUPIMA

Pages 77–81. In 2012 Supima returned to its graphic roots with a campaign shot by Roe Ethridge. Juxtaposing nature's extreme forces with the attributes of Supima cotton, the series elevated Supima and some of its leading partner brands, Brooks Brothers, Calvin Klein, Lacoste, and Splendid, in such publications as *WWD* and *T: The New York Times Style Magazine*.

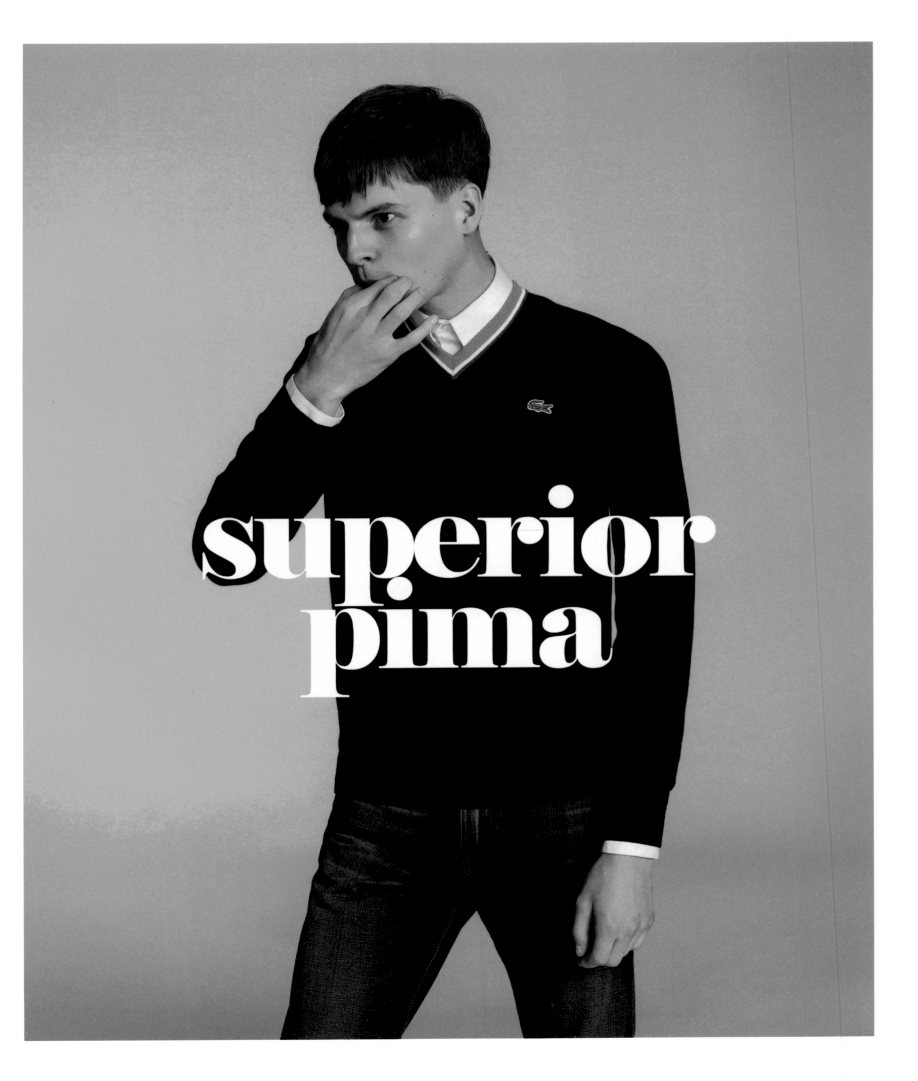

superior
west

superior
pima

superior
silence

superior
pima

ANNA WILLIAMS FOR SUPIMA

Opposite, page 84. Highlighting the purity and beauty of a cotton boll, Anna Williams created an enduring Supima ad series in 2014–15, each featuring a beautiful still life of longtime partner brands, including Barbara Barry, the Breakers, and Lacoste, opposite bolls of natural cotton.

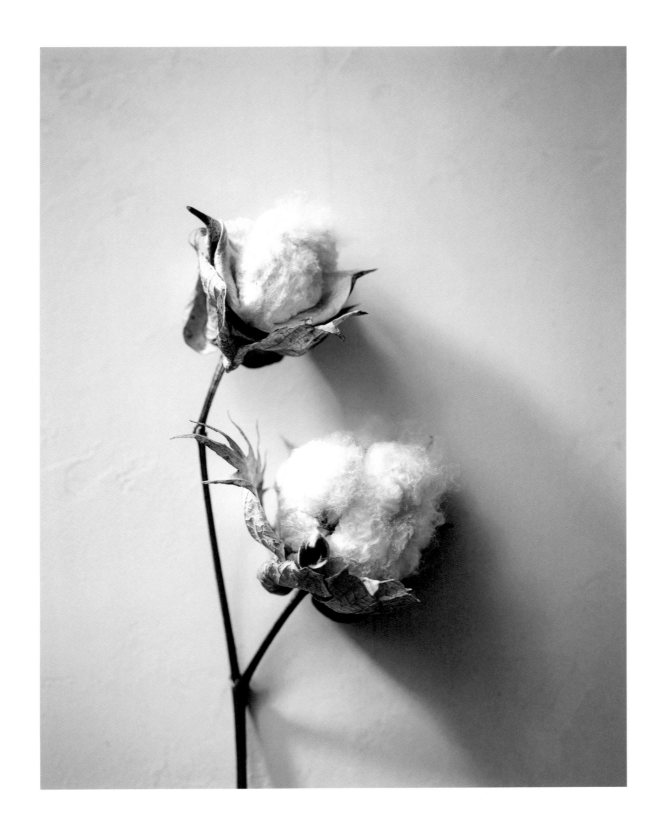

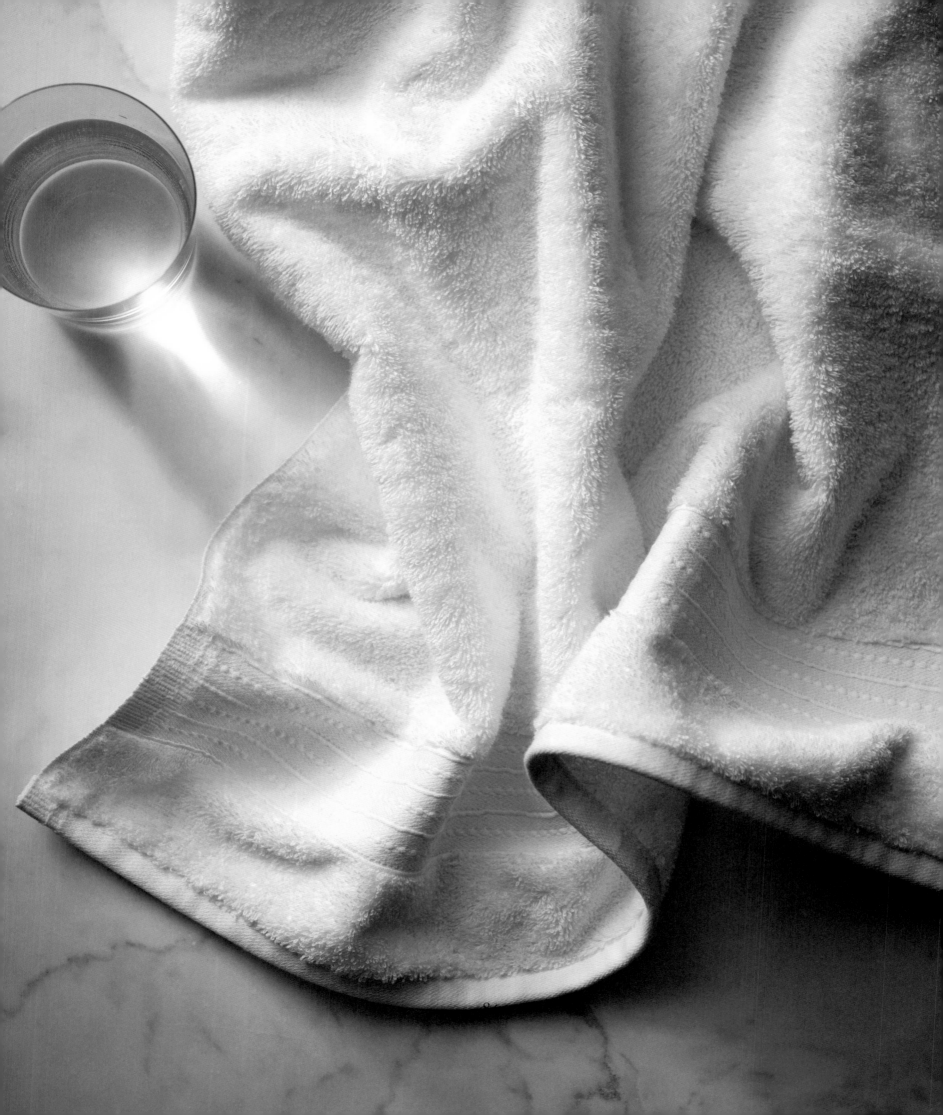

SCHELTENS + ABBENES FOR SUPIMA

Pages 86–87. Scheltens + Abbenes created multi-layered geometric abstractions out of garments by Supima's partner brands for the "Everyday Reimagined" campaign. Released in successive issues of *T: The New York Times Style Magazine* in spring 2017, the ads captured Supima's interest in technical innovation and innovative brands' awareness of the cotton's superior qualities.

A LOVE AFFAIR WITH COTTON: SUPIMA AND FASHION

Nick Remsen

The use of cotton in fashion and lifestyle products is ubiquitous. From home goods to Hanes undershirts to Hermès garments to Hanky Panky briefs, it is an omnipresent, universal textile, serving purposes from the everyday to the ultra-exclusive, from the plain white T-shirt or humble undergarment to the rarefied button-down or couture four-figure dress. That is not to say that all cotton is the same. It exists in different qualities and varieties, varying levels of softness and strength, and the fiber is produced on every continent except Antarctica. Supima ranks in the top one percent of the finest-grade cottons available on the planet.

In its more than 100-year history, Supima has grown steadily in reputation as the premier source for cotton supply. Its strands are longer, softer, and more durable than the majority of its competitors, and in the course of a century it has become known, beloved, and, most importantly, trusted for these exceptional properties. When Supima's most recent president, Jesse Curlee, retired in 2016—after having been with the association for decades—farmers and manufacturers across the globe went on the record in a tribute video, with many voicing a common refrain: Supima could be counted on, always, for its integrity. First and foremost, Supima cotton was reliable.

Over the four decades since its development in 1911, the rise in popularity of Pima cotton demanded some form of representation. To manage growth and quality, the Supima Association of America was officially organized in 1954. By then, the fashion industry had taken note and began building Pima cotton programs into its products.

Oleg Cassini, the famed midcentury designer, used Supima in his dresses. In 1956 the first Supima advertising campaign was released, promoting the cotton's qualities and newfound applications as an exceptional fashion tool. Furthermore, Supima was immediately endowed with a luxurious and high-brow association, thanks to the advertisement's subject: the model Suzy Parker, who was well-known for being a muse to none other than Coco Chanel. Even then, Supima was linked with the most aspirational names in the business; it was fast becoming the go-to source for the best, premium cotton fibers on the market. Yet for decades to come, Supima fabrics would remain a predominantly American product.

In 1988 Supima expanded beyond the United States by launching an international export program in response to high interest and demand on the part of overseas vendors, suppliers, distributors, and designers. Japan was

the first to apply for a license to use Supima's name locally. The rights were granted, and today Supima's franchise platform counts hundreds of participants.

Quickly and unsurprisingly, Supima became a recognized source for quality materials, earning a reputation with even elite Swiss and Italian shirting mills. As wardrobe tastes evolved into a more contemporary aesthetic, so rose the empire of premium denim—one that still reigns, or rather, has become de rigueur today. Here, too, Supima became a must-use, with mills in Japan, Italy, and Turkey all calling on the cotton's "blend of luxury and toughness." The ideal traits, these factories realized, to justify the cost of jeans that soared into the hundreds of dollars. From the 1980s onward Supima was widely adopted by leading brands in home fashion, including Charisma towels and sheets, which marked the beginning of what is now a comprehensive home and decor roster.

In 2010 it partnered with the legendary New York–based department store Bloomingdale's on a collaborative line, the Supima Collection. The capsule boasted unisex tees and tops and was conceived to illustrate the cotton's qualities all in one clean and simple package. It was a huge success.

In the recent past, Supima has worked with a vast and varied array of fashion and lifestyle brands, including Burberry, AG Adriano Goldschmied, Hanky Panky, J Brand, Save Khaki, Levi's, Banana Republic, Bills Khakis, Coldwater Creek, Cutter & Buck, James Perse, Lands' End, Josie Natori, Nordstrom, Splendid, The Gap, and Tommy Bahama, among many others.

For UNIQLO, the Japanese mega-label, Supima provides cotton for T-shirts that are dyed in over forty color palettes. For Brooks Brothers, the American purveyor of polished prep-wear, Supima cotton is used to construct classic button-down shirts. For Lacoste, Supima is integral to its signature polo shirt. Even the legendary Breakers Hotel has used Supima for its spa towels to ensure the comfort and satisfaction of its exacting Palm Beach clientele.

The list of partners is long and ever evolving, but one thing remains certain: from high to low and across the wide range in between, retailers and brands turn to Supima because they know that the product is trustworthy and proven. There is a reason that Supima is often singled out as the best, and the pages that follow will illustrate, in depth, some of the most fruitful, rewarding, and dynamic relationships that have been forged by the world's finest cottons.

THE
ICONS

BROOKS
BROTHERS

The name is well known, but the legacy may not be. Brooks Brothers is nearly two hundred years old and was the first brand in the United States to offer fully scaled ready-to-wear clothing. The company was founded in 1818 by Henry Sands Brooks, with the opening of a single store at the corner of Catherine and Cherry Streets in New York City. The "Brothers" part of the name comes from Henry's sons, whom he asked for help as the business took off. From then until now, Brooks Brothers has expanded and grown into an entity with an international reach and top-of-mind brand recognition.

In the two centuries since its establishment, the clothier has brought a number of now well-established staples to the American marketplace: seersucker, madras, argyle, as well as the "non-iron" (wrinkle-resistant) shirt and button-down collar. When you take into account the many scores of students, young professionals, adults, and grandparents who flock to Brooks Brothers for everything from formalwear to golf threads to a classic navy blazer, you realize just how large and significant its position truly is. In this respect, Brooks Brothers can be called a bastion of American fashion.

It can also claim a fascinating part in American history. Across the decades, Brooks Brothers has continued to build on its

storied past. The company began working with Supima nearly thirty years ago to produce selections of its signature pieces, attributing its choice to three unique facets: it is "softer," "brighter," and "stronger" than traditional cotton. In the case of Brooks Brothers, the fibers have been applied to tried-and-true everyday clothing and home goods, such as sheets and towels, with wide-ranging appeal and application. The roster of garments now includes button-down Oxford shirts, dress shirts, polo shirts, sweaters, and chino trousers. Brooks Brothers apparel is meant to be worn regularly and is appropriate for myriad settings from a high-rise office in the city to an off-duty weekend spent in the countryside. In these settings and beyond, Supima cotton has proven itself to be versatile and reliable.

In 2017 the company introduced its Performance Polo, a lightweight men's shirt available in twenty-eight colors. Such a range of hues is possible because of Supima cotton's resistance to fading when dyed. Also presented was a brand-new women's Oxford shirt, destined to soon become yet another classic. Enthralled with Supima's cottons, Brooks Brothers has even suggested a disclaimer for those experiencing them for the first time: "It is love at first touch."

"Supima—an American staple—is part of what defines our iconic dress shirts as well as many other Brooks Brothers favorites, from our sweaters to our chinos."

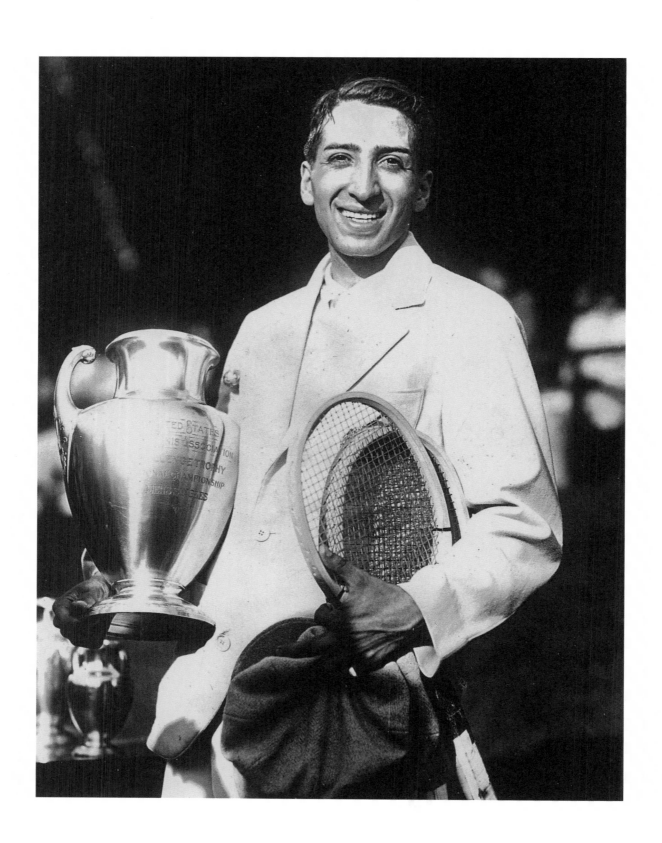

LACOSTE

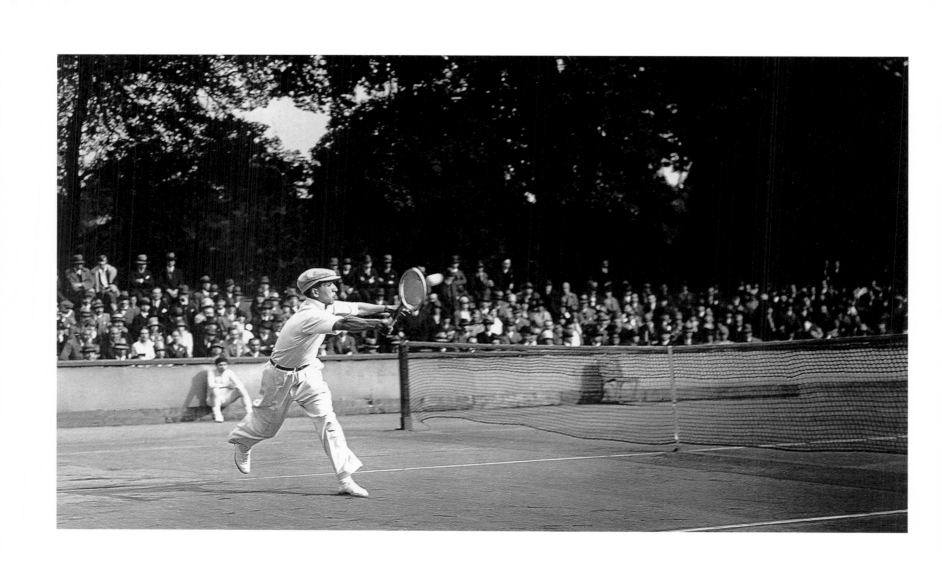

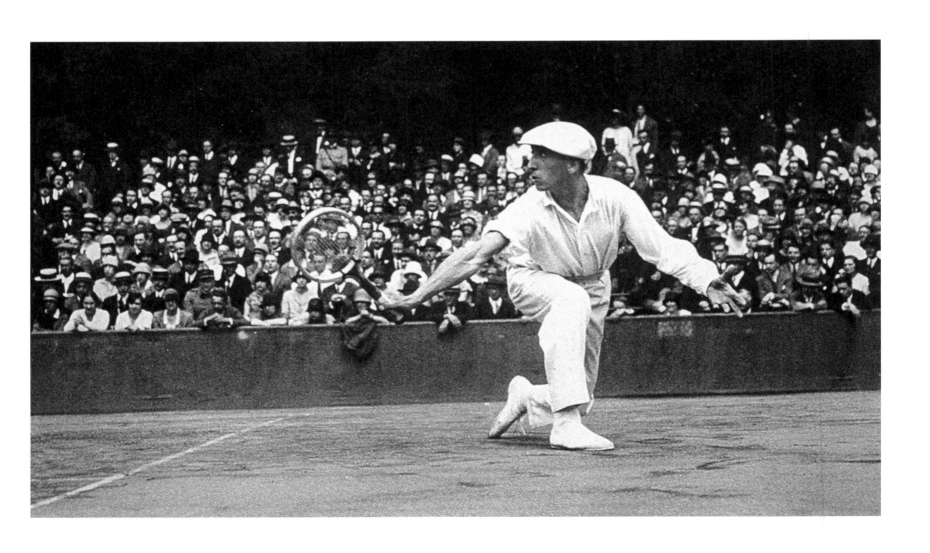

It's hard not to think of cotton when thinking of tennis. For decades, the lightweight short and the well-ventilated polo were the sport's de facto uniform. And when thinking of tennis, it's hard not to think of Lacoste, the brand started by the French tennis star René Lacoste in 1933.

Lacoste—the man, before the company—was an immensely talented player in the world of professional tennis. He won his first tournament at the age of seventeen and his first major, the French Championship (naturally), in 1925. He would later go on to win scores more singles and doubles titles over the years—seven grand slams in total, including the British and U.S. tournaments—and was ranked number one in the world in 1926 and 1927. He also helped the French team win the Davis Cup in 1927 and again in 1928. But what you might not know about René Lacoste—and it's a story that will immediately resonate if you are familiar with his brand—is that his nickname was "The Crocodile." A journalist gave him the moniker after hearing rumors of a bet that Lacoste had made over a suitcase crafted from crocodile skin.

In 1926, having grown accustomed to and evidently fond of his epithet, Lacoste asked a friend named Robert George to design a logo in the shape of a crocodile. The now globally

famous icon soon appeared, for the first time, on a blazer worn by Lacoste.

During that same year, 1926, Lacoste came to realize that the polo shirt—a garment he'd witnessed being worn by polo players in the United Kingdom—made the most sense for his on-court uniform. The design was breathable and lightweight, granting an athlete great mobility and comfort. The company now calls the polo shirt a piece of "functional elegance," a fitting description for this crisp quotidian garment. By 1933 Lacoste had started production of the polo shirt—with the crocodile in place on the chest—and launched his first advertising campaign as well. It was the beginning of what would become an international, inimitable, and gigantic success, the birth of a sportswear company still fervently sought after by professionals and hobbyists alike.

Lacoste incorporates Supima cotton into a number of its wares, from boxer briefs to soft V-neck tees to its famed historic polo shirt. Supima cotton's superior strands make sense for a house founded on performance. Just like the airiness that Lacoste appreciated in his original models, the same light touch can be felt in the garments today, thanks to Supima's combined traits of durability, softness, and ultra-high quality.

THE
INNOVATORS

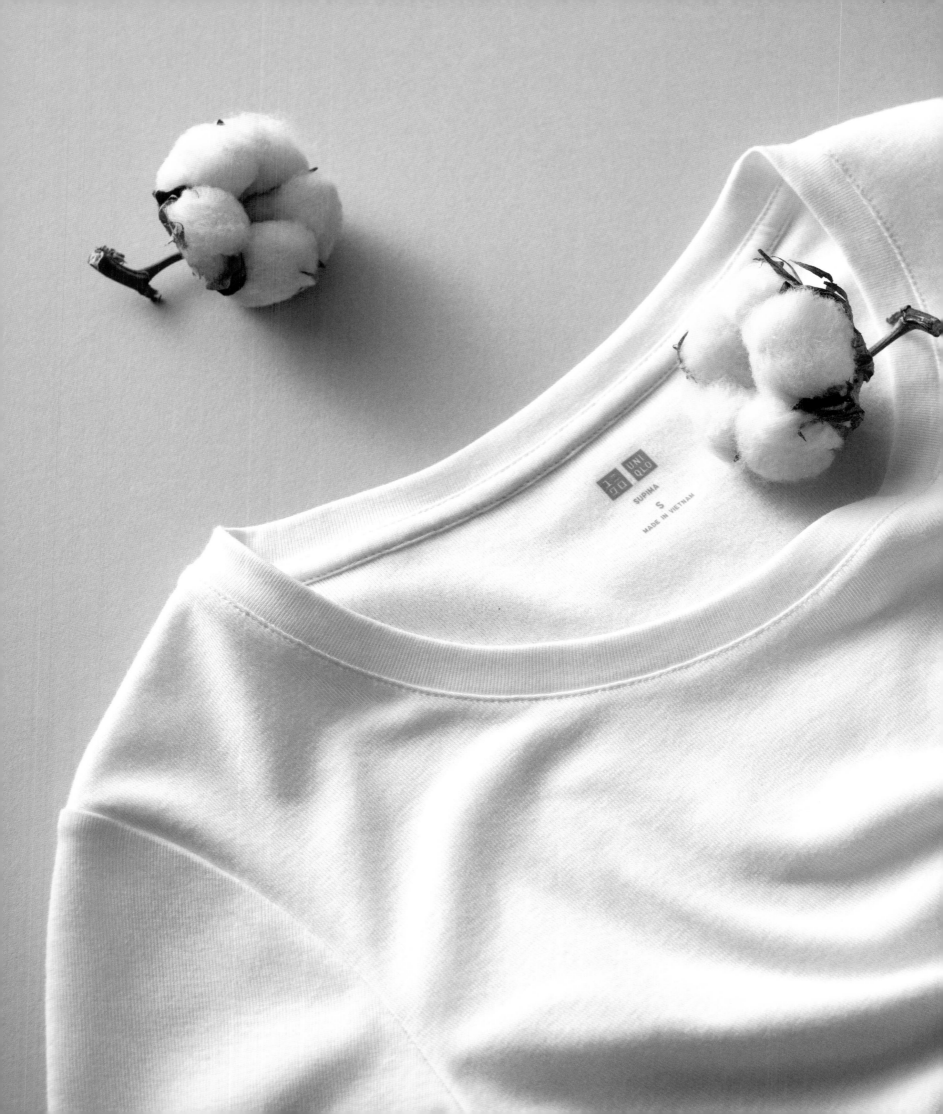

UNI
QLO

SUPIMA
S

MADE IN VIETNAM

UNIQLO

There is no other way to put it: UNIQLO is unique. Founded as a textile manufacturer in Yamaguchi, Japan, in 1949, it has, in the nearly seventy years since then, transformed itself into a global powerhouse of minimally chic and highly affordable clothing. Its stores are sleek and its branding ultra-clean (think simple white text and an even simpler red box). Essentially, it aims to ramp up the fashion in fast fashion. And speaking of fast fashion, Supima has long been an industry forerunner in offering creative collaborations, pulling from the worlds of art, the luxury sector, and pop culture to create attainable pieces with a wider, but no less specialized, appeal. Over the past few years, the company has sold capsule collections rendered with Jil Sander, Undercover, Christophe Lemaire, Pharrell Williams, and the artist Kaws.

What is extra special about UNIQLO is that it keeps price points attainable while continuing to prioritize and deliver top-quality goods. If you haven't tried a featherweight cashmere jumper or an even lighter and plusher T-shirt from the brand, venture, ASAP, to one of its 1,000-plus stores worldwide.

A key component of UNIQLO's high-grade focus is its relationship with Supima, which began in 2000 when it partnered with one of Supima's leading cotton growers.

By linking directly with Supima, UNIQLO has been able to ensure consistency and transparency throughout its supply chain, from raw fiber to ready-to-sell garment. Also with UNIQLO and Supima's close collaboration comes an added benefit: sourcing literally straight from the farm allows UNIQLO to keep its pricing, well, very appealing.

The use of Supima cotton is especially interesting in the context of UNIQLO's interest in high-tech textiles. The fiber's natural strengths—its long staple length and smoothness—allow for the creation of light, durable, breathable fabrics that outperform their synthetic counterparts. The basics have the drape and smoothness of an engineered textile but can hold their shape through daily washes and wears.

The company sells a significant range of Supima-made products, from "cut-and-sewn" items like polo shirts and tees to knitwear and even socks and underwear. UNIQLO, which is also known for offering a vast array of color options for its garments, also cites Supima cotton's notable ability to hold dye. Case in point: the brand has produced more than forty-five shades of T-shirts made from Supima. True colors, through and through.

"Designing clothes, like cooking, starts with the right ingredients. Good clothes require good fabrics—there is no question. Ever since I first visited the United States, I've felt that America is where sportswear originated. Today, when I think of cotton, I think of the U.S. We are proud that we have been planning, manufacturing, and selling UNIQLO products using Supima cotton, the best cotton in the world, since 2000. Customers from all of our markets compliment us on Supima; this deepens our pride and our confidence. With Supima cotton we offer unrivaled quality products that are truly appreciated."

Tadashi Yanai, President & CEO, Fast Retailing

3x1

3x1—the SoHo, New York City–based jeans label from denim designer and entrepreneur Scott Morrison—is by no means your average dungarees shop. Rather, it's more of a culmination of many decades' worth of denim obsession, one that began for Morrison in 1997 when he first visited Japan, a country famed for both its denim weaving processes and its indigo dyeing methods. Indeed, no country in the world has as much expertise in denim manufacturing as Japan. After extensively exploring factories, mills, and dye houses in Tokyo, Osaka, and Okayama, Morrison launched Paper, Denim & Cloth in 1999, just as the denim boom of the 2000s began its soon to be powerful influence. Then came the highly popular Earnest Sewn label in 2004. Seven years later, in 2011, Morrison introduced 3x1, which subtly acknowledges the trifecta. Three brands, one goal: perfect, premium, and passion-infused denim. The moniker also pays tribute to the weaving used in the creation of Morrison's textile of choice, a style dubbed the 3x1 Right Hand Twill.

The mission of 3x1 is to both honor and illustrate the well-practiced art of Japanese jeans-making. It also aims to embody Morrison's deep love of selvedge denim, a type made of a tighter and denser weave that ultimately produces a hardier product. The brand believes in transparency and in edu-

cating its customer about the process of putting together a piece of denim clothing. Morrison therefore introduced an innovative, immersive retail concept in 3x1's atelier on Mercer Street in New York. There's stock for shopping, of course, but also an ostensible glassed-in denim "factory" where clients can view the entire 3x1 operation. The idea is both smart in its conceit and purist at its heart.

Supima entered the picture when Morrison started thinking about his wares beyond their "slub, shade, weight, and weave." He wanted to dig deeper, to delve into the vitality and longevity of the material itself. In his research he found that, somewhat ironically, many of the Japanese mills he most admired were using American Pima, the cotton that Supima promotes. "Knowing that Supima was out there changed a lot about the way I looked at a pair of jeans," Morrison says. "I started thinking about where the cotton was grown, as well as the staple." Here Morrison means the length of a cotton fiber, known as the staple, which comes from the cotton boll and can be found in segments of varying length. He concludes: "Ultimately, I consider the strength of the yarns themselves."

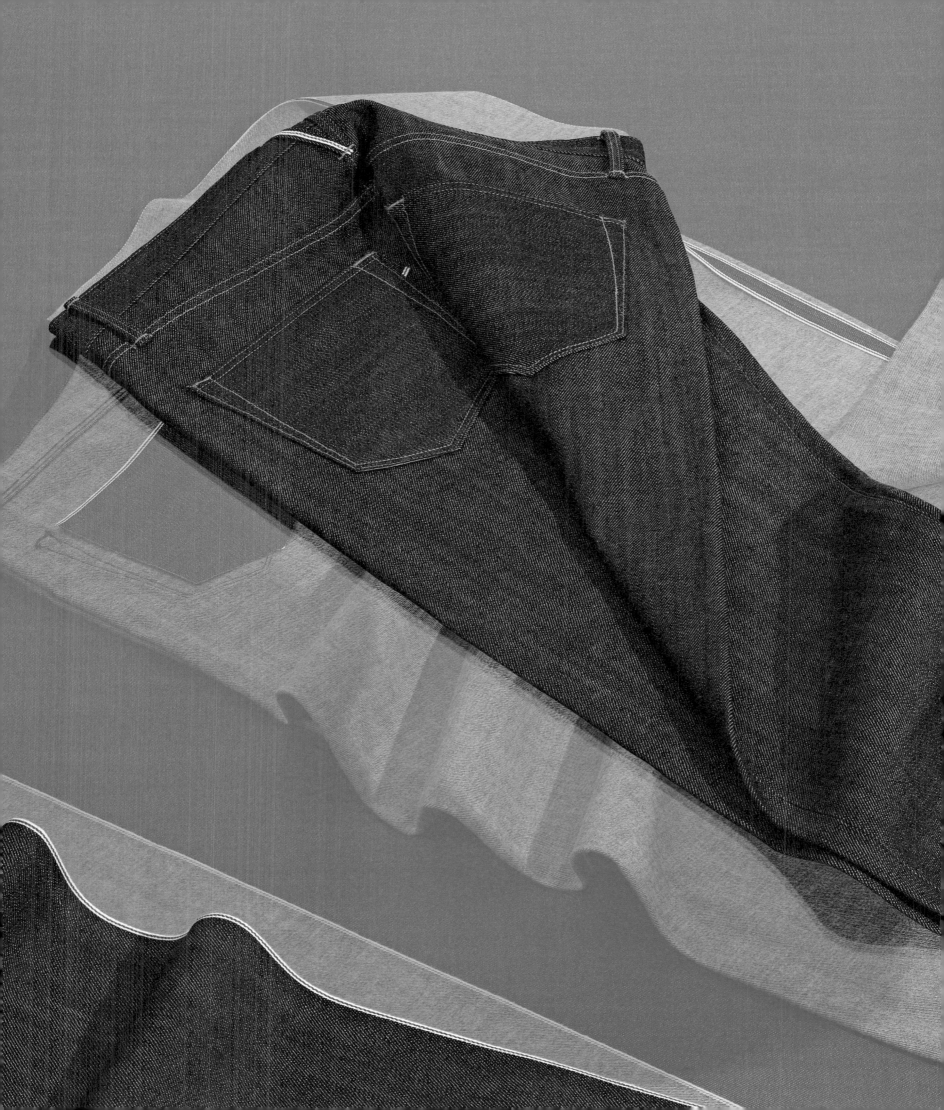

"Supima cottons are the first place I look when I'm thinking of making a jean or a shirt for a customer who demands both the highest quality and the longest wear."

Scott Morrison, Founder, 3x1

EVERLANE

The San Francisco, California–based Everlane is a master-stroke in innovative enterprise. Founded in 2011 by Michael Preysman, the company sells a deft mix of elevated "normcore" pieces underpinned by strong design and high-quality fabrics. Preysman does not have a formal education in fashion, but he does hold degrees in computer engineering and economics, equally useful fields in today's ever-changing marketplace. He started Everlane because he felt the retail system was broken beyond repair—his goal was to rethink it by lowering overhead and keeping down costs. Preysman also recognized the need to go straight to buyers, wherever they may be.

The Everlane look is nondescript, comfortable, and stream-lined chic. The company sells both the classics and the basics: white T-shirts, navy office trousers, logo-less black hoodies, suede day heels, cross-back ribbed tanks, and waterproof jackets, sported by everyone from Ange-lina Jolie to Gigi Hadid to Malia and Sasha Obama.

The organization also believes in full transparency in its communication with consumers. It reveals pricing strate-gies, demands stringent workplace compliancy, and strongly emphasizes a commitment to partnering with the best fac-tories and manufacturers in the world, including Supima.

Everlane has also been a forerunner in the increasing tendency for brands—especially new ones—to operate in the direct-to-consumer retail space. Its e-commerce site is extensive and displays a glossiness characteristic of contemporary brands appealing to millennial audiences and eyes: it is clean, easy, and relatable. Indeed, the imagery looks as if it were filtered through an Instagram setting. And speaking of Instagram, the brand's handle is sharply conceived as well. With 360,000 followers and counting, its online visual identity is as sleek, streamlined, and modern as its products.

Everlane has been working with Supima since its launch back in 2011. Supima is used to produce Everlane's most popular women's T-shirt designs, including the cotton V and the cotton crew. Additional Everlane products that incorporate Supima cotton are the U-neck tees, muscle tanks, drop-shoulder tees, and standard tank tops.

Across the board—or, rather, the screen—Supima helps to keep Everlane's highly engaged audience coming back. It, too, is clean, easy, and relatable. And for a rising generation with an increasingly no-fuss approach to dressing, the relationship stands poised to continue well into the next decades and beyond.

"We love the soft hand and clean look of the fabric. We searched many U.S. mills before landing on Supima. We picked it for its high quality characteristics."

The Everlane Production Team

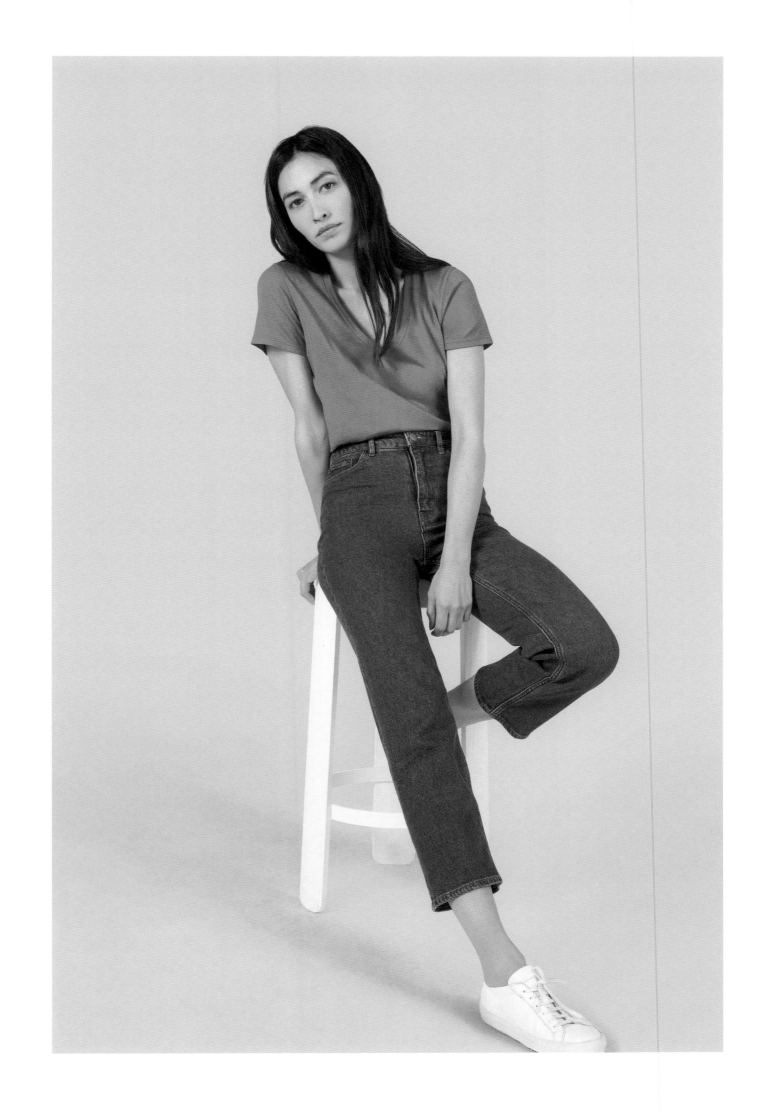

AMERICAN
CONTEMPORARY

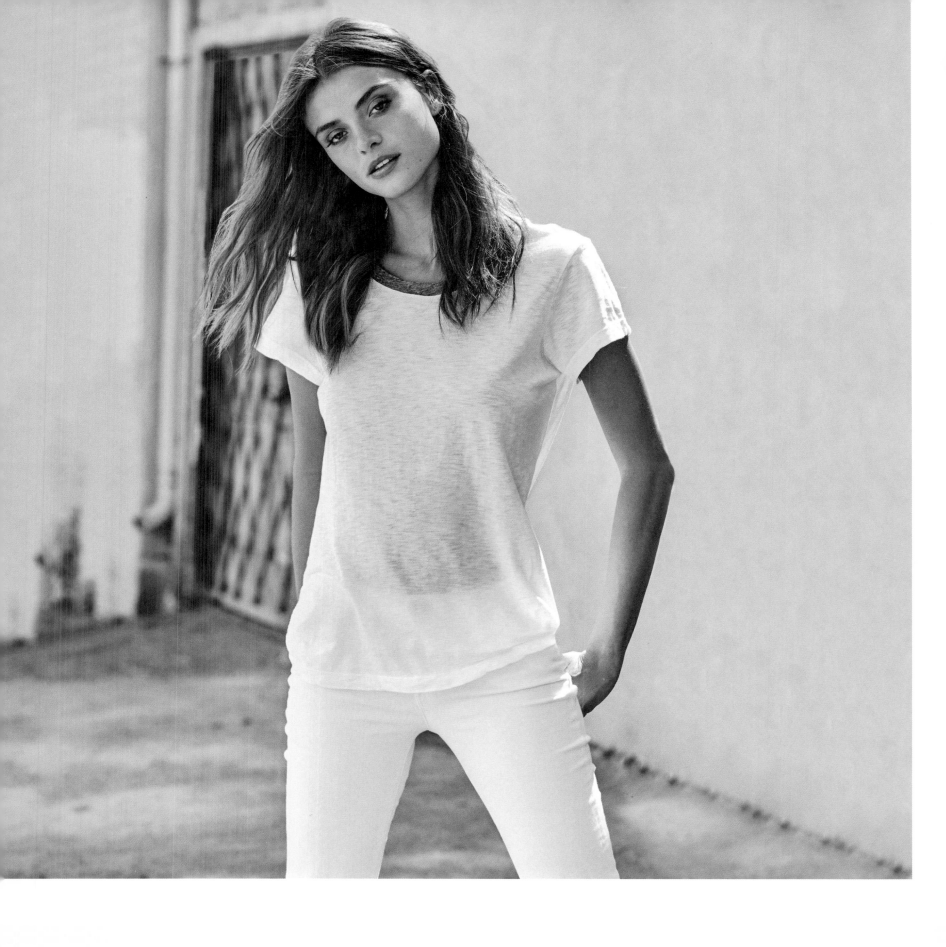

MICHAEL
STARS

The best ideas are often the simplest. For Michael Stars—
the at-ease sportswear line founded by Michael Cohen
and Suzanne Lerner in 1986—that concept was forth-
right: How does one elevate the omnipresent T-shirt?

The question took on a particular urgency, given that both
Cohen and Lerner were based in Los Angeles, where the
T-shirt forever reigns. Lerner's and Cohen's individual
experiences—the former with a national wholesale fashion
showroom called Lerner et Cie, and the latter with
an import-export fashion agency in 1956—prepared
them to understand the landscape of basics and how
to improve them. Working together, the duo's answer
quickly became a hit. Jessica Alba, Sarah Jessica Parker,
Olivia Wilde, Emmy Rossum, Elizabeth Banks, and Jan-
uary Jones have all been spotted wearing the brand.

Michael Stars began working with Supima in 2006. The collab-
oration catalyzed what would develop into an ethical element
within the company's ethos: eco-friendliness. Supima cottons
are sustainable, but the parallels extend to other aspects of
Michael Stars' business; approximately 75 percent of its gar-
ments are cut and sewn in Los Angeles, and all of its clothing
is made in the United States, which lowers its carbon footprint.

The keystone of Supima's involvement with Michael Stars is comfort. With its extra-long fibers—which Lerner says are "smoother and softer" than most fabrics—a Supima tee is both cozy and long lasting. "Our customers can wear our T-shirts forever, with each piece maintaining its original color and softness. The clients love the quality and the durability."

These two characteristics are at the core of a partnership that has lasted for over a decade. The first products were soft, extra-long Supima blends, which evolved to become 100 percent Supima cotton tees. As Lerner says: "They are gorgeous to the hand, with fantastic wearability." A loving attention to detail is a signature of the Michael Stars T-shirt, making Supima cotton a natural fit.

The brand's Supima-anchored product category has expanded as well. At first the styles were straightforward. Think short-sleeve crew-neck tees that, to this day, remain best sellers. Since 2006, however, Michael Stars has used Supima cotton as a base to develop more experimental iterations of the basic T-shirt. Supima remains very much grafted to the heart of Michael Stars' effortless, and inspiring, California verve.

"Around 2008, I had the opportunity to fly with Supima up to the San Joaquin Valley, near Fresno, California, during the harvest time. It was really exciting for me—I had never been there before, had never witnessed cotton being harvested or even seen a cotton gin. It was incredible to watch, and to truly understand what it takes to go from the fields to the T-shirts that we make."

Suzanne Lerner, President of Michael Stars

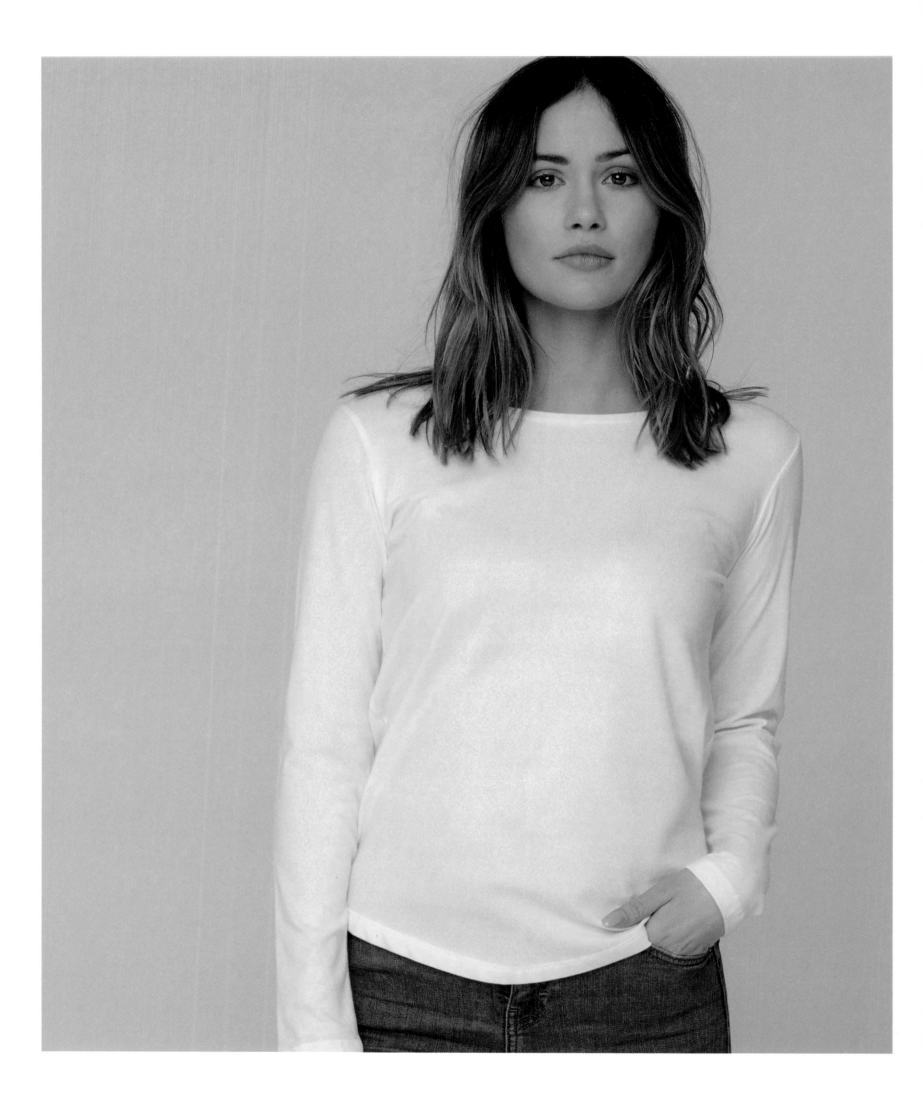

MAJESTIC

There are few things more stealthily luxurious (and covetable) than an everyday basic. Majestic Mills—the Canadian corporation that produces premium fabrics for approximately 170 of the world's most upscale, top market brands—knows well how to procure the ultimate staple of all: the T-shirt. And for their very best models, they use Supima cotton.

Majestic is universally recognized in the industry for its luxe fabric blends. In addition to manufacturing fabrics for fashion houses worldwide, it also sells its own designs— ultra-comfortable and top-tier essentials ranging from the aforementioned tees to leggings to cashmere sweaters to linen dresses, all of which are favored by off-duty models like Constance Jablonski, haute athletes, and global travelers. These luxury basics, designed in Paris, convey ease and glamour with a relaxed fit and softly draped silhouette.

In 2010 Majestic and Supima linked up to develop an unusual project: a T-shirt line that bears no label other than Supima's. The line was sold exclusively in Bloomingdale's and was, according to Brian Cytrynbaum, Majestic's president and chief executive officer, "the first time a premium fiber was sold [at Bloomingdale's] under its own name, a real tribute to the strength of the Supima brand." The tees were so soft,

and durable, that they displayed an almost vintage-like patina, attributable to the tactility and longevity of the Supima fiber. The thinking behind the endeavor was simple: why not name a premium basic after the material of which it's made? Supima T-shirts soon became known and requested by consumers nationwide.

"We've had a relationship with Supima for many years. We have some very intricate equipment and some very interesting knowhow; with Supima, we've been able to use Supima's extra-long-staple cotton to create finished products of a quality that isn't easy to achieve. The strength of their cotton allows us to make a very unique product. The difference in quality is meaningful," says Cytrynbaum.

Majestic still works consistently with Supima cotton, including its blends—one particularly interesting example is a cashmere hybrid, which is seventy percent Supima cotton and thirty percent cashmere. This plush mix is also anti-pilling, antimicrobial, and anti-fade. The natural qualities of both materials, the former long described as "the cashmere of cotton," allow for the combination of warmth, strength, and smoothness that is characteristic of these renowned luxury fibers. Majestic's Supima T-shirt line continues, having evolved into a huge business and selling in fifty-four countries.

FASHIONING THE HOME

CASPER

A sleep company that's shaken up the industry, Casper has quickly become a household fixture. Where once the market thought of Serta, Sealy, and Tempur-Pedic as top-of-the-line labels, Casper is now amongst the most recognized names in the good night's sleep game.

How did it reach those heights? Because the three-year-old start-up has modernized the practice of mattress shopping. Casper sends its mattresses and other sleep products—free of charge—to the buyer, in a size-defying box, whereupon a 100-day trial window is activated. The concept is brilliant, and it's working—within one month of its launch, Casper sold one million dollars worth of mattresses.

The company recently launched a line of bedding to complement and enhance its mattresses, including sheets, a signature pillow, and a delicious duvet. Casper has chosen Supima cotton, from a specific farm in California's Central Valley, for its sheets, citing the cotton's exceptional fibers, which are thirty-five percent longer and forty-five percent stronger compared to other available fibers. The result is exactly what consumers are looking for: bed linens that get softer and more lustrous after every wash. And what does that produce? Well, the sweetest of dreams.

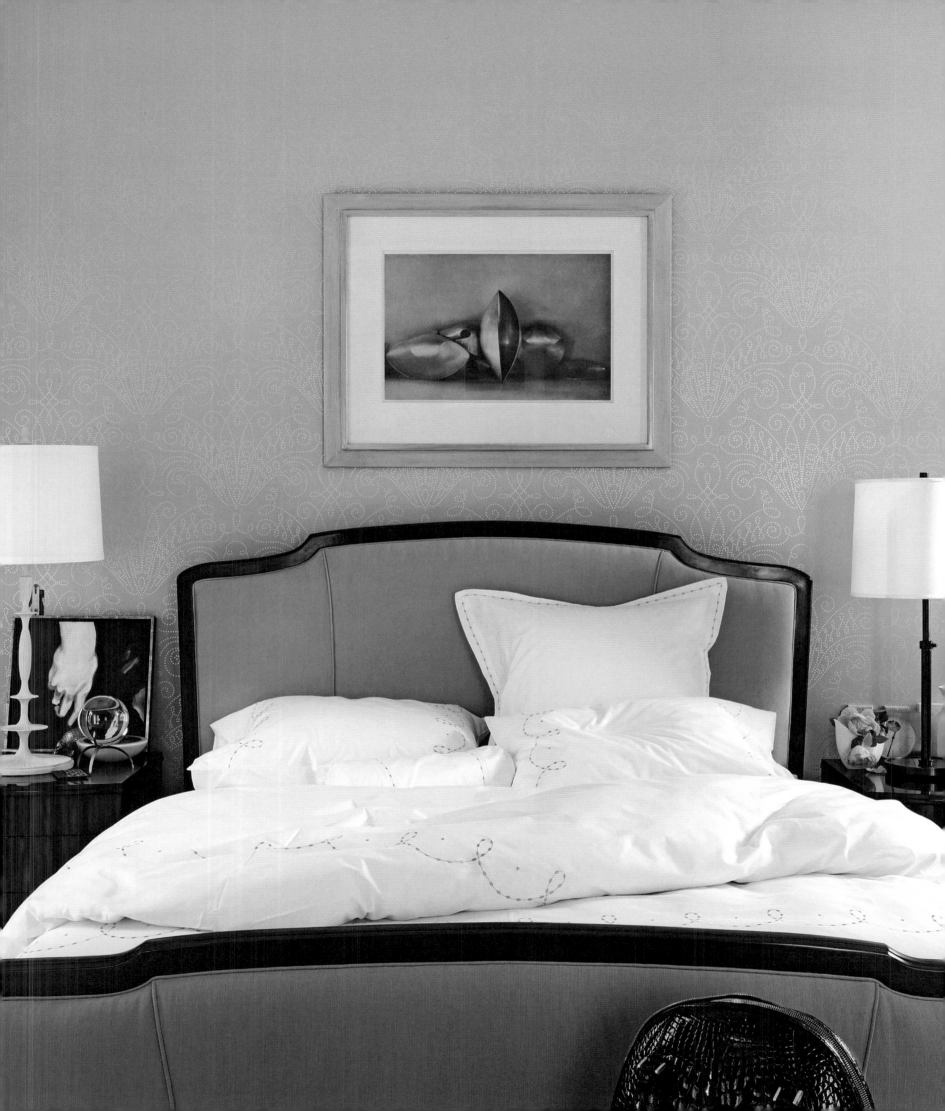

BARBARA BARRY

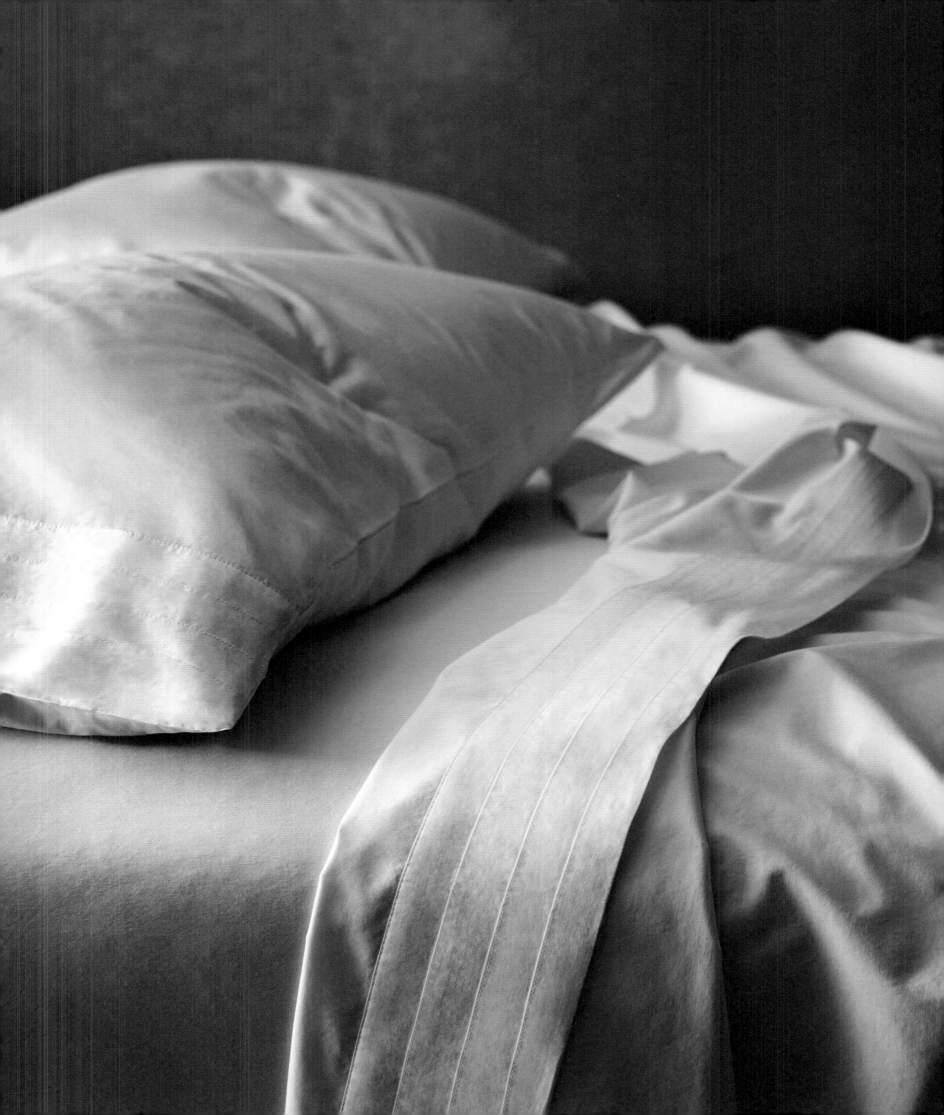

"Living simply is the highest form of luxury."

Barbara Barry

Barbara Barry makes living, well, easy. Hailing from a family of Californian artists, she has always been attracted to beautiful things—noticing, especially, subtle variations in color and in texture. This rings resoundingly true when it comes to nature— Barry is constantly inspired by the biological world's elegant hues and exactingly generated patterns. This organic love is what propelled her to build a career in spatial and residential design. Her thinking is: if we're going to live in and on this world, we should surround ourselves with airs of ease and beauty, because that, to her, is what nature—what life—is all about.

Barry formed Barbara Barry Incorporated in 1985 in Los Angeles, California. At over thiry years in business, her company has evolved into a multi-hyphenate creative powerhouse. Barry and her team work as interior designers, but they also oversee a product line of wholly original, self-designed home furnishings and accoutrements. With everything she does, the focus is on "living well"—Barry develops and nurtures close relationships with her clients, and aims to ignite a sensory experience when creating and crafting their homes. What's even more impressive is that her company delivers a bespoke service as deep as bespoke goes, drilling down to custom furniture and bed linens, dishes, silver, glassware, and more.

The essence of "living well" is served, naturally, by Supima, with both its exceptional comfort and its long-lasting strength. Barry incorporates Supima cotton in much of her bedding wares, including her Pearls linens, which feature strands of pale golden elliptical pearls embroidered on sheets and pillows. This series is made entirely of Supima. Barry also uses Supima on other elements of bedding, including neck-roll pillows, accents, and much, much more. Softness and durability are keystones; a Barbara Barry bed will last for years, as will its beauty.

Barry often mentions that her process—and in fact, her career—has been circular, and not exactly following a distinct line. That sense of wholeness, and borderline holistic centered-ness, extends all the way to her bedding collections. In the aggregate, they are of a piece—from their aesthetic right down to construction. "Our bedroom can be our respite, our private domain, a place where we can turn off sound, cease speaking, and just unwind," says Barry over the phone from California.

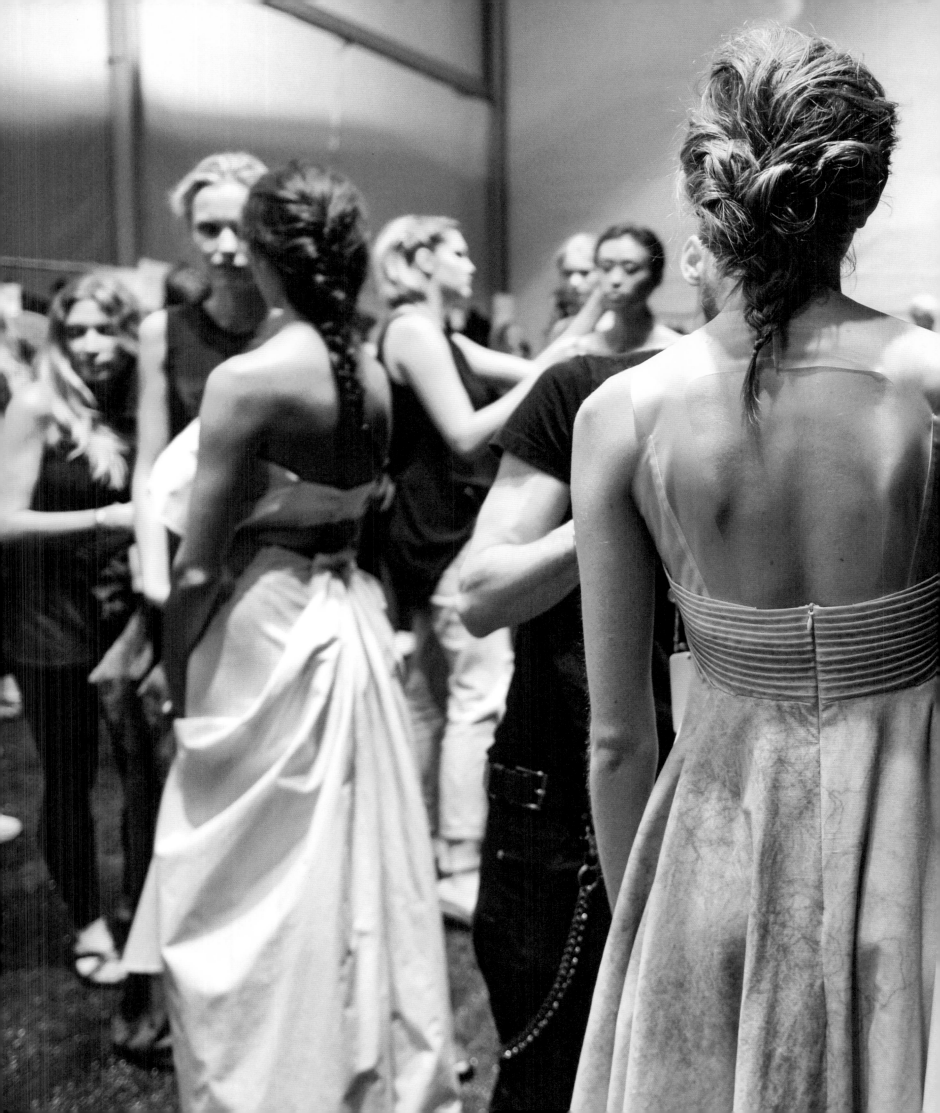

THE SUPIMA DESIGN COMPETITION

Tracey Greenstein

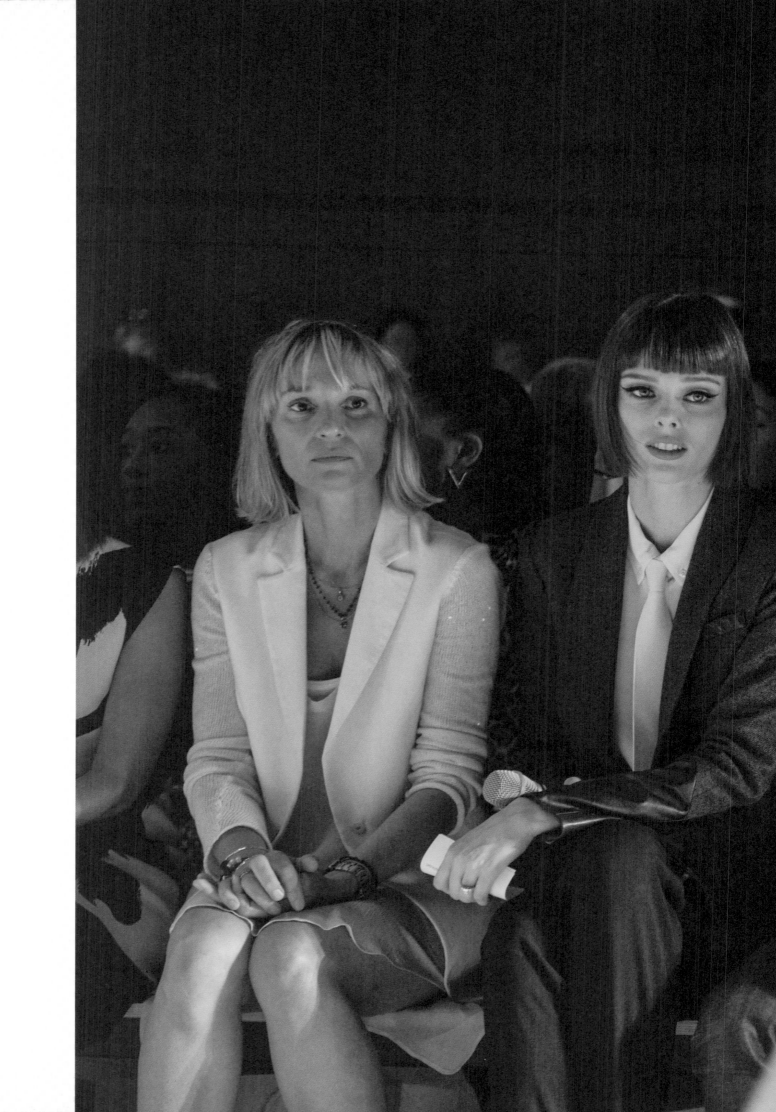

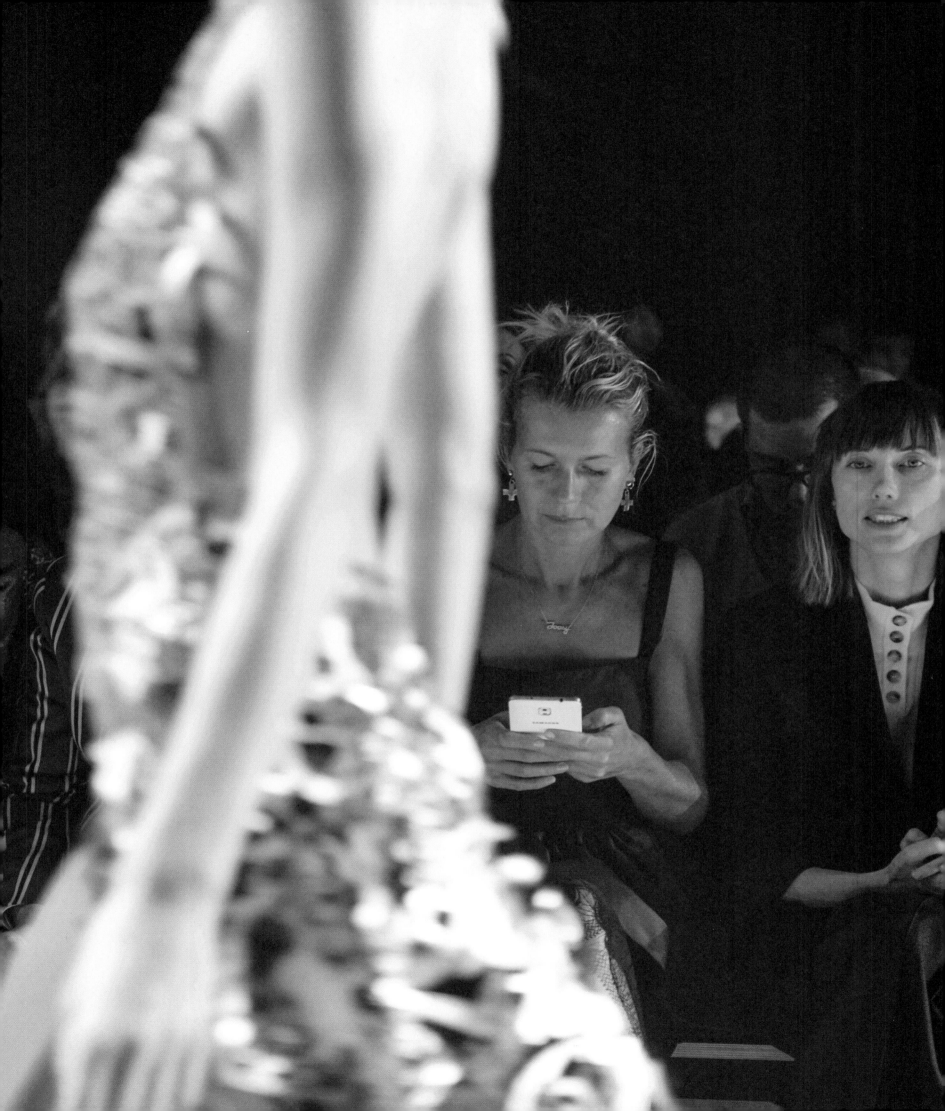

From its beginnings as a local design contest in 2008, the Supima Design Competition has evolved into a highly selective international showcase for emerging talent. The competition's finalists—chosen from the next generation of fashion designers—see the culmination of their dedication and hard work walk down the runway during New York Fashion Week each fall, followed by a presentation at Paris Fashion Week a short time later. The deserving winner also takes home a cash prize and gains exposure to top fashion industry executives, press, and social media influencers.

Even in its early years, when the event was more of a fabric show and participants responded to an open call for entries, Supima viewed the contest as an opportunity to work with budding designers. In fact, giving back to the industry and supporting young designers is the primary reason the organization inaugurated the annual show, which presented two editions in 2009, making 2017 a tenth-anniversary milestone.

It was the event's fourth year, however, that marked a key turning point, when what was a contest became a true competition. The evolution was made possible by Supima's move to partner with top design schools from across the United States, each of which selects one graduating senior to represent the school.

Once the finalists have been chosen, they are then presented with an exciting challenge: to design a capsule eveningwear collection using only Supima fabrics. From this same starting point of five humble yet luxurious textiles—shirting, knit, velveteen, denim, and twill—the competitors develop and produce an extraordinary range of innovative garments.

They, along with their colleagues, experience these superior cotton fabrics firsthand at presentations given by Supima at each partnering school. It is during these visits that the young designers come to understand the qualities of luxury cotton and the benefits of incorporating it into their creative process. They learn about not only the superior luster, strength, and vibrancy of Supima, but also the sustainable model promoted by the organization, with its hands-on approach to working with the supply chain and goal of having the least possible impact on the environment. Hearing Supima's stories about working with American growers and internationally known brand licensees to craft well-made, authentic products is particularly important to today's creators and consumers alike.

With fabrics in hand and awareness in mind, the finalists must next bring their creations to life. The task of helping them develop and refine their pieces for the runway is deftly handled

by an industry mentor, a position that was first filled by the award-winning eveningwear designer Bibhu Mohapatra beginning in 2013.

Providing additional support and direction are faculty mentors who guide their students to imagine details and designs that will resonate with the judges. And it is to the judges—all professionals from the fashion and media worlds—that perhaps the most difficult job falls. During the runway show, when designers present their full-fledged collections, the panel members must scan and analyze each garment, searching for the most unexpected and successful use of textiles and fabric manipulation, whether pattern or color, volume or silhouette, embellishment or texture.

The winner is announced at the end of the show, and although only one designer can claim the honor, all finalists will have created stunning examples for their portfolios. These will surely open up all kinds of exciting opportunities, which is just what Supima has always hoped the competition would do.

Finalists have indeed gone on to forge impressive career paths; some have started their own companies while others have opted to join top-tier fashion companies and brands, such as

Ralph Lauren, Calvin Klein, and Theory. Among past successes is Jeffrey Taylor, a graduate of the Savannah College of Art and Design and winner of the 2016 competition. Taylor was featured in *Teen Vogue* and toured to show his collection to prominent industry members. Abbey Glass, a finalist representing Rhode Island School of Design, started her own women's ready-to-wear and custom clothing business based in Atlanta.

To many participants, the competition is a dream come true, a life-changing educational and practical experience that launches their careers. The Supima Design Competition serves not only as a bridge between academic coursework and the realities of the runway, but also as a launch pad for the next generation of groundbreaking fashion designers.

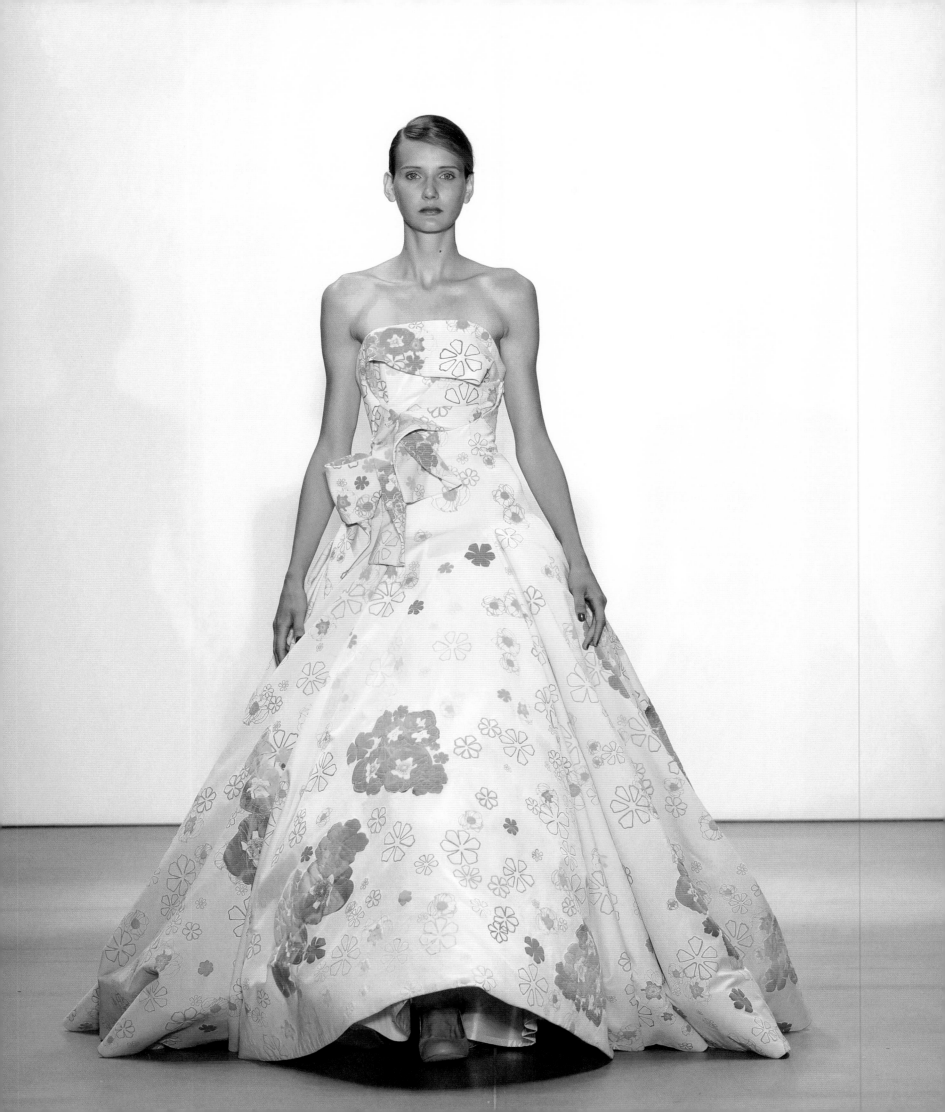

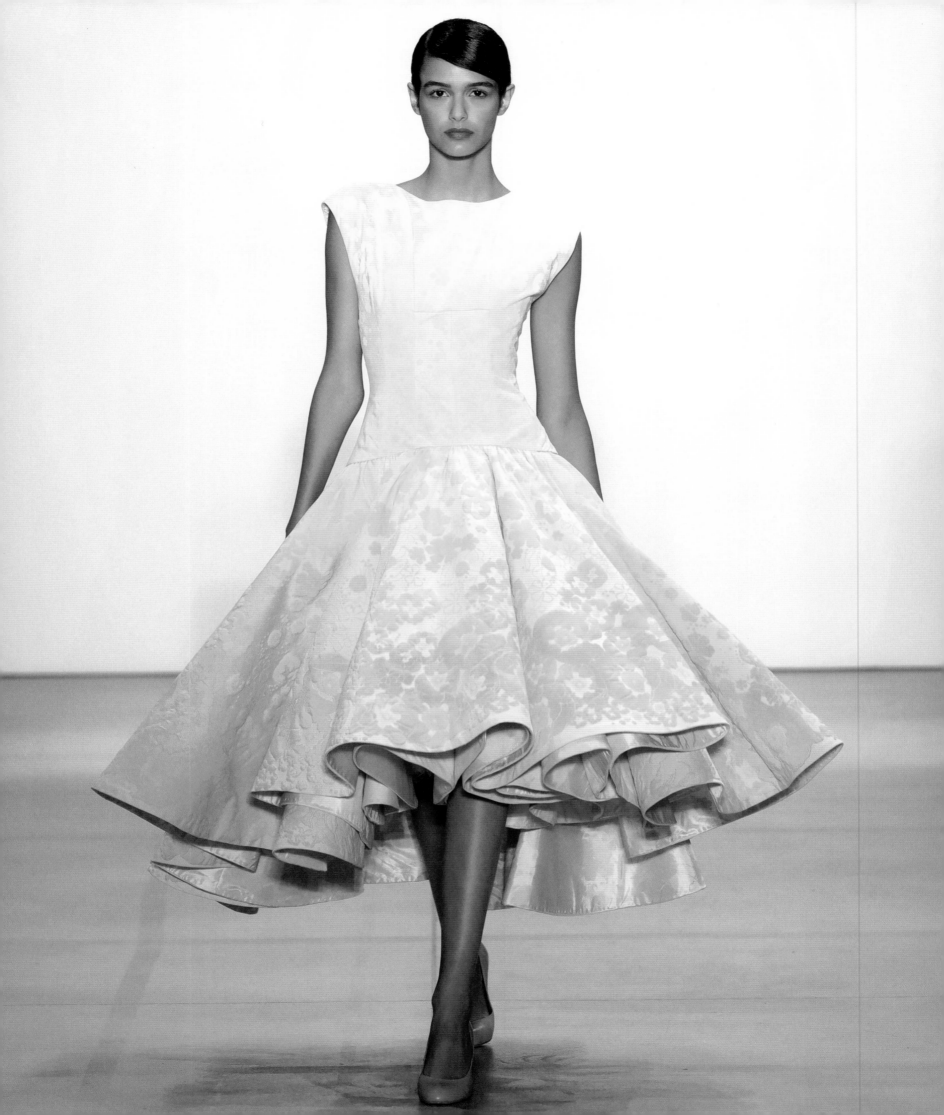

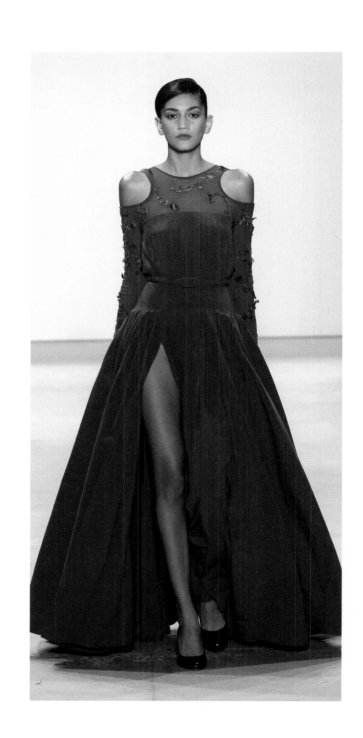

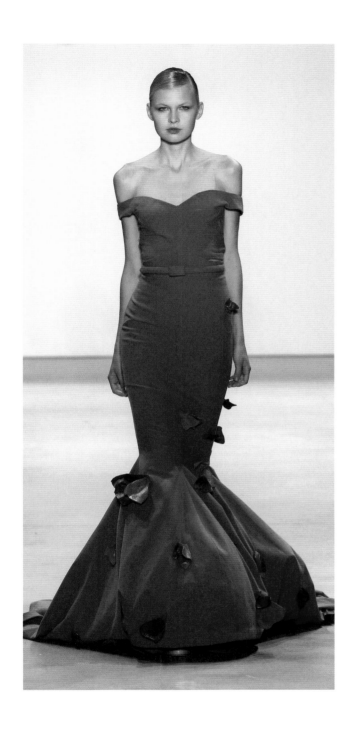
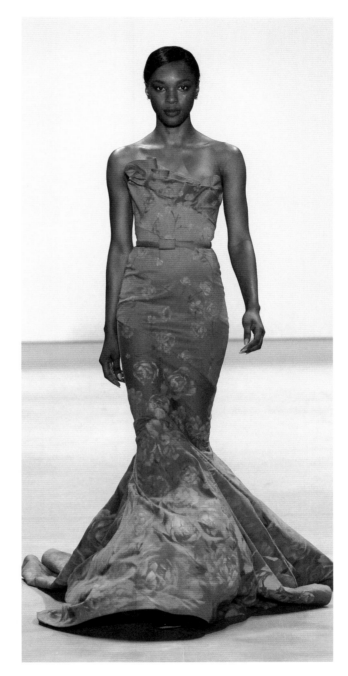

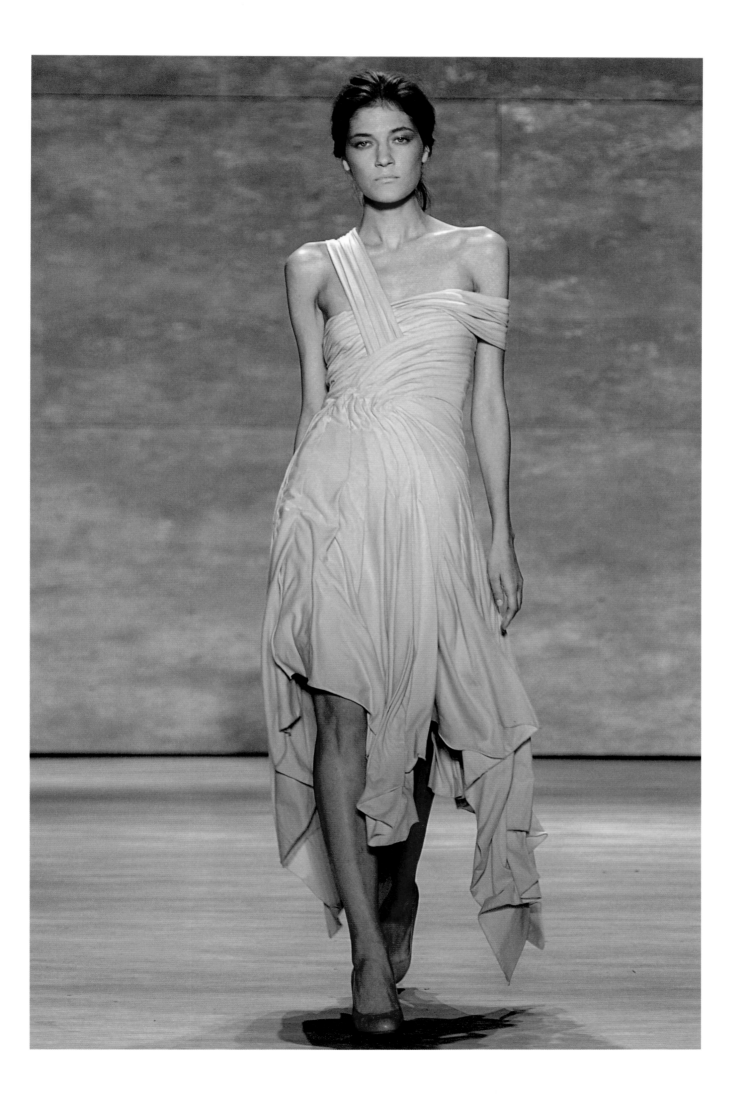

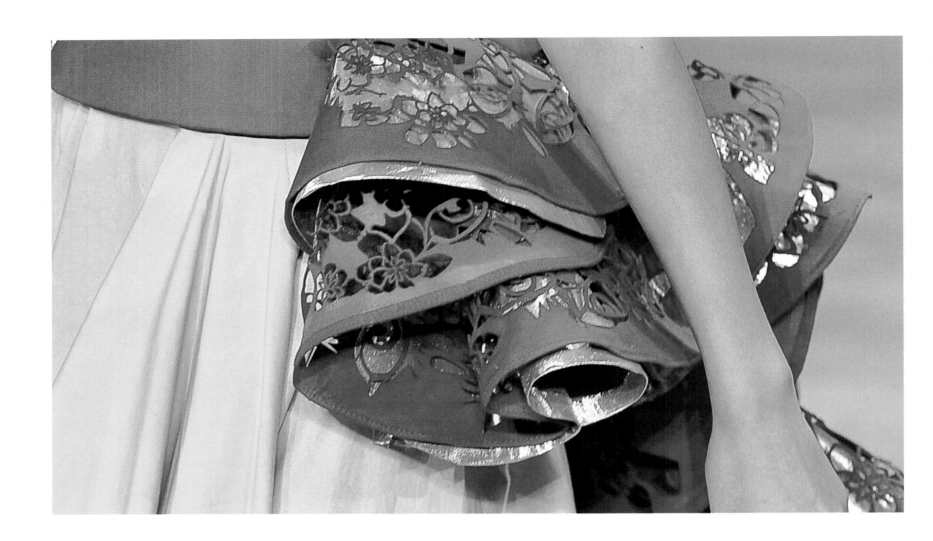

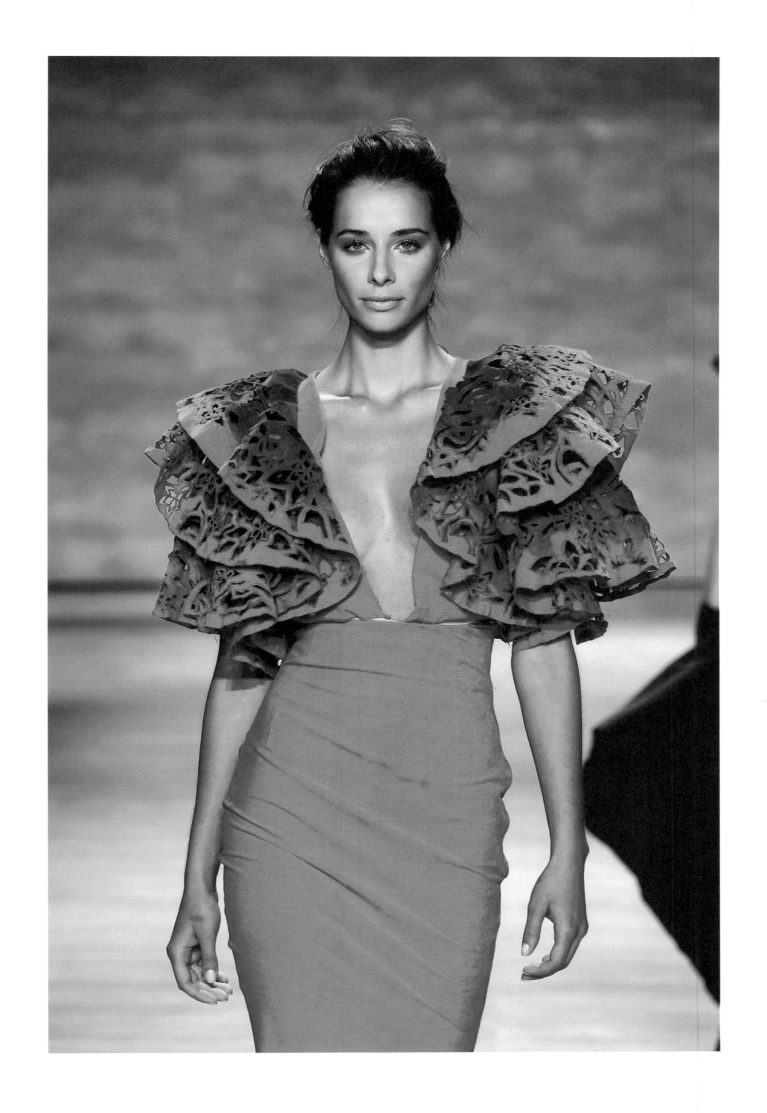

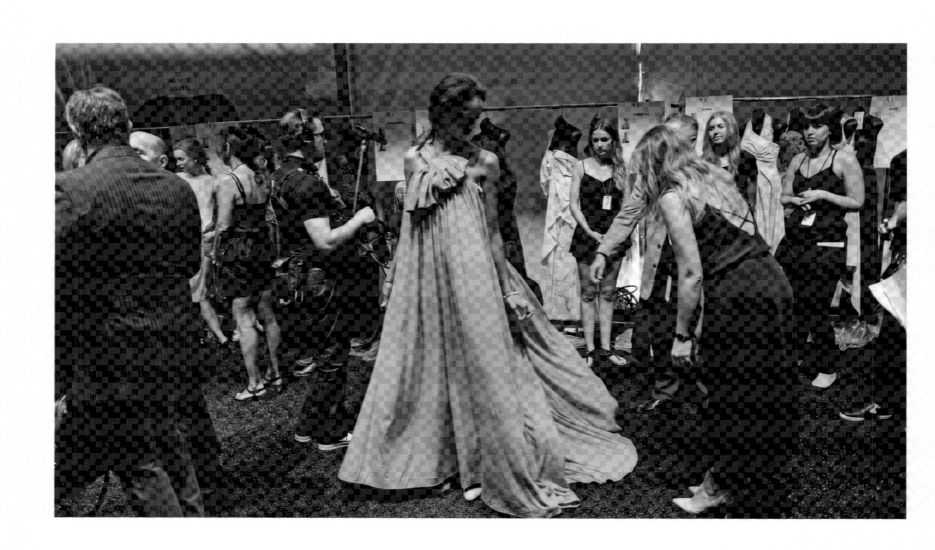

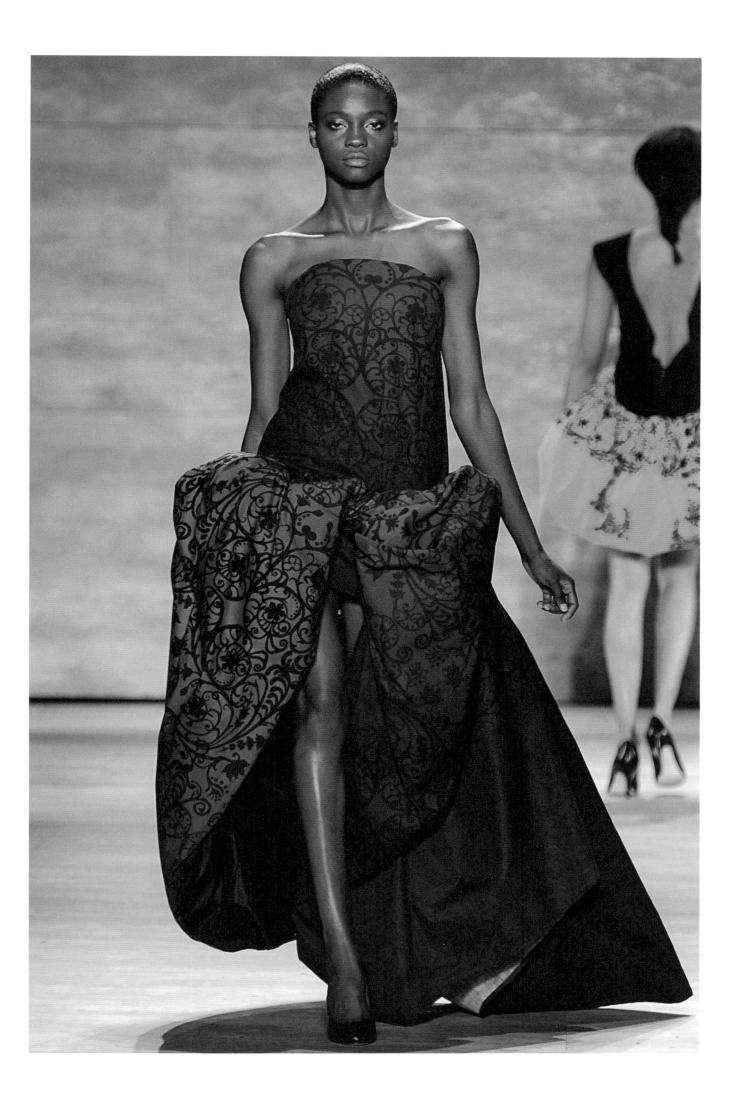

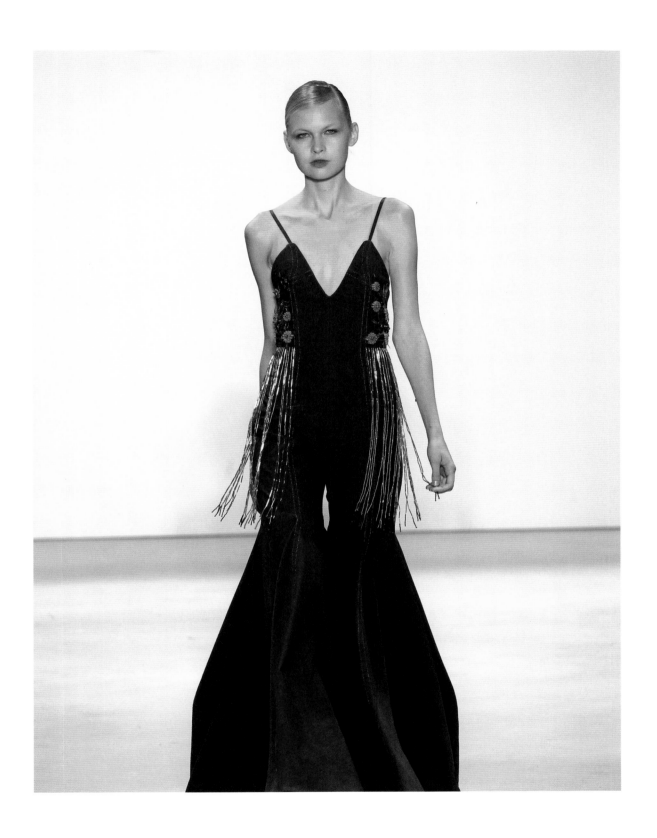

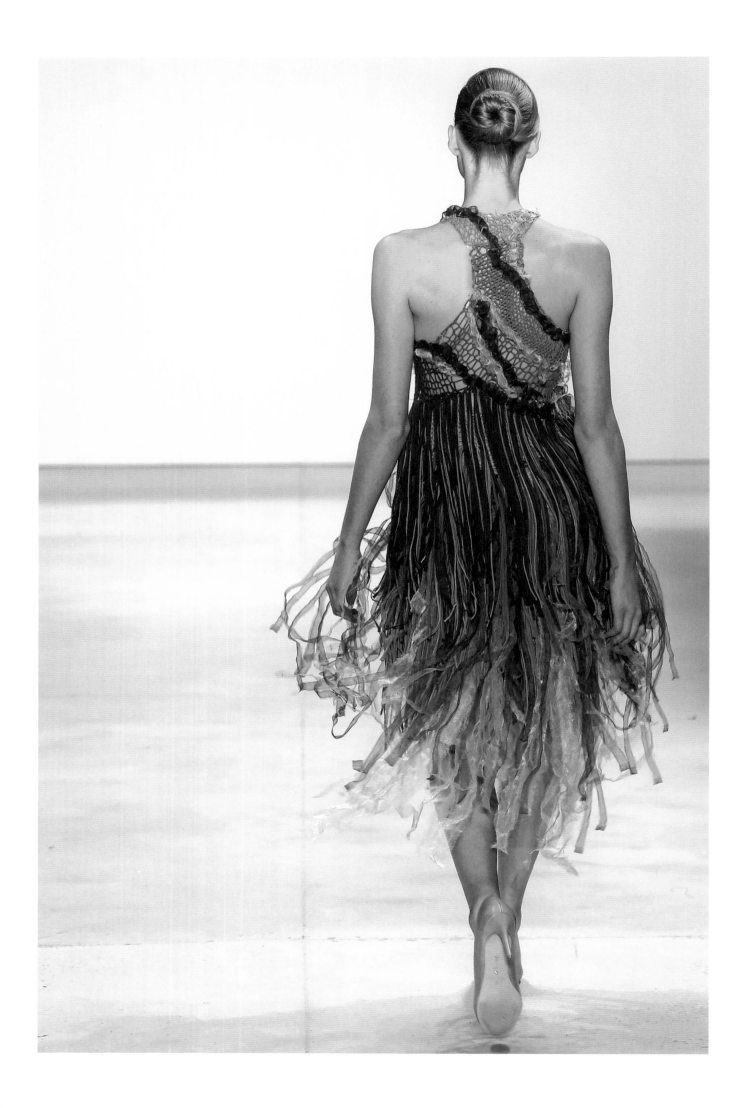

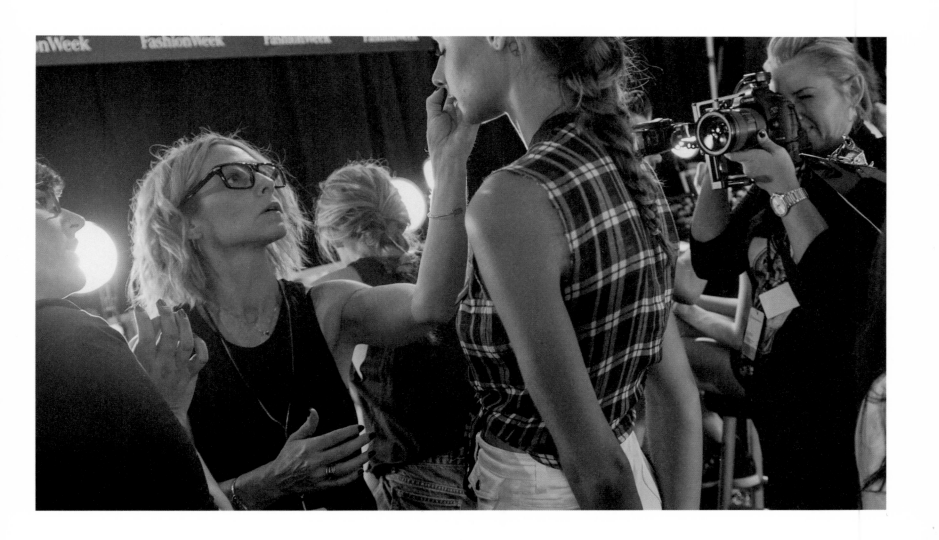

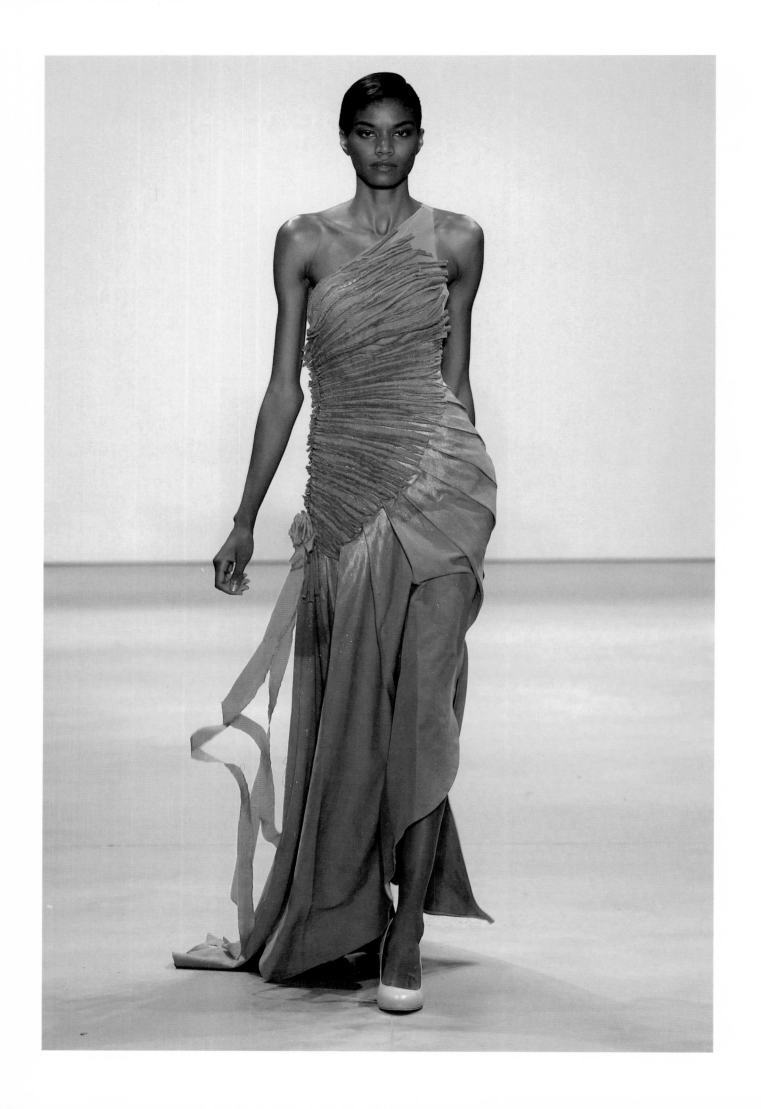

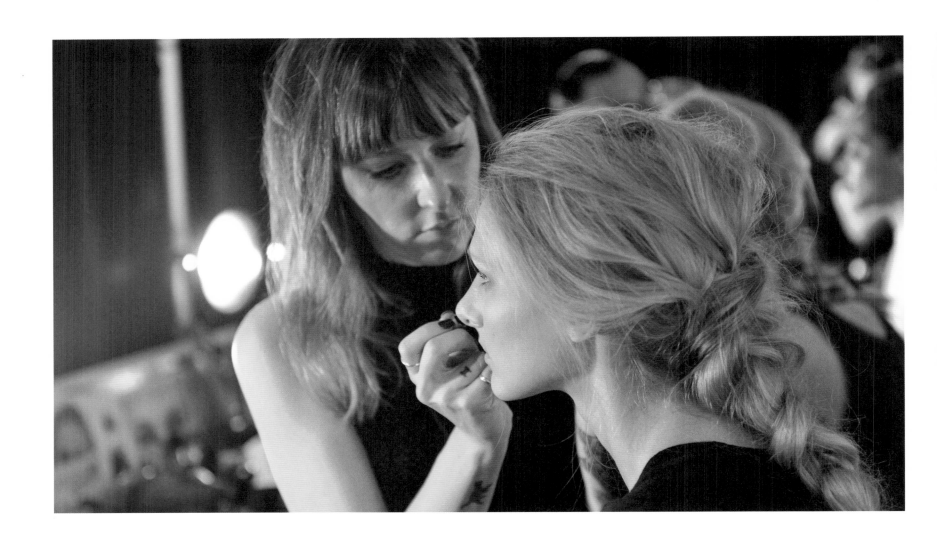

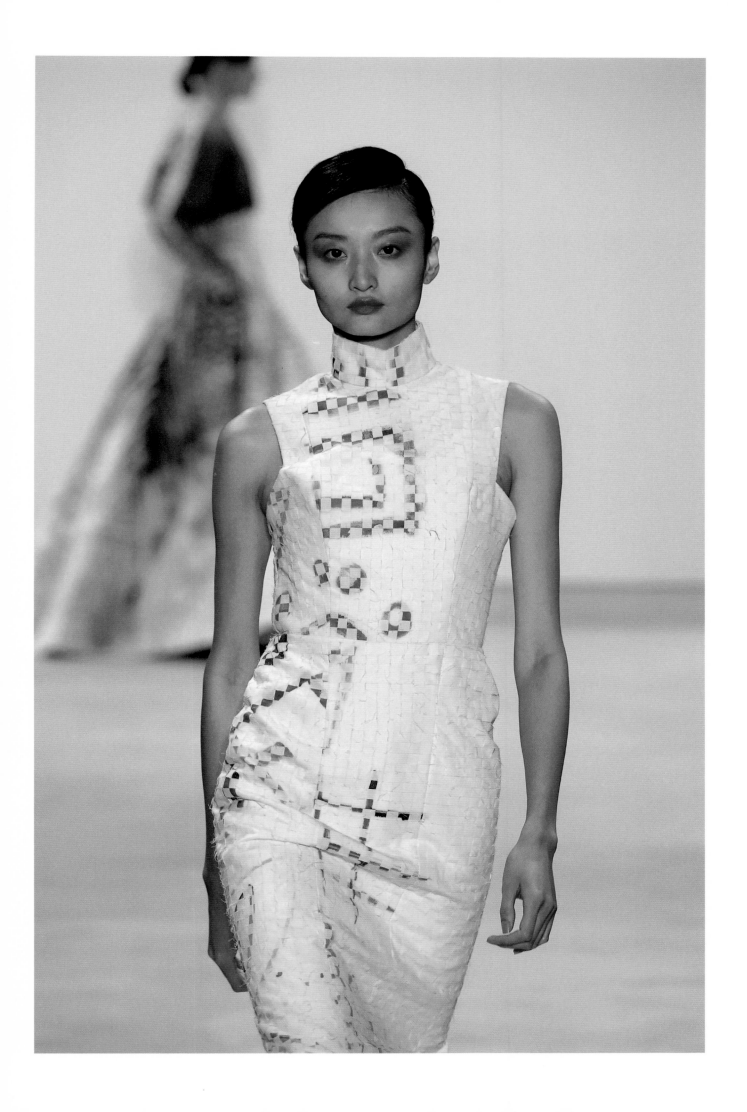

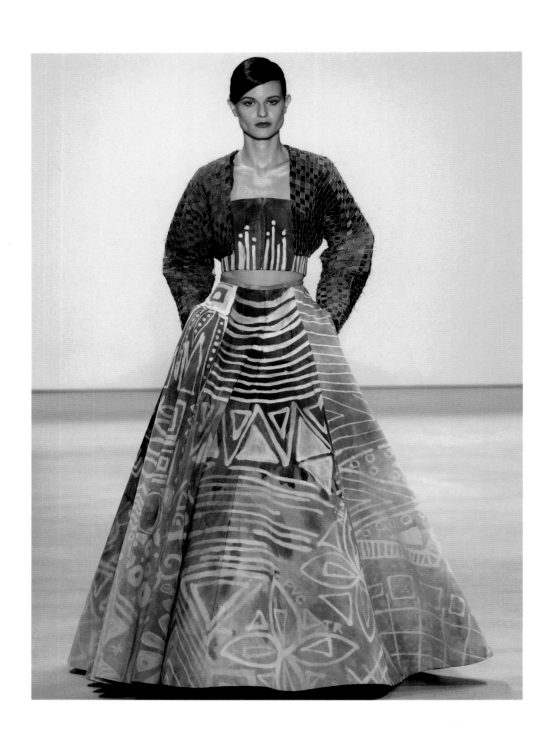

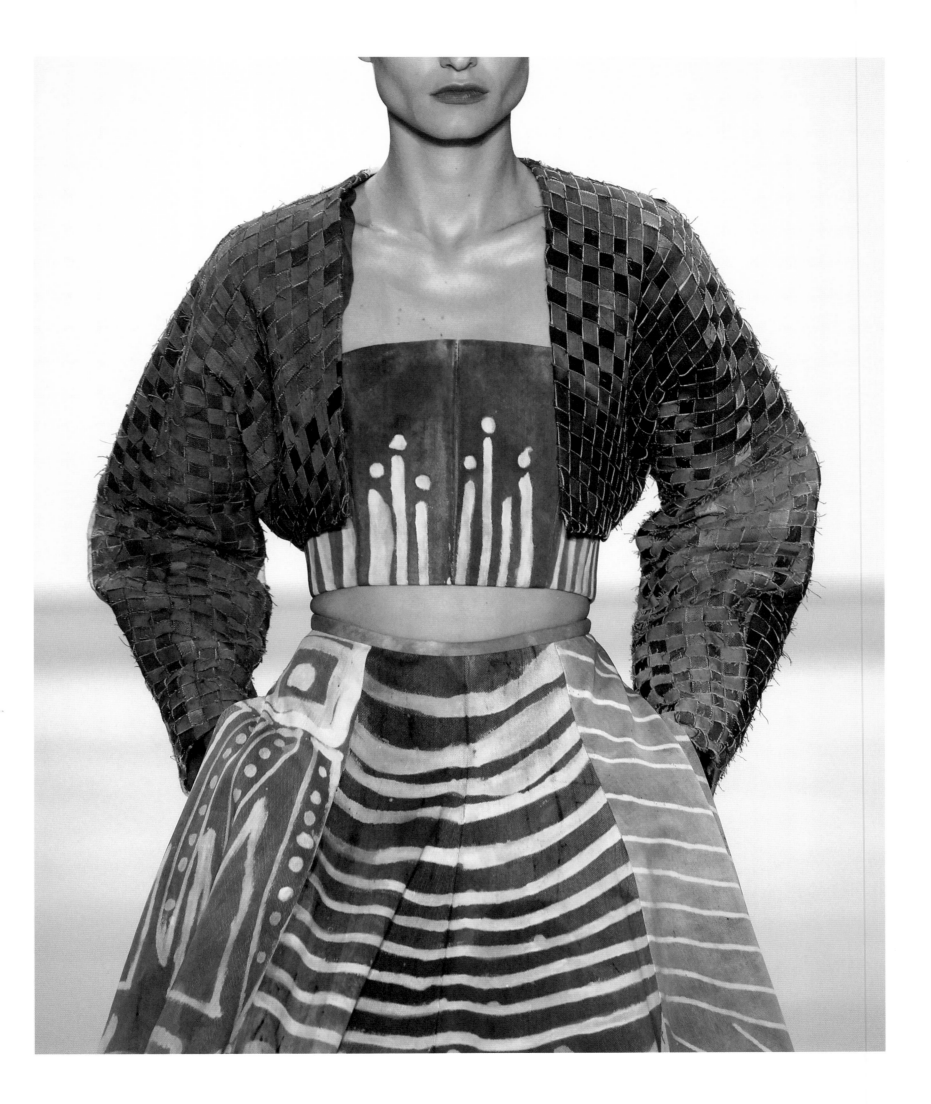

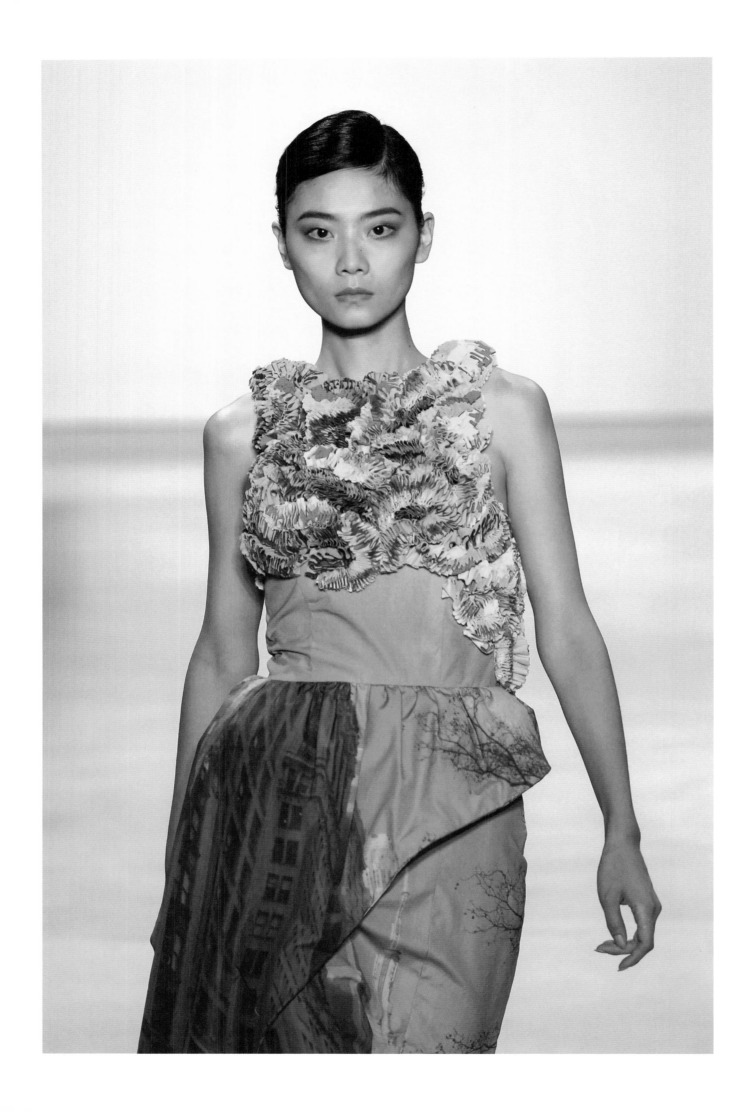

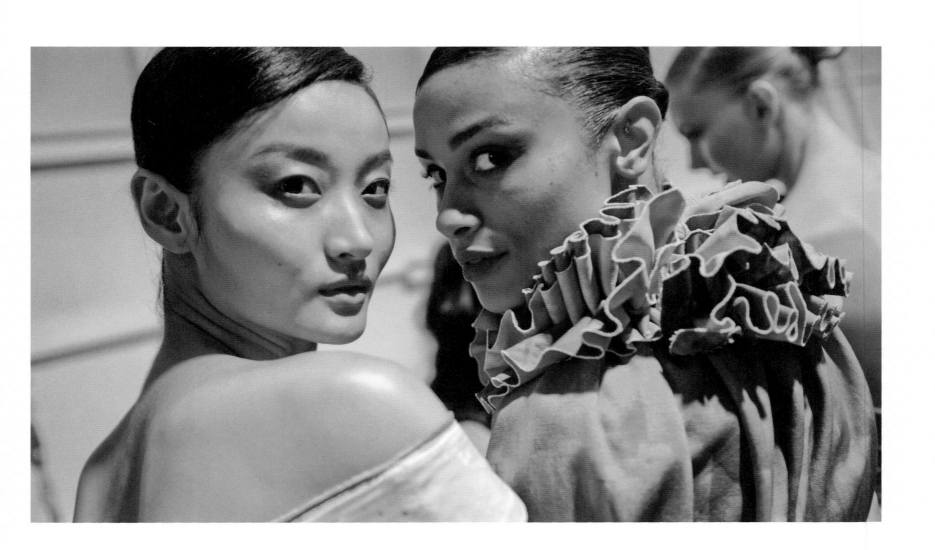

Pages 187–189. Kate McKenna, SCAD, Award Winner 2015.

Pages 190–191. Paige Meacham, Kent State University.

Opposite. Nnamdi Agum, FIT.

Pages 194–195. Karen Dang, Academy of Art University, and Leetal Platt, FIDM, Paris Fashion Week presentation.

Pages 196–197. Jacob Blau, RISD.

Page 198. Jacqueline Zeyi Chen, Parsons School of Design.

Pages 200. Design mentor for the competition and CFDA-award winning designer Bibhu Mohapatra assists a finalist backstage.

Pages 201–203. Duston Jasso, FIDM.

Page 204. Kara Kroeger, Kent State University.

Page 205. Front row at the Supima Design Competition, 2016.

Page 206. Supima Design Competition finalists with US Ambassador Jane Hartley—Paris Fashion Week, 2015.

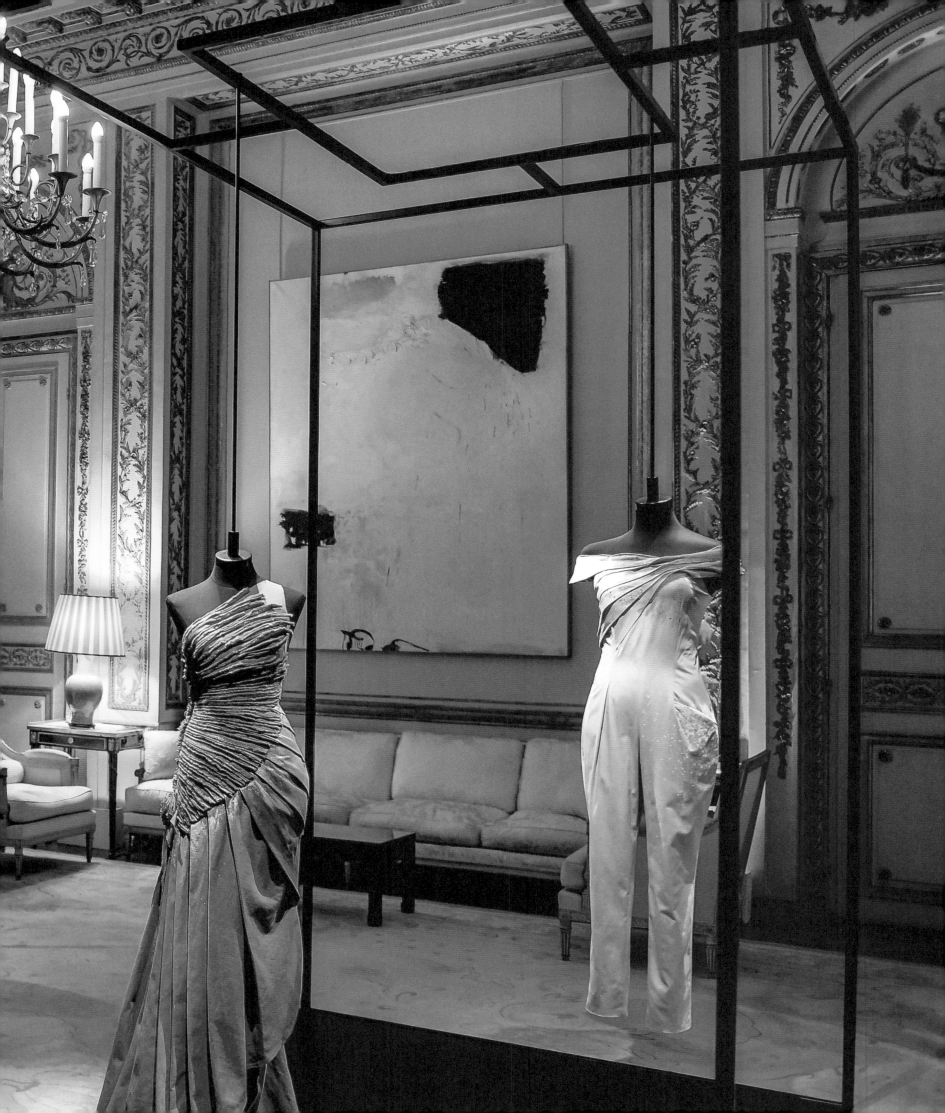

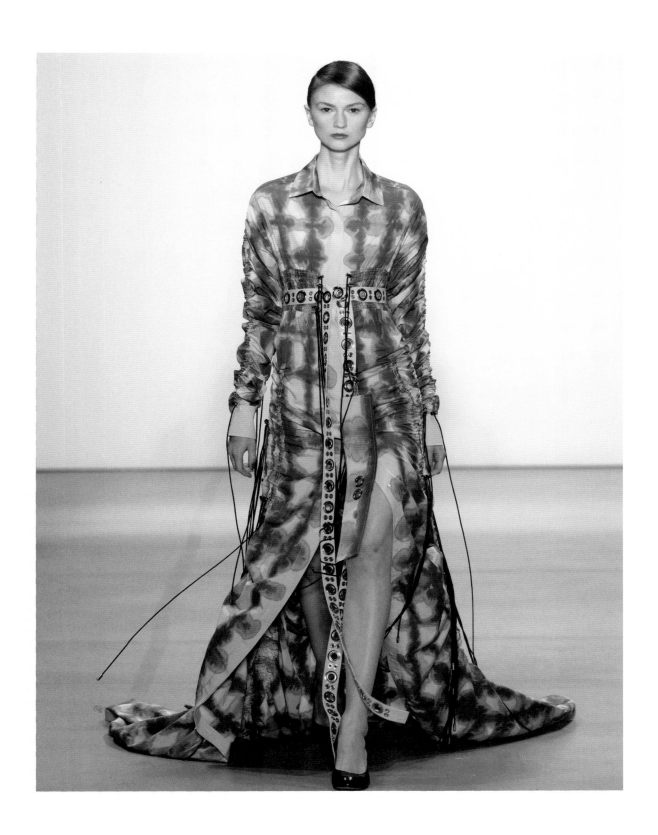

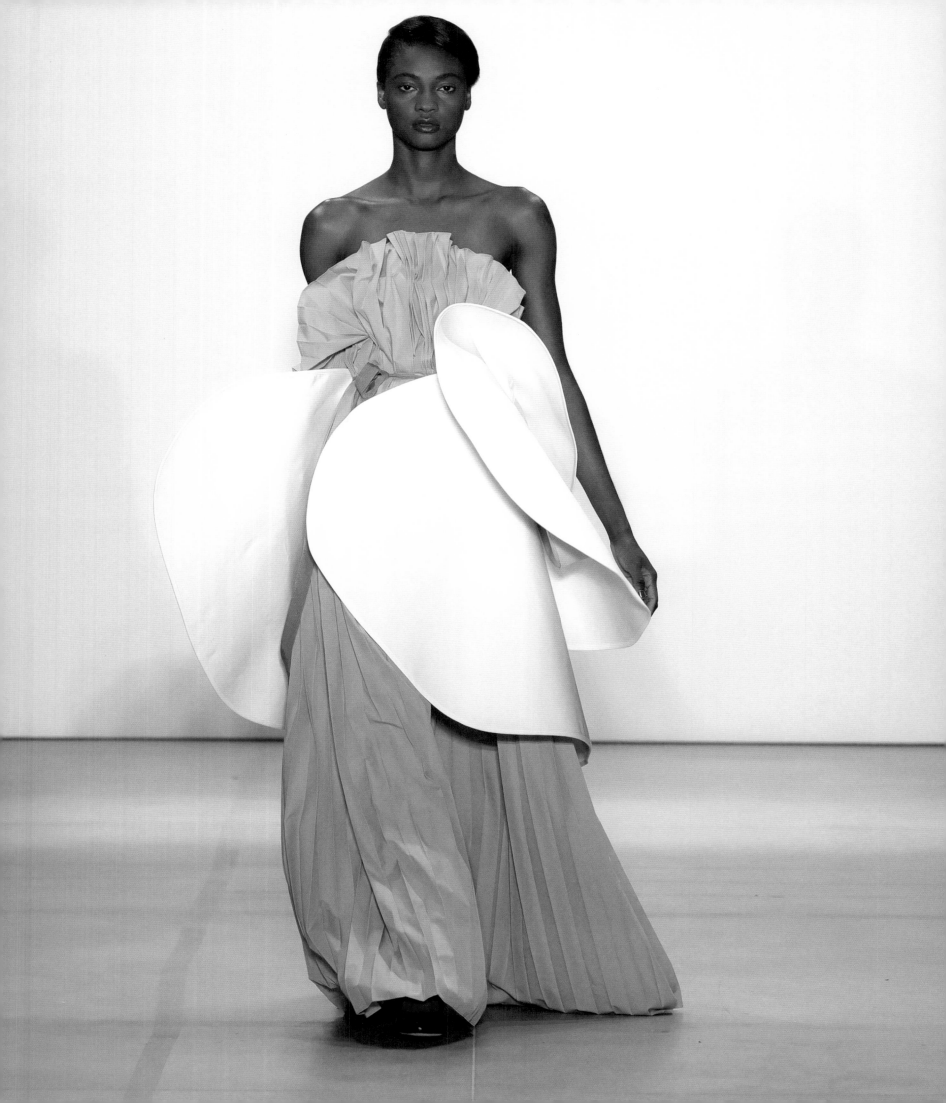

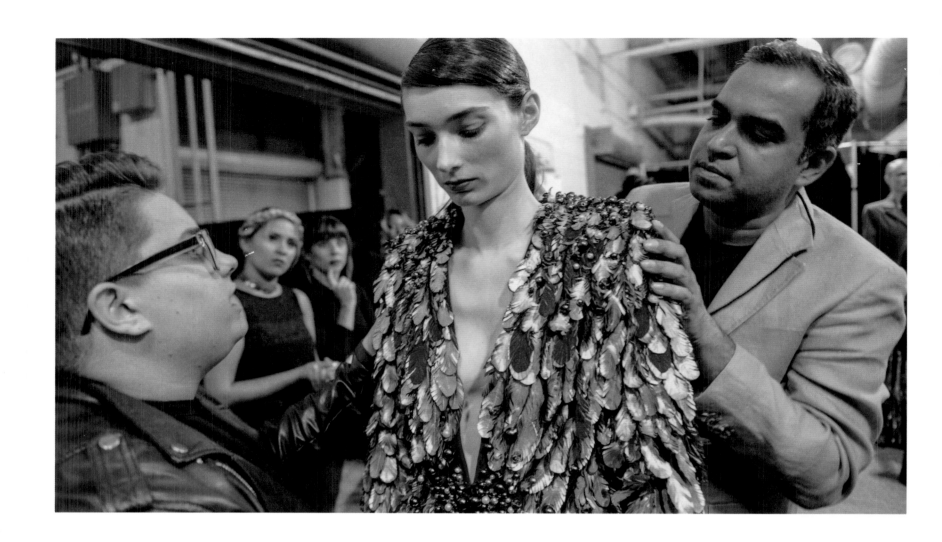

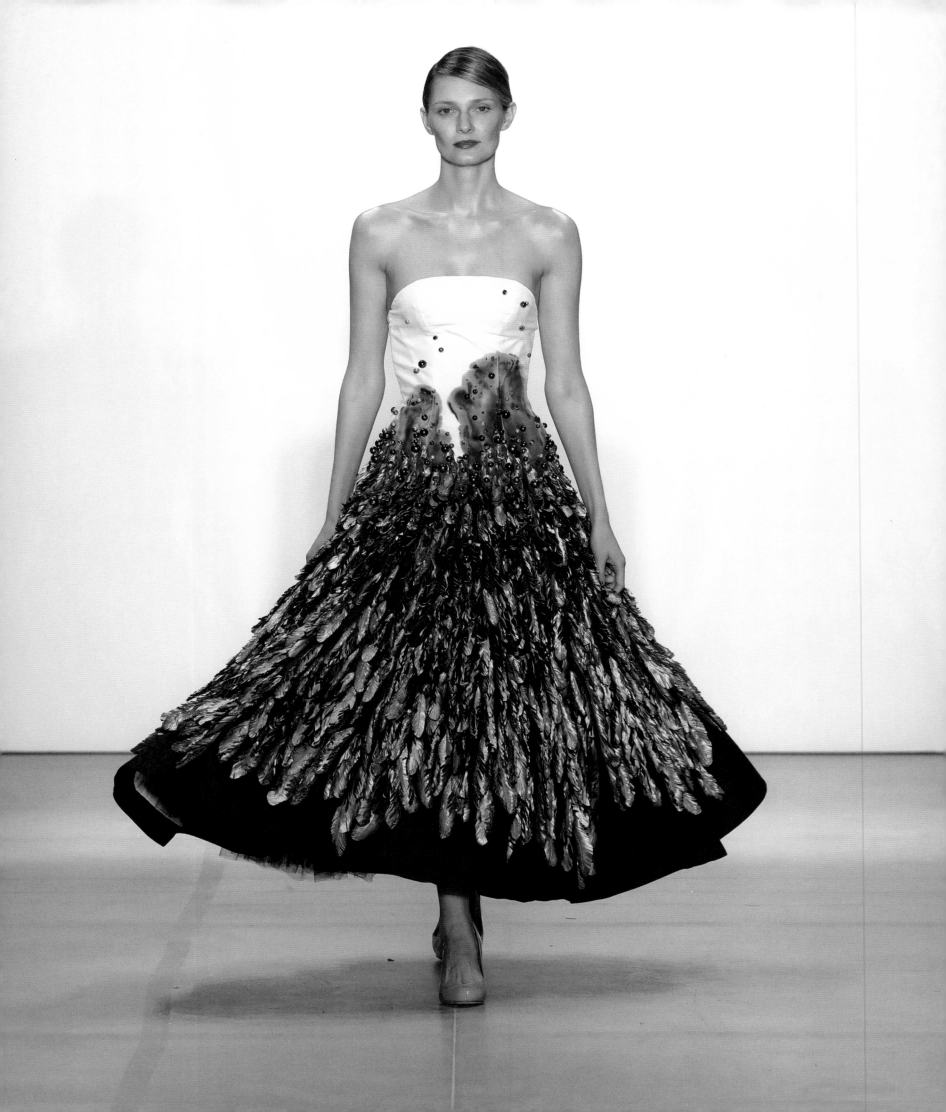

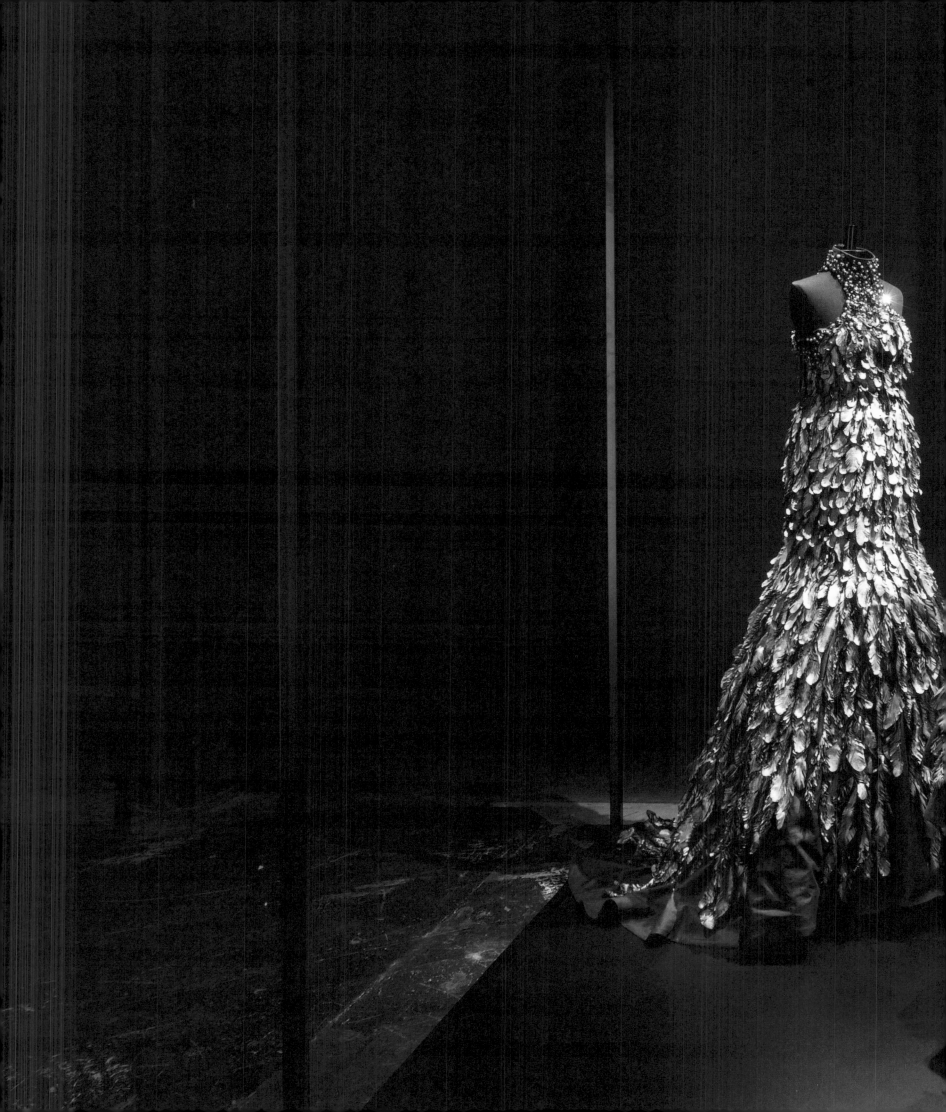

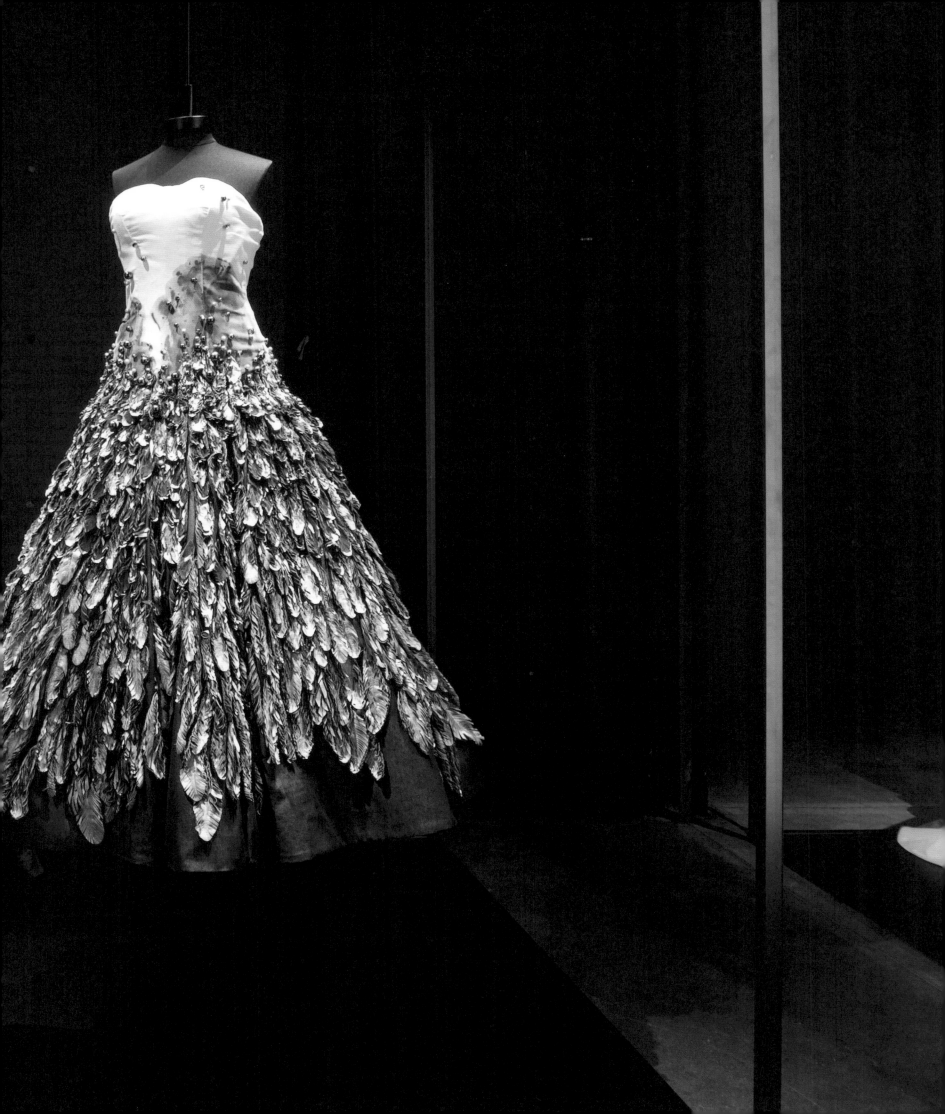

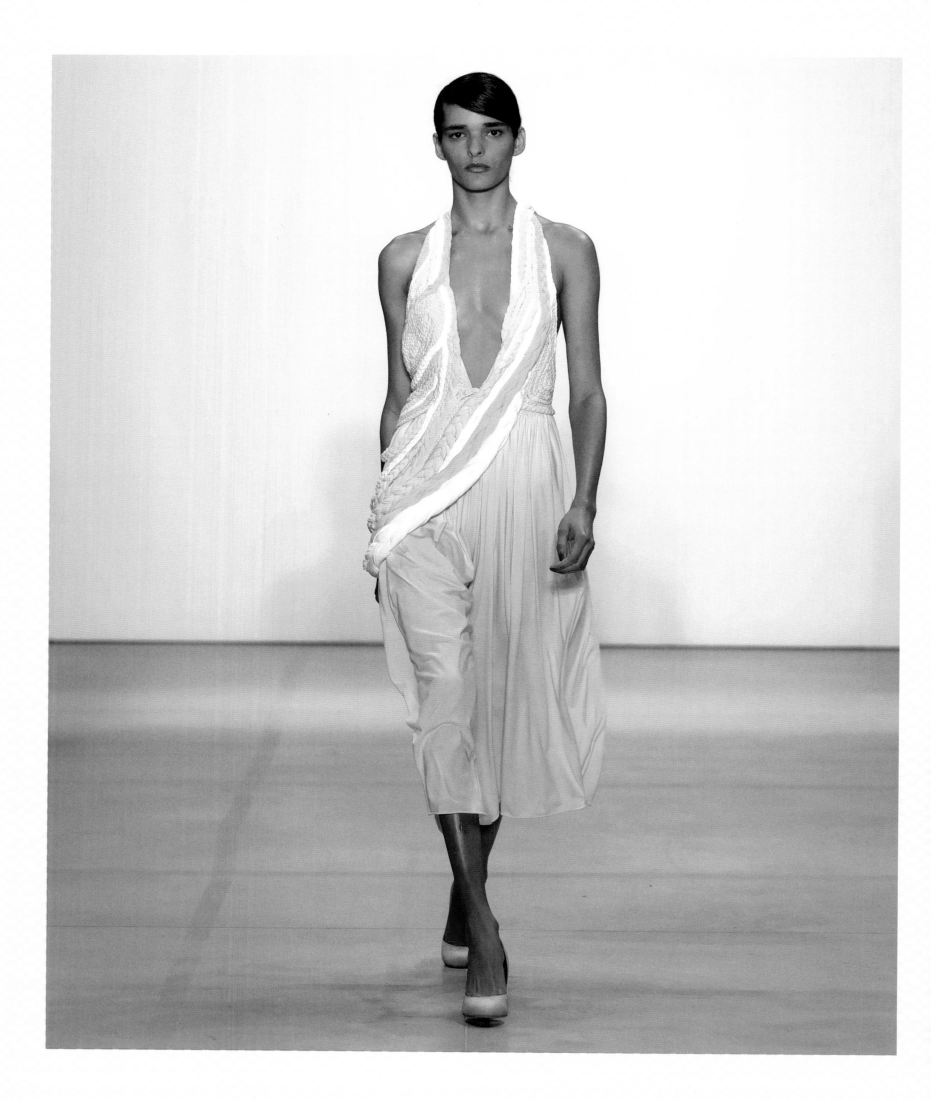

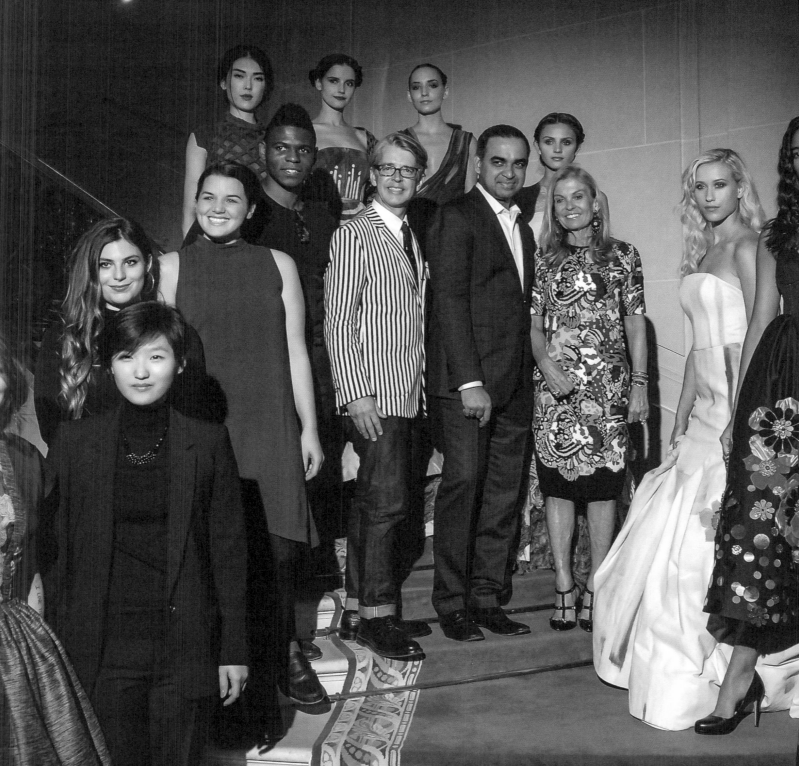

CULTIVATING DESIGN: SUPIMA IN SCHOOL

Paula Wallace

Supima stands at the apex of America's cotton industry. The name itself evokes pastoral landscapes and classic American authenticity, derived as it is from the Pima people, who were instrumental in cultivating the variety from farms within reservations in early twentieth century Arizona. The supremacy of Supima cotton honors their persistence, innovation, and legacy.

Cotton is defined by the hand-heart connection people feel when they touch this durable, unpretentious fabric. Often, women's work of spinning, weaving, and knitting is associated with cotton. Women of all eras and all socio-economic strata have used cotton to fashion home goods and construct apparel. My grandmother Olive's quilts were hand-sewn by four women in a quilting circle. When I was a girl, the quilts already were worn with time, washed and aired on her clothes- line, soft to the touch and redolent of memory. She never complained when I bundled one under a tree for reading. You see, they were meant for use. I still have these quilts, and they speak to me of my grandmother's love, of timelessness. They speak to me of lasting value. They speak to me of cotton.

Students learn a similar lesson when they engage with raw materials, which is why the partnership between Supima and higher education is so essential to the future

of cotton. The tactile qualities of this historic and perennially relevant textile should be experienced by all students in fashion and fibers—students at SCAD and across the world who will one day lead these professions.

Every year, the Supima Design Competition invites emerging designers to conjure unique garments of shirting, twill, denim, jersey, corduroy—the entire corps de ballet rendered from premium Supima cotton. For months they research, sketch, drape, and construct. The collections these novice designers conceive and create are woven with heart and soul. Supima's elegant New York Fashion Week-sanctioned show unfolds before throngs of fashion arbiters. This Promethean presentation signals the arrival of a new generation.

For millennia, cotton has compelled fortunes and cast shadows, clothed generations and bandaged wounds. It's brought warmth, comfort, confidence, and expression to those who coax it from the earth, those who work it to their will, and the billions of us who wear it morning, noon, and night. Supima ensures American cotton continues to be coveted the world over, just as educators assure the success of aspiring designers from all the far corners of the globe.

SCAD and Supima share a core tenet: creative thinking is paramount to success. For nearly a decade, Supima has been a defining presence in classrooms and studios across the fashion-related programs at the Savannah College of Art and Design. Supima representatives engage students in discussion and exploration of different cottons and Supima fabrics, while hands-on presentations extend the "real-feel" experience to demonstrate the superior attributes of Supima cottons. They discover the infinite applications that Supima's unique properties make possible—discoveries that have the potential to place them front and center at the Supima Design Competition.

Each SCAD academic year is bookended by the autumnal rush of incoming students, eager to immerse themselves in their studies, and the springtime scene of graduating fashion students, who share their capstone collections during the spectacular SCAD FASHWKND. Between these two events SCAD students explore fashion from the conceptual to the commercial and cultivate technical dexterity and personal vision—including the unparalleled experience of working with Supima cotton. For SCAD fashion students, every day of every academic year is one step closer to an acclaimed fashion career.

Michael Fink, Dean of the School of Fashion,
Savannah College of Art and Design

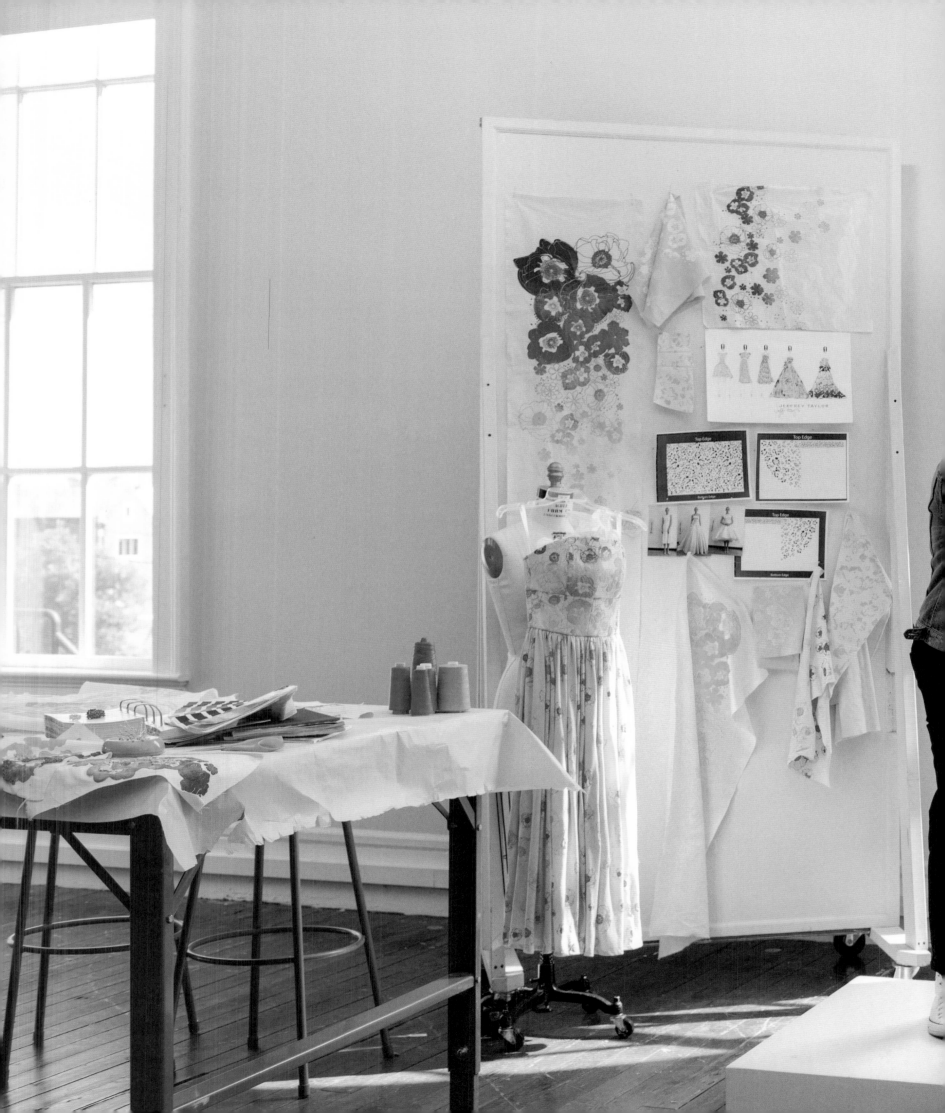

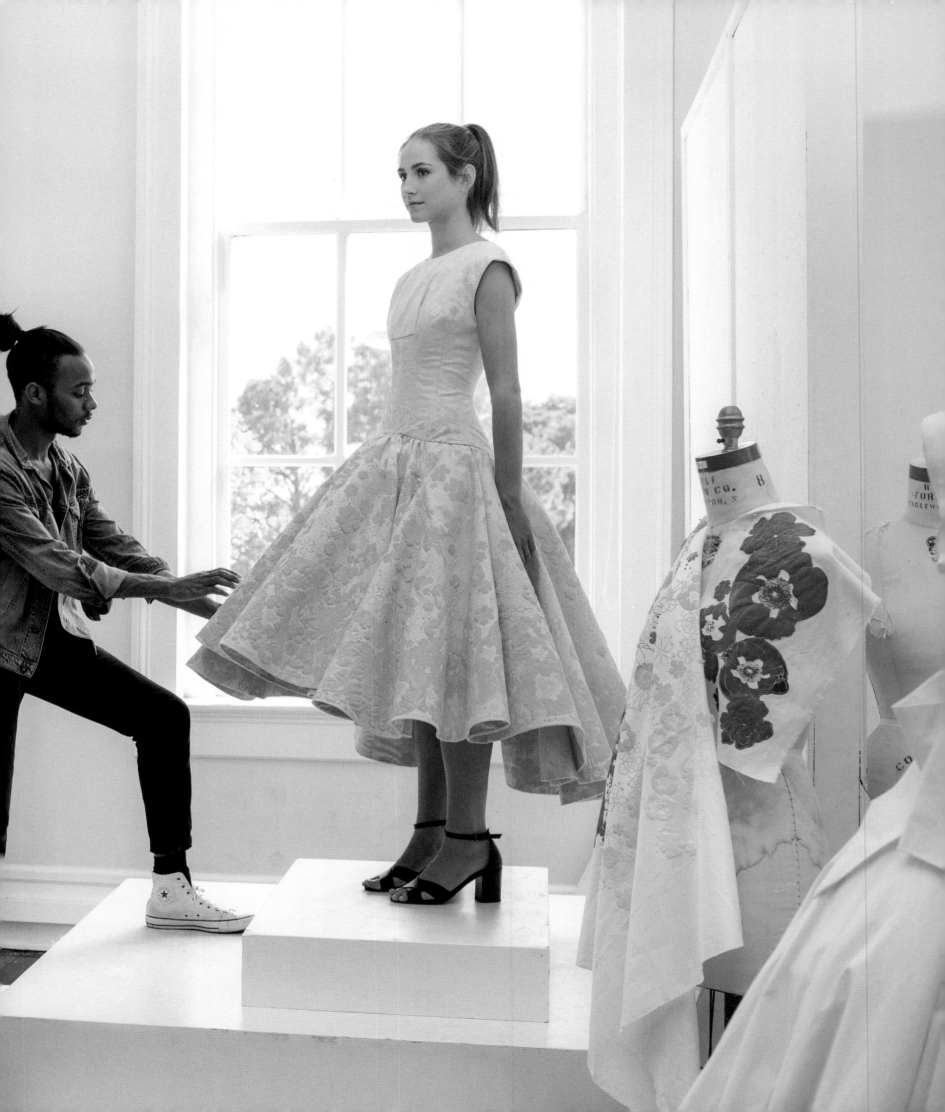

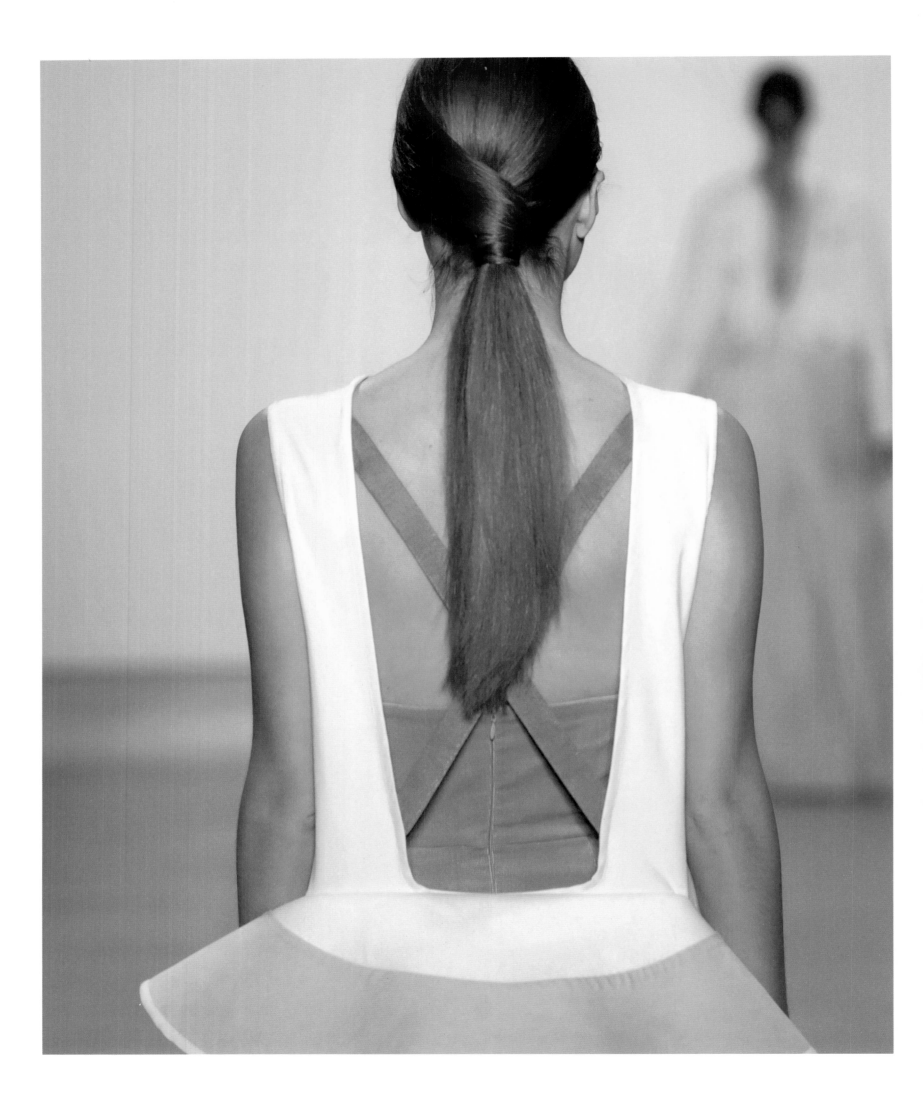

Supima's commitment to producing equally strong and soft cotton fabrics enriches the possibilities of our design students to create beautiful and lasting garments. The creativity and critical thinking that lie at the heart of a Parsons education are brilliantly showcased each year through our collaboration with the Supima Design Competition, as well as by Supima's generous sponsorships for our students.

Burak Cakmak, Dean of the School of Fashion,
Parsons School of Design

The Supima Design Competition experience has afforded emerging Rhode Island School of Design apparel designers the chance to create collections using superior Pima cotton, which might not otherwise be readily available to them. All of the fabrics—shirting, velveteen, twill, denim, and knit—are of the finest quality and far outperform other cotton fabrics in the industry. RISD apparel students who used and explored the properties of Supima corduroy in both bomber jackets and jeans found that it dyed well and produced high-quality final pieces. The use of luxury Supima fabrics in the classroom allows our students to stretch the boundaries of traditional garments, which is our trademark. RISD students who work with Supima see the difference immediately and become fans of this luxurious extra-long-staple cotton fiber for life.

Margaret DeCubellis, Senior Critic, Apparel Design Department,
Rhode Island School of Design,

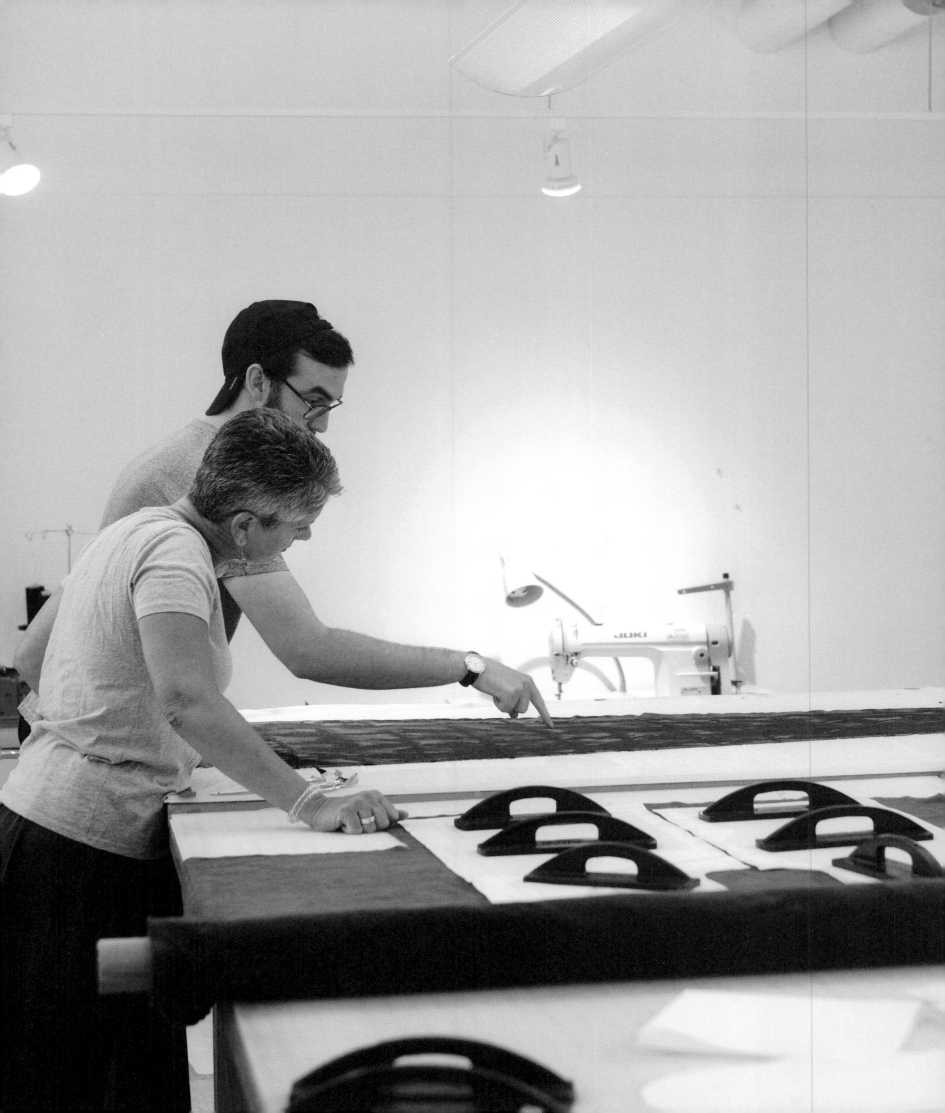

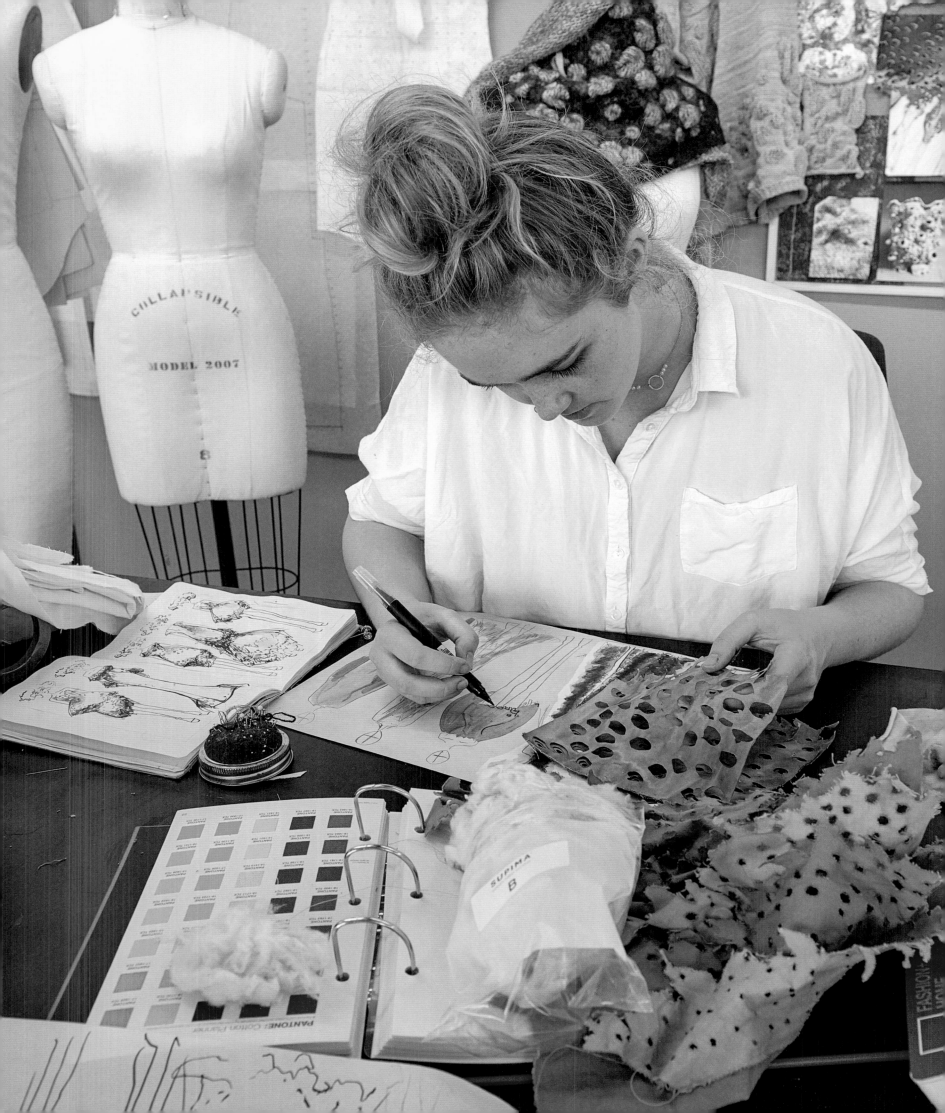

Supima's involvement with the students in our Fashion Design department has been a great experience. The first year that Drexel became a partner was 2017. For the design students, it's been a unique and in-depth learning process. Supima visited the campus in the fall and gave a presentation, highlighting the qualities of the extra-long-staple cotton so that students could understand the benefits of incorporating these materials into their designs. They were impressed by the luxury cotton's softness and strength, but also by Supima's history with American growers. Seeing how Supima visits and works with their domestic growers has been an important factor for this generation of young designers. They were also able to learn about the differences in finished products and the variety of brand partners in both fashion and home furnishings. For the Supima Design Competition, students are challenged to rethink conventional fabric application in the design research process. The Supima project encourages young designers to embrace experimentation, to consider the possibilities, and ultimately to keep their eye on the goal of creating individual, unique, and, most importantly, beautiful pieces in luxury cotton.

Lisa L. Hayes, Program Director, Fashion Design, Drexel University

The Fashion School at Kent State has been incredibly pleased to be included among the schools participating in the annual Supima Design Competition. Supima's vision for a high-impact event that raises awareness for the organization and provides great support and opportunities for both the students and the schools has truly been borne out over the first ten years of the competition. It is the most professionally planned and executed national competition that we partner with through the Fashion School. Our graduates who have been selected to represent Kent State at the Supima Design Competition have learned a great deal and developed important connections that helped kick-start their careers.

J.R. Campbell, Professor and Director, The Fashion School, Kent State University

Supima opportunities are unrivaled for Fashion Institute of Design & Merchandising students and unique for FIDM faculty and staff. Since the institution became involved with Supima, student awareness of cotton's deployable role in multiple design worlds has increased immensely. Students in our Advanced Fashion Design classes and the Textile Design population are now keenly aware of its wonderful properties and employ cotton in their design projects. For example, Supima cotton plays a big part in our annual Chairing Styles project, which brings together three design disciplines to create an exhibition of textiles, furniture, and fashion design. A total of thirty student designers participate. First, the textile students create their designs and print them onto Supima cotton. This lays the foundation for the rest of the project. Next, the interior design students use the cotton for their chair creations, and then the fashion design students create cotton fashions.

Barbara Bundy, Vice President,
Fashion Institute of Design & Merchandising

The Fashion Institute of Technology has proudly collaborated with Supima since the inception of the Supima Design Competition in 2008. Each year, our talented graduating fashion design BFA students compete with top-tier fashion design students from universities across the United States.

The leadership role played by Supima, and its impact on nurturing and supporting these young designers, is immeasurable. Emerging designers learn about a variety of Supima fabrics. Challenged to push the boundaries of these premier cotton fabrications to another level, they use fabric manipulation, dyeing, stitching, and other unique processes to develop their creative directions and produce their own cohesive collections. Supima also exposes them to worldwide venues during the kickoff of New York Fashion Week each fall and at Paris Fashion Week in October.

We are honored to celebrate a decade of partnership with Supima. FIT and its Fashion Design department share our best wishes for continued success and our sincere gratitude for Supima's dedication to higher education.

Eileen Karp, Chairperson, Fashion Design Department,
Fashion Institute of Technology

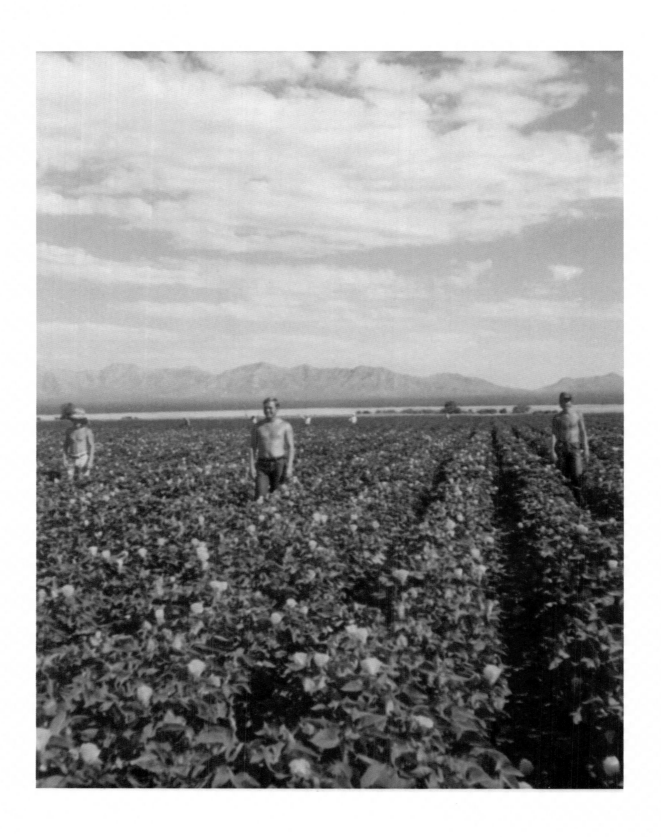

FROM THE
FIELDS

Ted Sheely

Supima was formed in 1954 by a group of forward-thinking farmers who chose the name "Supima," a play on "superior Pima," to describe their unique cotton. The backbone and foundation of this organization continues to be the several hundred family farms growing Supima cotton in Arizona, California, New Mexico, and Texas. It is their dedication and passion for creating the best product that allows for all the cotton's exceptional applications. While Supima represents less than one percent of cotton grown globally, it is known as the world's finest cottons for good reason.

Supima's singularity originates with its fiber, the outcome of over a century of seed breeding and continual improvements in farming practices. Early in the twentieth century, breeding experts at the United States Department of Agriculture set up research farms in Sacaton, Arizona, to develop a cotton of exceptional strength and length.

In 1911, the years of breeding and research yielded a new variety of cotton, named Pima in honor of the Pima Indians who were instrumental in its cultivation and allowed the trials to be conducted on their lands. Probably the most appreciated quality of Supima cotton is its softness, which is due to extra-long fibers that create a smoother yarn. Shorter fibers

are rougher and pill over time; Supima cotton actually gets softer. The fibers are particularly strong, resilient, and long lasting, making Supima ideal for everything from denim, to lightweight knits, to luxury shirting. Though strong, the fibers are fine, a quality that allows for better dye penetration.

After decades of breeding and countless crosses of different types of cottons, Dr. Walker Bryan created Pima S-1 in 1951, a new variety with an improved fiber and increased yields. Additional evolutions, variety S-2 through S-7, were released through the subsequent years. Research and development continues to this day as the American Supima grower is continually striving for premium, consistent quality and yield improvements.

Cotton growers in the arid American West and Southwest have been cultivating Supima cotton for more than a century. It's a rich heritage passed down from generation to generation, and a growing community. To understand the whole story of Supima cotton it's essential to visit the fiber's beginnings in the field. Here, we see how the beauty of Supima's final products originates from a little seed nurtured in fertile soil, stroked by the sun and warm days of summer to produce the world's finest cottons.

FROM ABOVE

Pages 2–3, opposite, 232–233. Aerial views of fields sown with Supima cotton, Arizona.

Pages 4–5, 235. An eye-level view of Supima cotton fields, ready for harvest.

Pages 6–7. Freshly gleaned cotton in its natural state, before carding and cleaning.

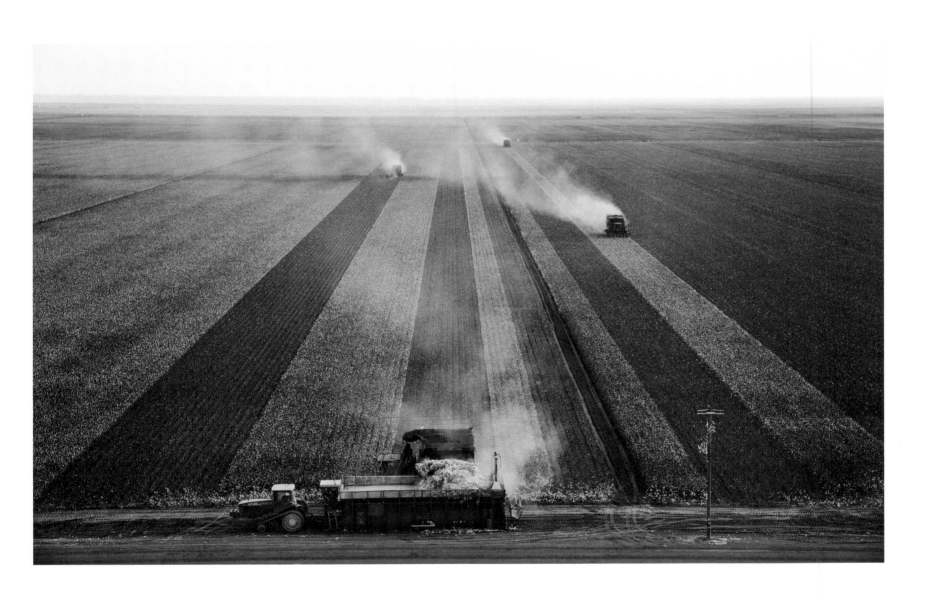

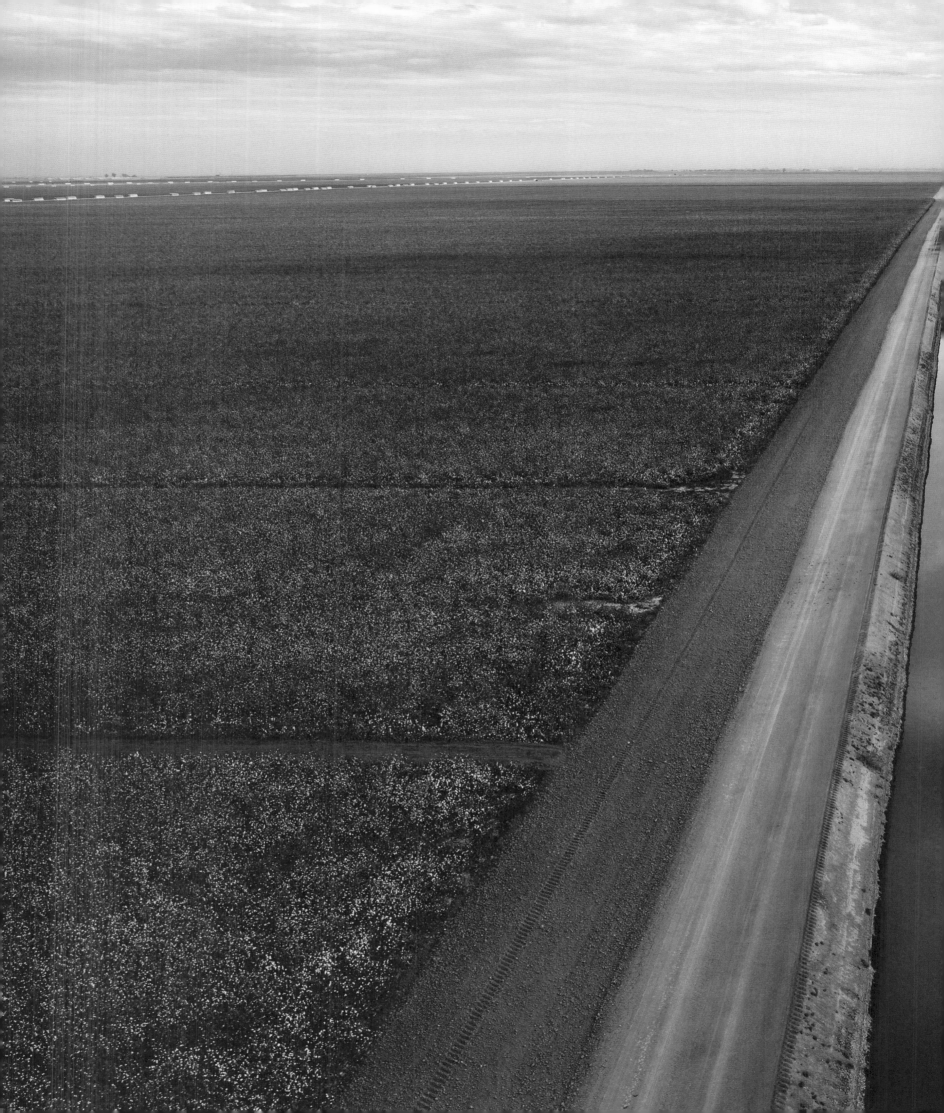

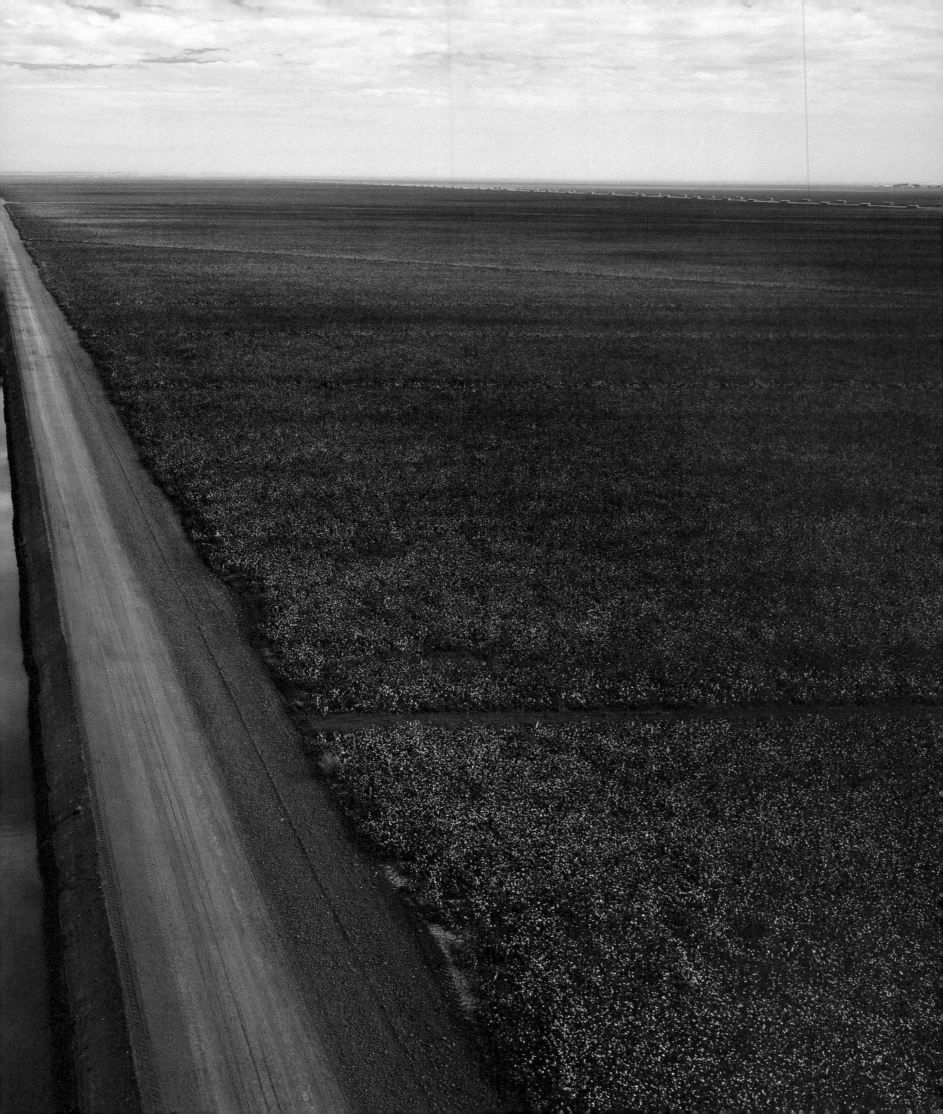

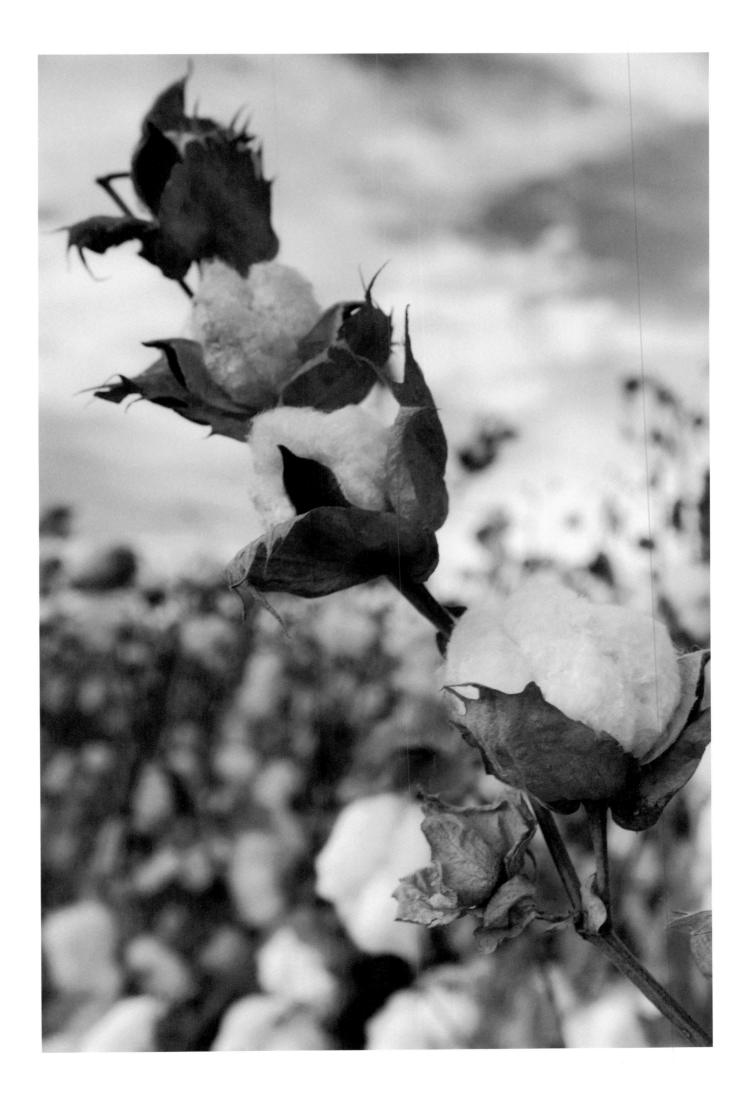

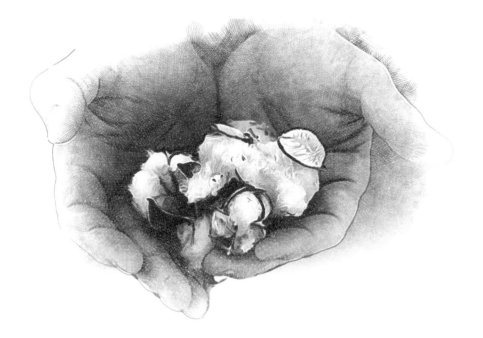

The distinct anatomy of a Pima cotton boll includes the bract, which is the base of the boll, and three locks. The locks distinguish Pima cotton from Upland cotton, as an Upland boll has four locks. Each boll has approximately twenty-five seeds. The fiber is an outgrowth of the seed.

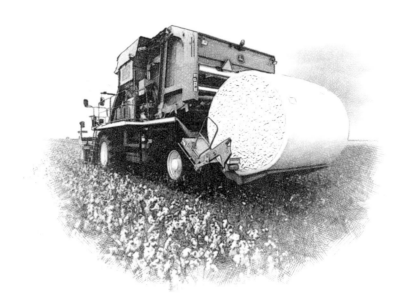

Specialized equipment is used to pick the cotton from Supima's precisely furrowed rows. The latest technology is used in Supima's cultivation. Fields are laser-leveled and then monitored by satellite for nutrient content, pests, and crop growth. At the moment when fiber quality is highest, the Pima cotton is harvested by tractors guided using GPS technology.

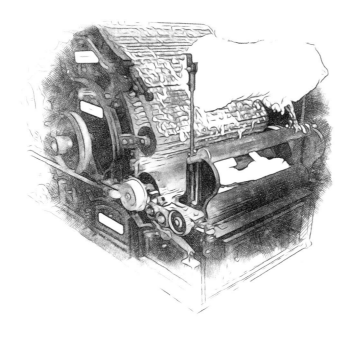

During the carding process, fibers begin to be aligned and the last remnants of plant material are shaken out.

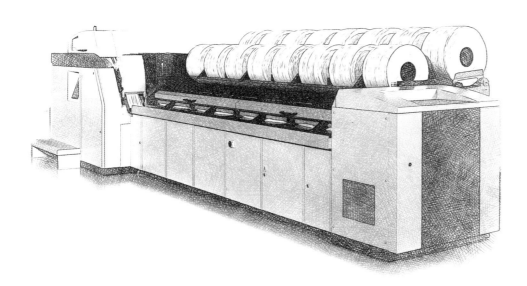

The carding process results in formation of loose ropes of Pima cotton called sliver. These are collected in canisters and are then fed into the spinning process.

In the yarn formation process, twist and tension are applied to the sliver in successive steps to begin to arrive at finer yarn counts.

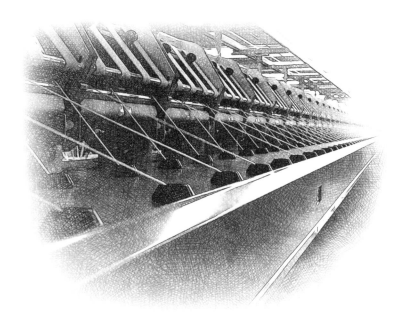

Great care is always used in processing precious Supima fibers. High output can be achieved by running spinning frames at greater velocity. However, many times machines will be run at lower speeds to increase the strength and consistency of the resulting yarns.

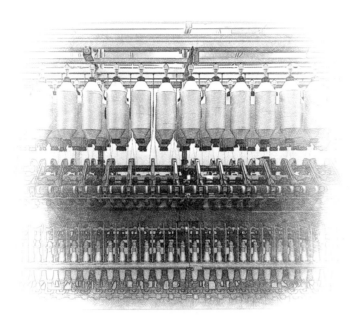

In the final ring spinning stage, the amount of twist and tension are varied to determine the ultimate fineness of the yarn.

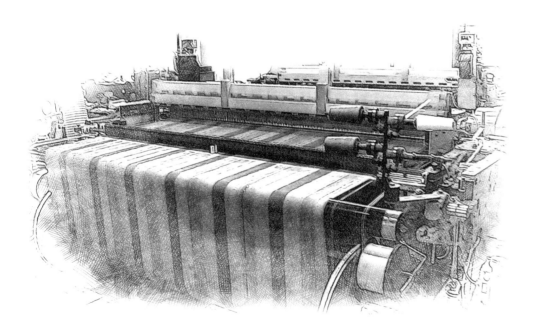

Finally, the finished yarn is woven together to form fabric of the highest quality, ready to be made into beautiful shirting, sheets, or slacks.

This
is
the
story
of

SuPima®

WORLD'S FINEST COTTONS

SUPIMA AND THE FUTURE

Marc Lewkowitz

This book celebrates over six decades of Supima, the world's finest cottons. The tremendous growth and success that the Supima organization, our American-grown extra-long-staple cotton, and our brand partners have experienced has provided us an opportunity to look back on a remarkable journey. As we pause and recognize our successes, we also look forward to a bright future.

The Supima organization was formed in 1954 with the objective of supporting and promoting American-grown ELS, or extra-long-staple, cotton. A collective of forward-thinking farmers believed in the idea of growing premium cotton in the United States and partnering with like-minded companies that knew the best fibers could elevate everyday products to a premium position in the market. With great foresight, the Supima organization recognized that a separate and dedicated marketing body was essential for these goals.

Supima's foundation was built on education and research. The key to creating demand for our American-grown cotton was to educate everyone across the supply chain, as well as end consumers, about the benefits and premium qualities of our cotton. We knew that once we could convey this story, and show firsthand what makes Supima

special, brands and retailers would choose to use our fiber.

From sustainable production, to supply-chain transparency, to global distribution, Supima and our brand partners are committed to consumer awareness. Through countless initiatives developed with our partners, we navigate an ever-changing business climate. The Supima organization aims to serve a broadening group of consumers through meaningful activations that reinforce Supima's message and those of our partners.

American Supima cotton growers are committed to an ongoing research and development process to improve quality and yield. To create better fiber quality, they work closely with agricultural researchers, scientists, breeders, the United States Department of Agriculture, and university and college agricultural programs. This is done with an eye to increasing productivity in the field while reducing resources to achieve greater levels of efficiency and sustainability.

Sustainability is a key component in our story. One of Supima's successes is the Grown in America effort, which continues to inspire consumers. As demand for locally produced products increases, and with millennials playing a bigger role in the economy, Supima expects such initiatives to become even more

critical to consumer decision-making. Grown in America and regulatory oversight, as well as more efficient modern farming practices, are combining to result in a smaller carbon footprint.

Supima's dedication to sustainability is demonstrated by our increased involvement with the Better Cotton Initiative and Cotton LEADS. The goal of these two organizations is to find more sustainable solutions for farmers and the environment.

As the world seeks greater transparency throughout the supply chain, Supima will continue to work on enhancing traceability on both physical and digital platforms. New technologies include identification of DNA and other applied markers. On the digital front, new decentralized technologies further enhance traceability by utilizing various verification protocols. Supima will work on industry best practices to ensure the authenticity of its trademark and of products made with Supima cotton.

Of course, Supima will continue to focus on licensing efforts. We are dedicated to building a global network of partners across all product categories and continuing to grow the licensee network of global partners. The licensing program plays a key role in clarifying the a supply chain and building upon reliable connections from which to source Supima cotton products.

Supima is always looking for new ways to engage. From social media to traditional advertising, our goal is to educate customers about the benefits of Supima cotton. By deepening relationships with current and future partners, we can convey the story of Supima in a way that drives sales. We will continue to work closely with all of our brand partners to communicate this story through promotions, videos, and other efforts that resonate with consumers.

Having learned from ongoing programs with our established retail partners, Supima continues to push the boundaries and explore new opportunities. As demographic shifts emerge and populations expand in international markets such as Europe, India, and China, Supima can build upon successful programs and work closely with international licensees to bring the Supima message to consumers worldwide.

We must keep seeking ways to help consumers identify premium products. For a consumer base willing to invest in the very best, Supima's mission is to create brand awareness for both our cotton and our partners. The more global the economy, the more important it is for us to work closely with all our partners to ensure the continuation of our long and successful history in the years to come.

$Su\ Pima$ 1954

$Su^{u}Pima$ 1969

1971

1980s

SUPIMA®
WORLD'S FINEST COTTONS

1911

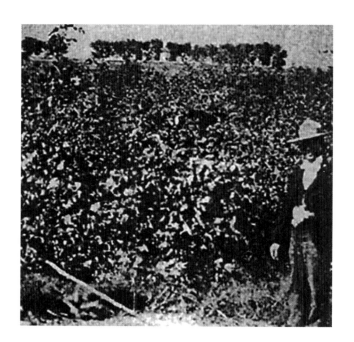

The First Farm

A USDA experimental farm in Sacaton, Arizona, identifies a particularly strong and soft variety of extra-long-staple cotton with a high yield and names it Pima in honor of the area's Pima Indians. Pima cotton is born!

1916

A New Cotton Is Produced

Recognizing Pima's combination of high strength and light weight, Goodyear buys up 16,000 acres of land in Arizona and vastly expands Pima production for use in its automobile, bicycle, and airplane wing tires.

1954

1956

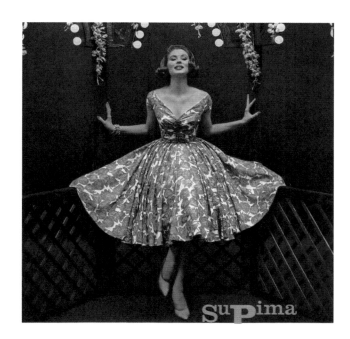

Supima Is Born

As demand grows for high-quality Pima
cotton produced in the U.S., a group of
family farmers establish the Supima organiza-
tion and rename American-grown Pima cotton
as Supima®. The name comes from a combi-
nation of the words "Superior" and "Pima."

Supima Featuring Suzy Parker

The Supima organization launches its first
advertising campaign to promote Supima
cotton. Supermodel, and Coco Chanel muse,
Suzy Parker stars in the ad campaign estab-
lishing Supima as America's luxury fiber.

1970

1988

Pierre Cardin Stripes

Throughout the late 1960s and 1970s, brands like Lily Pullitzer and Pierre Cardin take advantage of Supima's distinct colorfastness to create boldly contrasting prints, as seen in this pyschedelic Pierre Cardin Supima ad.

Export Promotion Program

With demand in the U.S. at an all time high, Supima launches its international export program. America's luxury fiber quickly becomes the first choice of Swiss and Italian high-end spinners and shirting mills.

1990

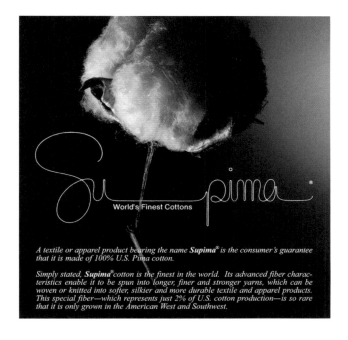

*A textile or apparel product bearing the name **Supima*** is the consumer's guarantee that it is made of 100% U.S. Pima cotton.

Simply stated, **Supima** *cotton is the finest in the world. Its advanced fiber characteristics enable it to be spun into longer, finer and stronger yarns, which can be woven or knitted into softer, silkier and more durable textile and apparel products. This special fiber—which represents just 2% of U.S. cotton production—is so rare that it is only grown in the American West and Southwest.*

Launch of Licensing Program

In an effort to manage and promote Supima cotton, the Supima organization introduces a licensing program for brands and retailers.

2002

Supima And Denim

With the premium denim trend in full swing, leading denim mills in Japan, Italy, and Turkey turn to Supima cotton for its blend of luxury and toughness.

2004

2008

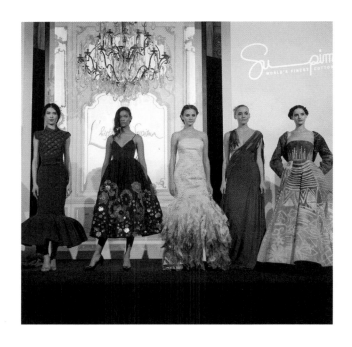

50th Anniversary

Supima celebrates both its 50-year
anniversary and a record crop of close
to 750,000 bales of cotton. Hailed as a
"Cinderella story" by the national media,
Supima cotton's catalog of licensees climbs
to 200 companies in over 41 countries.

Supima Design Competition

Responding to an industry need for creativ-
ity and design innovation, along with the
responsibility for supporting and promot-
ing recent design graduates, Supima hosts
its first ever Supima Design Competition.